COLLECTING
FINE ART

THE LUMAS PORTFOLIO VOL. III

Edited by
Heike Dander
Stefanie Harig
Marc A. Ullrich
Gunnar Wagner

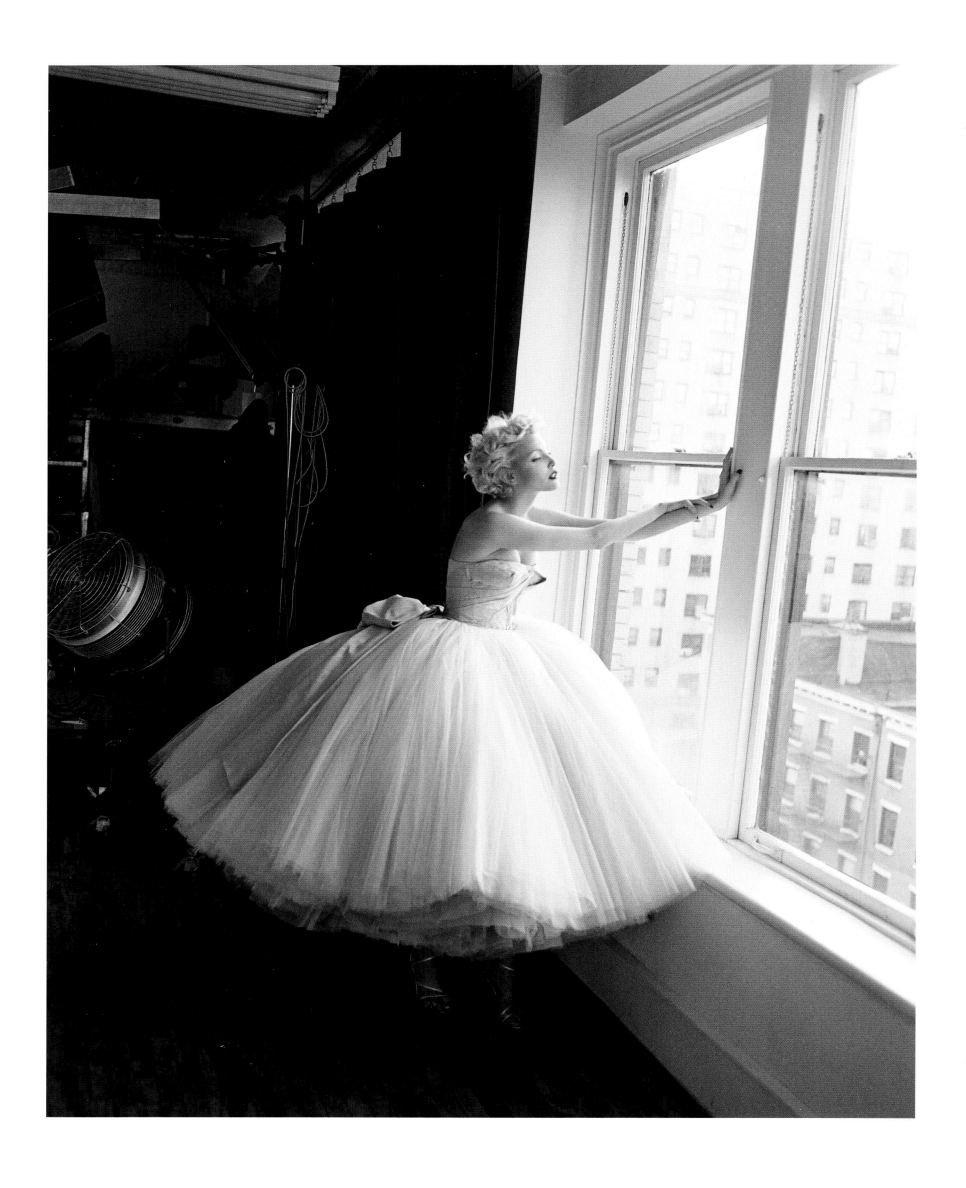

PATRICK DEMARCHELIER | HEARST | TRUNK ARCHIVE
Ballerina

Erich Lessing, geb. 1923 in Wien, Österreich, arbeitet seit 1947
als Fotoreporter u.a. bei Associated Press. Seit 1951 Mitgliedschaft
bei Magnum Photos. Seit Mitte der 1950er-Jahre als Kulturfotograf
tätig. Ihm wurden zahlreiche Preise und Auszeichnungen verliehen
u.a. 1997 der Große Österreichische Staatspreis, 1992 die Imre-
Nagy-Medaille, 1956 der American Art Editor's Award. Lessing ist
Mitglied der UNESCO International Commission of Museums
und des CIDOC.

Ein Wort vorab.
Oder von der Photographie zur Fotografie

Schon vor Jahrhunderten nutzten Landschaftsmaler die
Camera obscura – die Urkamera, um mit ihrer Hilfe
Umrisse nachzuzeichnen. Doch erst LOUIS DAGUERRE in
Paris und HENRY FOX-TALBOT in England gelang es, in
den 30er Jahren des 19. Jahrhunderts chemische Prozesse
zu entwickeln, mit denen diese *Licht-Bilder* fixiert werden
konnten. DAGUERRE beschränkte seine Photographie
fast ausschließlich auf Portraits. Jedes Bild war ein Unikat,
das auf einer Metallplatte fixiert wurde.

Was aber das Publikum, das englische wie das französische,
sofort begeisterte, war die Unmittelbarkeit des Bildes,
seine „Wahrheit", ja, seine Wirklichkeit, die noch über das
hinausging, was das Auge sehen konnte. Die Frage nach
der „Wahrheit" einer Photographie wurde seitdem immer
wieder gestellt, ebenso wie die Frage, wie viel Wahrheit ein
Publikum zu ertragen bereit ist, wenn es sich zum Beispiel
um die Kriegsberichterstattung handelt.

Die Photographie ist, wie jede andere darstellende Kunst,
immer auch ein Spiegel ihrer Zeit. Die Leica hat unsere
Auffassung von der Dokumentation der Zeit zu Beginn
der 1920er-Jahre nachdrücklich verändert. Die neuen
technischen Möglichkeiten, die durch das Kleinbild
ermöglicht wurden, haben der Fotografie seit dem Ende
der 1920er-Jahre bis heute den Stempel aufgedrückt:
von ERICH SALOMON über ROBERT CAPA zu MARTIN PARR.

Die digitale Technik hat wieder ein völlig neues Bildbewusst-
sein geschaffen und die alten Koordinaten (Komposition,
Schärfe, etc.) zur Geschichte erklärt.

LUMAS hat respektvoll das gesamte Medium bis heute in sein
Programm aufgenommen und repräsentiert alle Tendenzen
der klassischen Photographie, alle Möglichkeiten der moder-
nen digitalen Fotografie, sowie alle technischen Weiterent-
wicklungen, die dem Fotografen als Ausdrucksmittel zur
Verfügung stehen. Wegweiser in die Vergangenheit und
gleichzeitig in die Zukunft. Das Gebot der Dokumentation
ist hier voll erfüllt.

ERICH LESSING

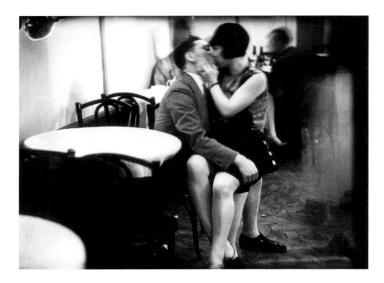

ERICH SALOMON
Paar in Karnevalsstimmung

Erich Lessing, born in 1923 in Vienna, Austria, has worked as a photo reporter with Associated Press since 1947, and has been a member of Magnum Photos since 1951. Around the middle of the 1950s he began to work as a culture photographer. He has received numerous awards and prizes, including the Grand Austrian State Prize 1997, the Imre Nagry Medal 1992, and the American Art Editor's Award 1956. Lessing is a member of the UNESCO's International Commission of Museums, and the CIDOC.

A brief introduction – the story of photography

Centuries ago, landscape artists began using the *camera obscura*, the original camera, to help them trace the outlines of their scenes. It was not until the 1830s that chemical processes were first used to develop and capture these *light images* – by LOUIS DAGUERRE in Paris, and HENRY FOX-TALBOT in England. DAGUERRE limited his photography almost exclusively to portraits. Each shot was unique, and fixed on a metal sheet.

It was the immediacy of the images that won over the public so quickly. Their "truth" went beyond what even the naked eye could see. The question of how much truth a photograph contains is still relevant today, as is the question of how much truth should be shown to an audience, especially when it comes to war reporting.

Photography, like any form of representative art, will always be a mirror of its time. At the beginning of the 1920s the Leica camera had a profound impact on our understanding of the documentation of time. The new technical opportunities created by the production of small images have influenced photography from the end of the 1920s till today, from ERICH SALOMON, to ROBERT CAPA and MARTIN PARR.

Digital technology has created another dimension to images and relegated the traditional variables (sharpness, composition etc.) to history.

The LUMAS portfolio covers the entire medium of photography up to the present. It embraces the nuances of classical photography, the opportunities of modern digital photography, and the vast range of other technical developments that are available to the photographer as a means of expression. A window to the past, and to the future, it fulfils the promise of "documentation".

ERICH LESSING

Erich Lessing, né en 1923 à Vienne (Autriche), travaille depuis 1947 comme reporteur photo entre autres pour Associated Press. Depuis 1951 membre de Magnum Photos. Depuis le milieu des années 1950 est actif comme photographe culturel. Il a été récompensé par de nombreux prix et décorations notamment le grand prix national autrichien en 1997, la médaille d'Imre-Nagy en 1992 et l'American Art Editor's Award en 1956. Lessing est membre de l'UNESCO International Commission of Museums et du CIDOC.

Avant-propos. Ou comment l'on est passé de la technique photographique à la photographie

Il y a plusieurs siècles déjà, les paysagistes utilisaient une *chambre noire* (camera obscura), l'ancêtre de l'appareil photographique, pour simplifier le tracé des formes. Mais il a fallu attendre les années 1830 pour que ces *images lumineuses* soient fixées grâce à des procédés chimiques développés par LOUIS DAGUERRE à Paris et HENRY FOX-TALBOT en Angleterre. DAGUERRE a presque exclusivement concentré sa photographie sur des portraits. Chaque image était une pièce unique fixée sur une plaque en métal.

Mais ce qui a le plus passionné le public des deux côtés de la Manche, c'était la présence de l'image, sa « réalité ». Un réalisme qui dépassait ce que l'œil pouvait percevoir. La question de la « réalité » de la photographie n'a jamais cessé d'être posée, autant que celle de savoir quel degré de réalité le public est prêt à supporter lorsqu'il s'agit par exemple de couvrir une guerre.

La photographie, comme toutes les autres formes d'art figuratif, est aussi le miroir d'une époque. Le Leica a intensément marqué notre vision du documentaire au début des années 1920. Les nouvelles possibilités techniques apportées par le petit format ont influencé la fotografie depuis la fin des années 1920 jusqu' aujourd'hui: d'ERICH SALOMON, à ROBERT CAPA et MARTIN PARR.

Le numérique a à son tour permis le développement d'une conscience entièrement nouvelle de l'image et a relégué les anciens paramètres (composition, netteté, etc.) au passé.

Dans le respect de l'art, le programme LUMAS couvre la photo dans toute son étendue et représente toutes les tendances de la photographie classique, les possibilités de la photographie numérique moderne, ainsi que toutes les évolutions techniques qui offrent au photographe un moyen d'expression. A la fois témoin du passé et regard vers l'avenir. De quoi remplir comme il se doit toutes les exigences du documentaire.

ERICH LESSING

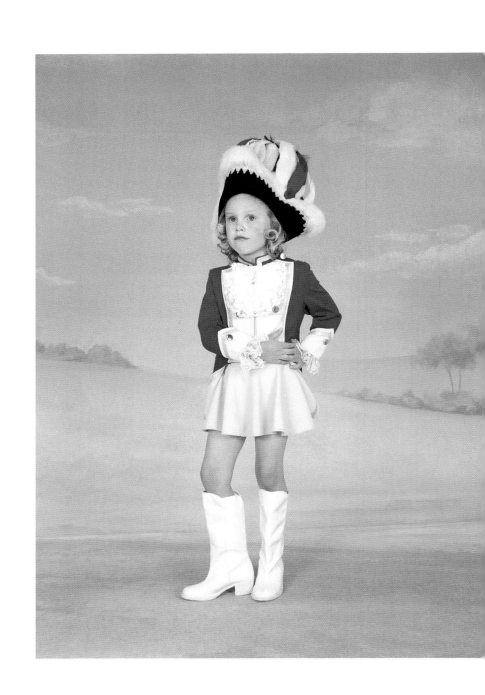

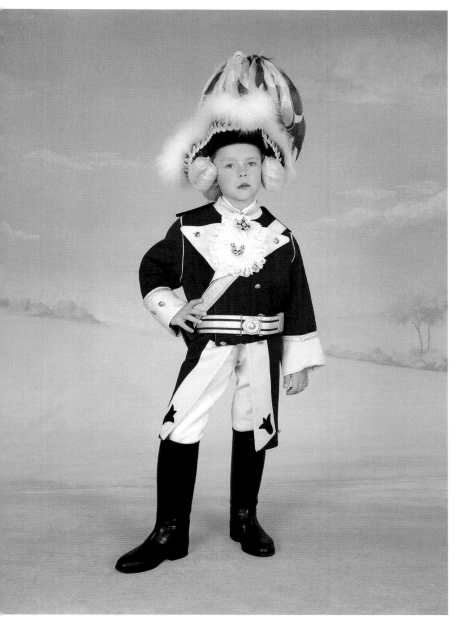
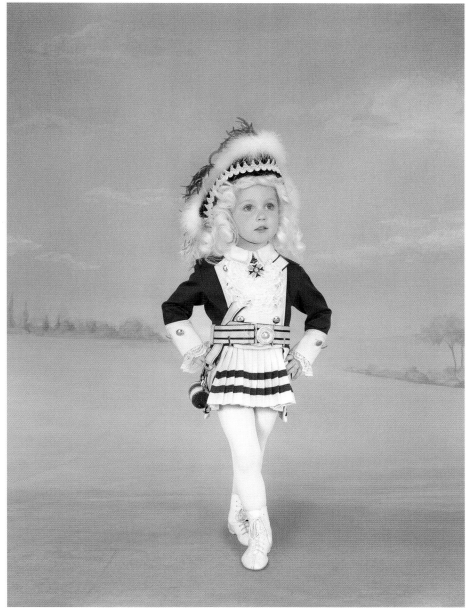

ACHIM LIPPOTH | TRUNK ARCHIVE
Girl Cadet, Boy Soldier, Girl Soldier

MIKI TAKAHASHI (FOLLOWING PAGE)
Warm Rain

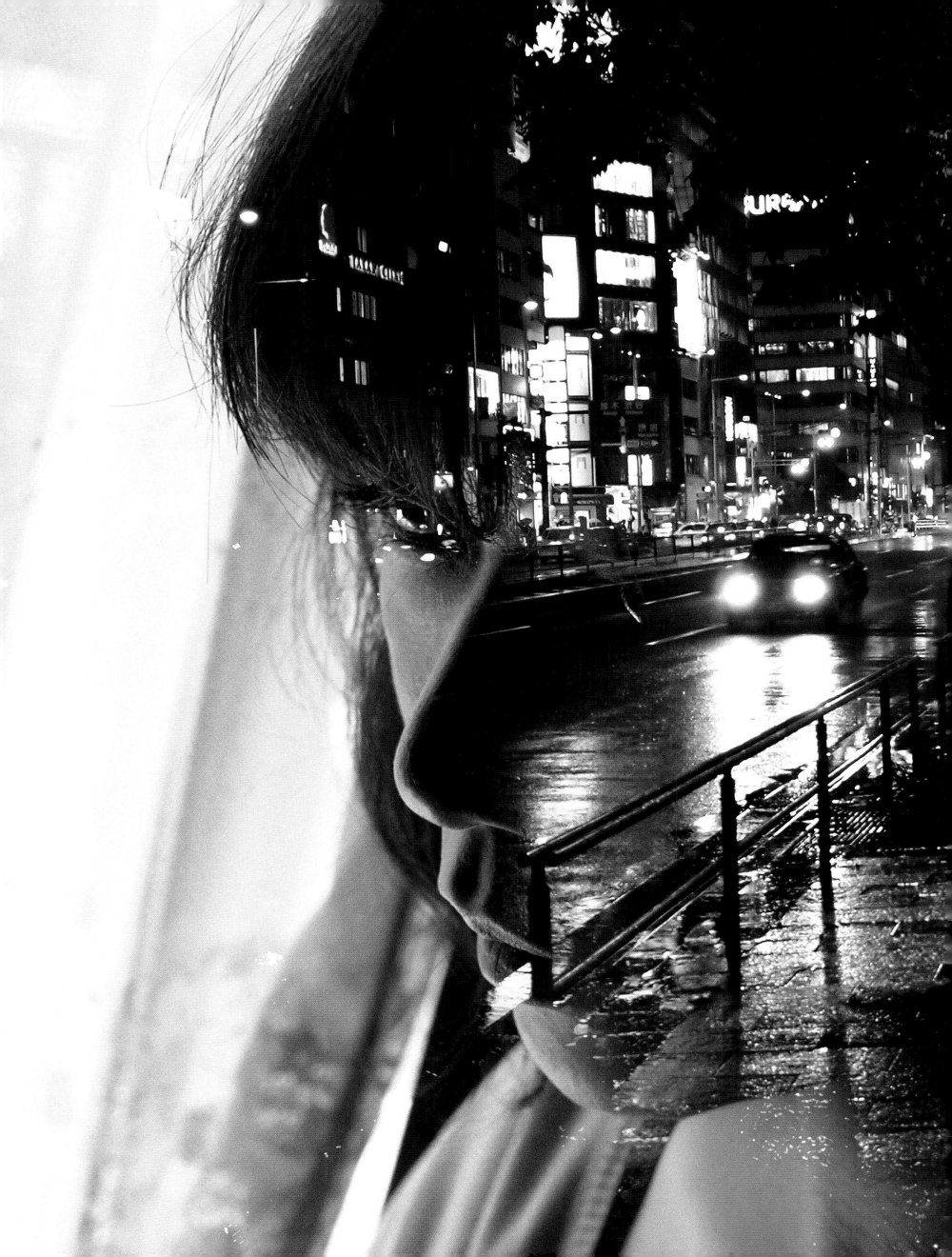

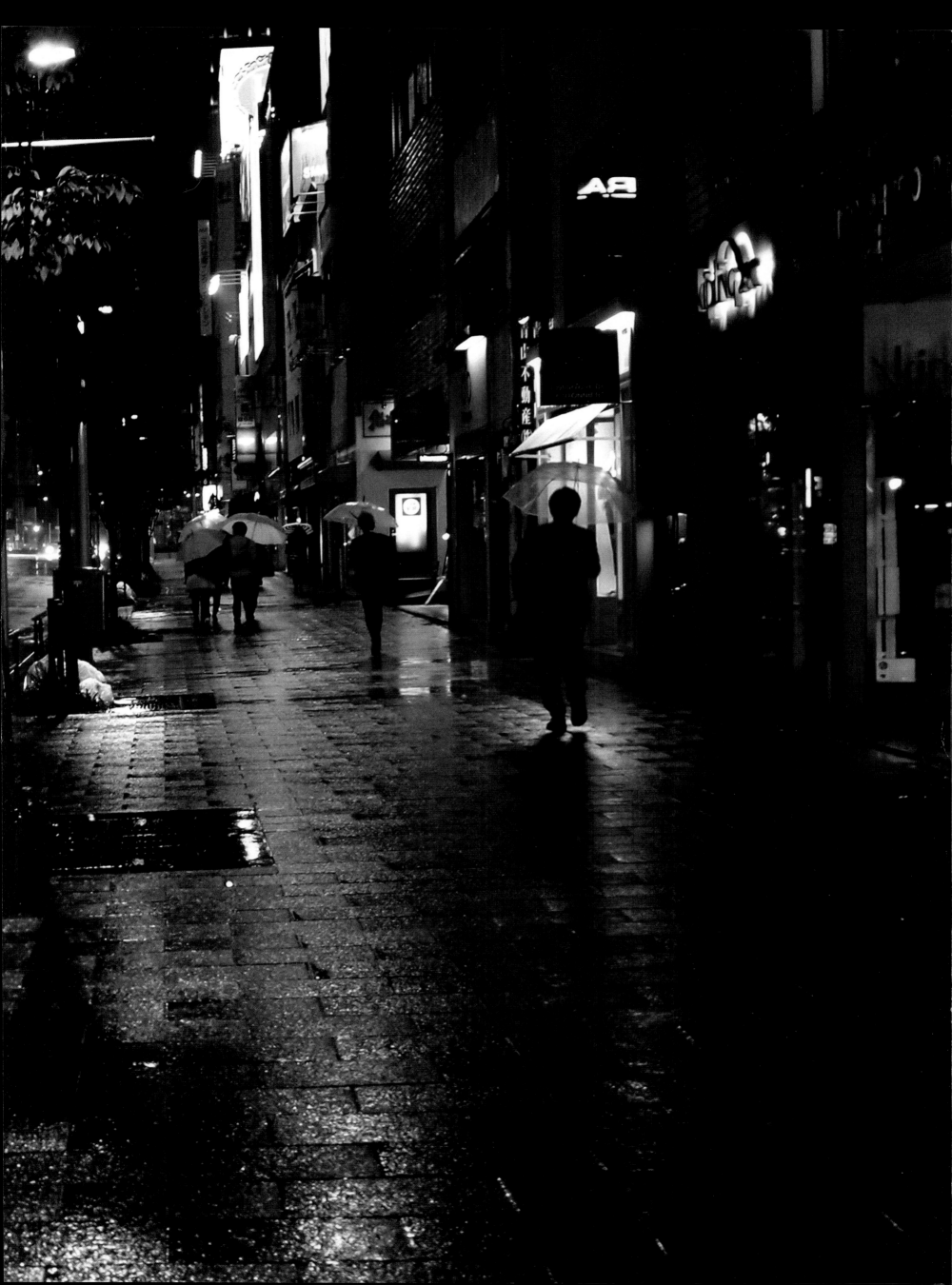

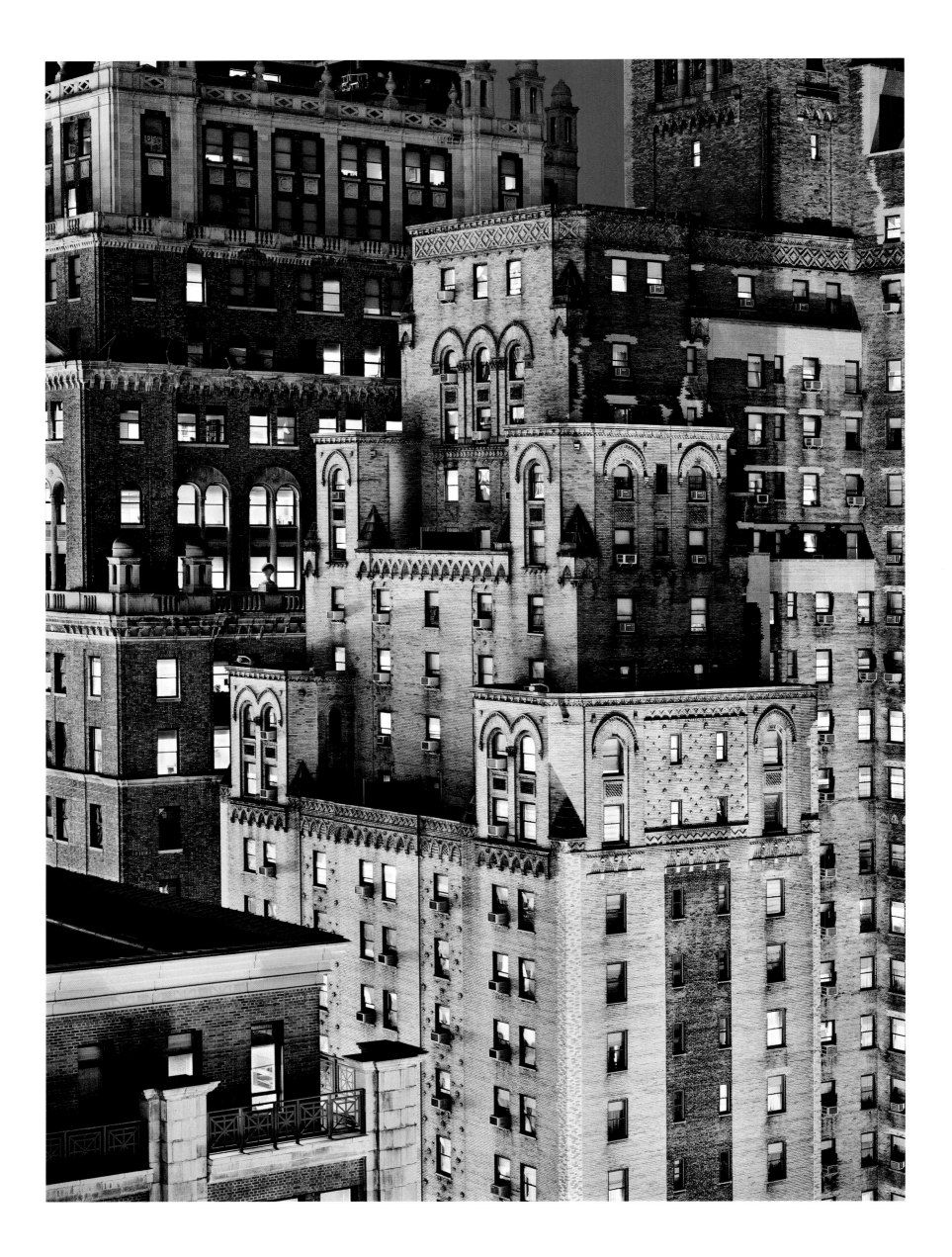

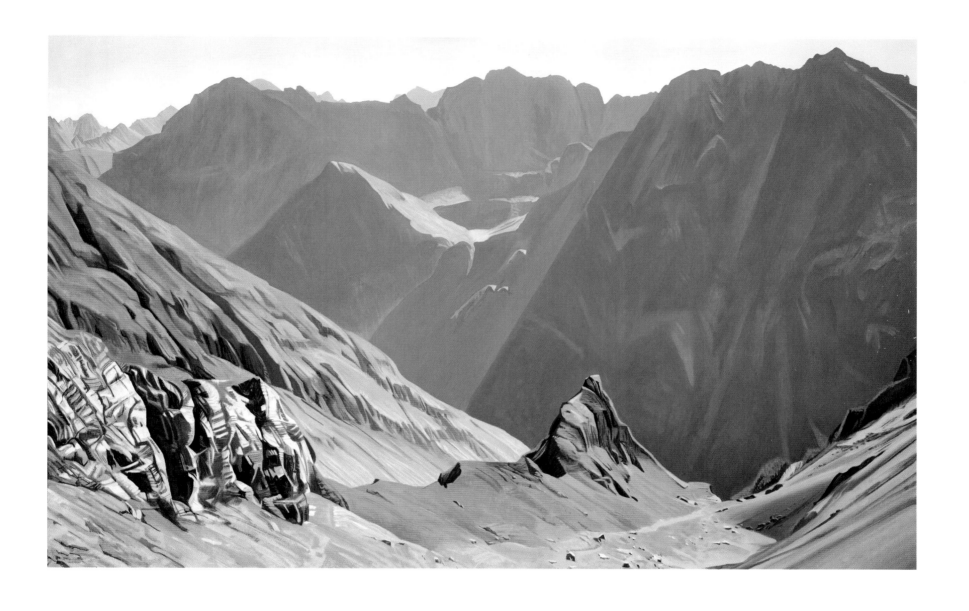

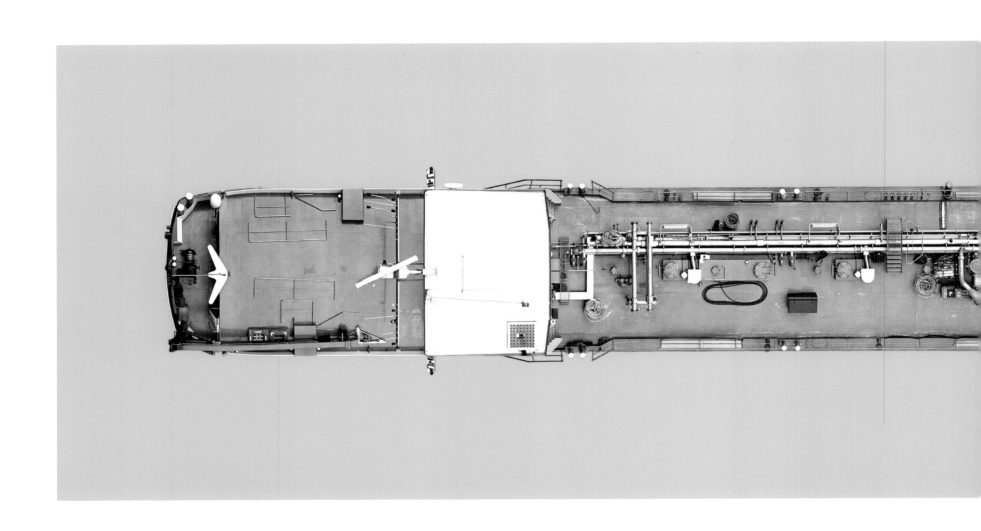

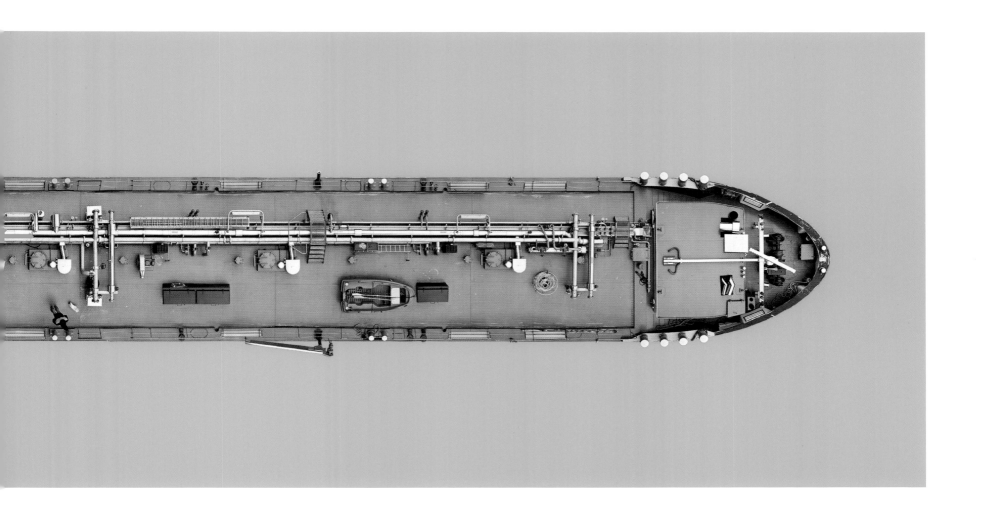

DIRK BRÖMMEL
Schiff #9

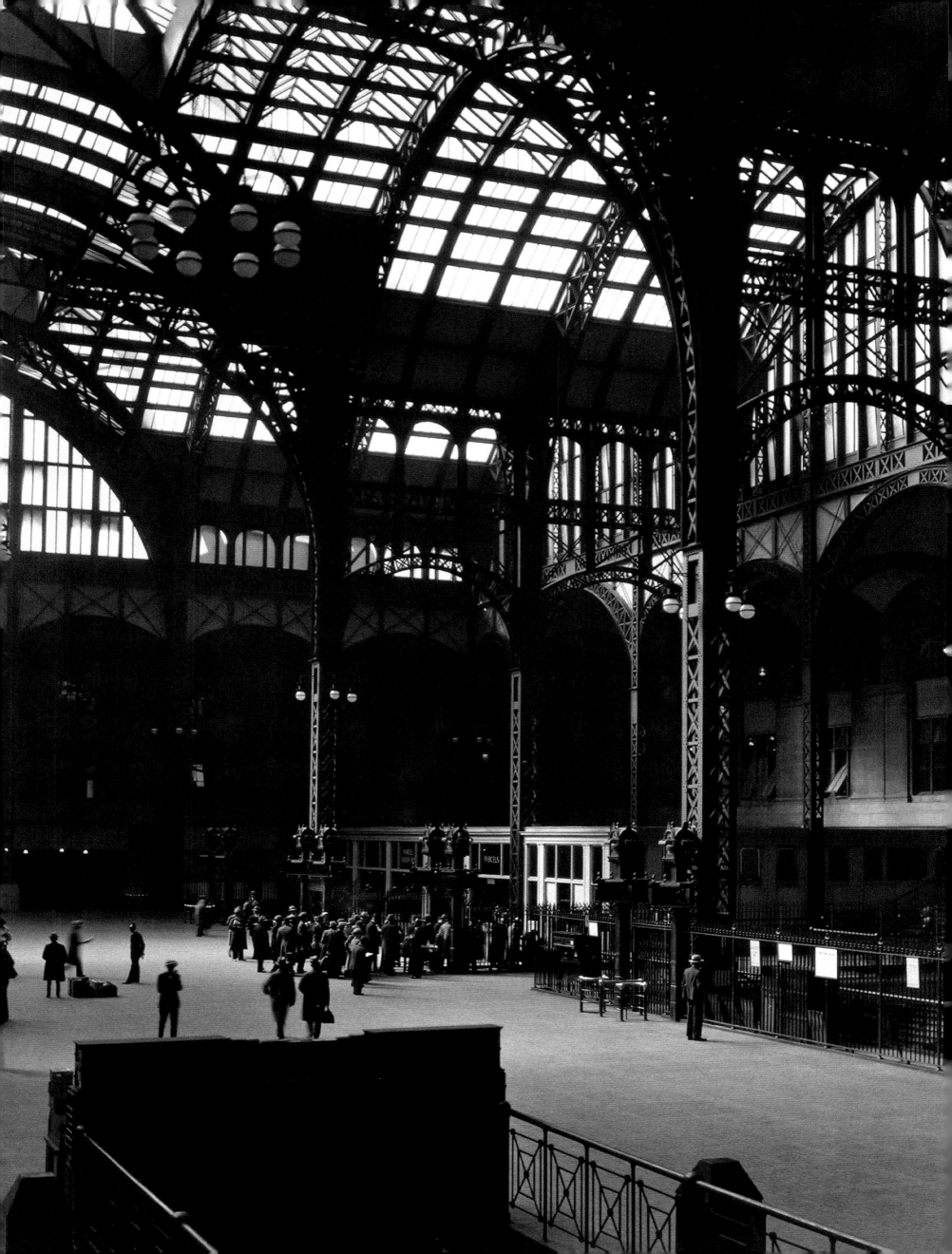

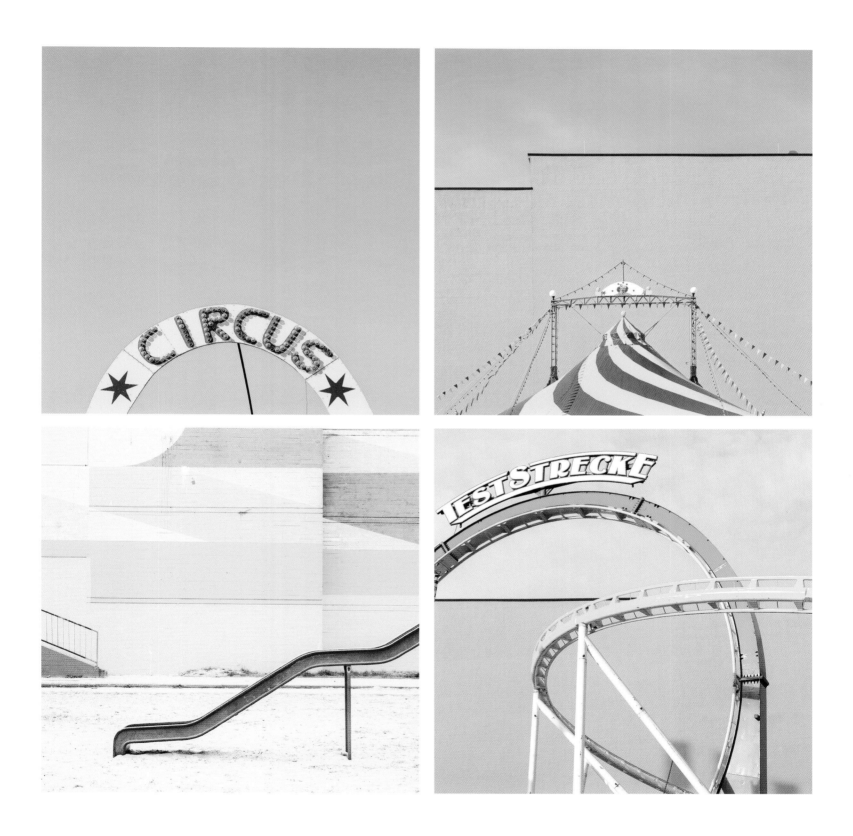

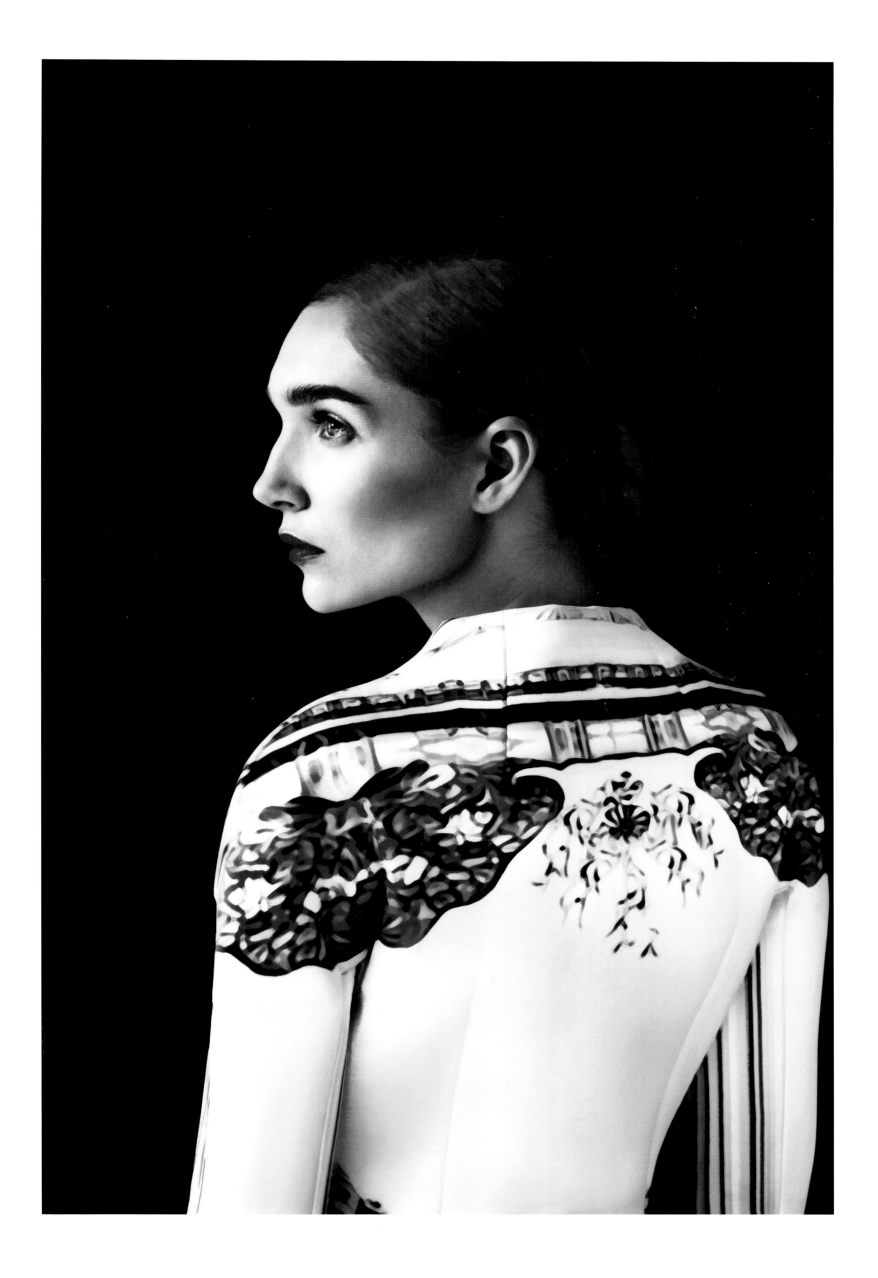

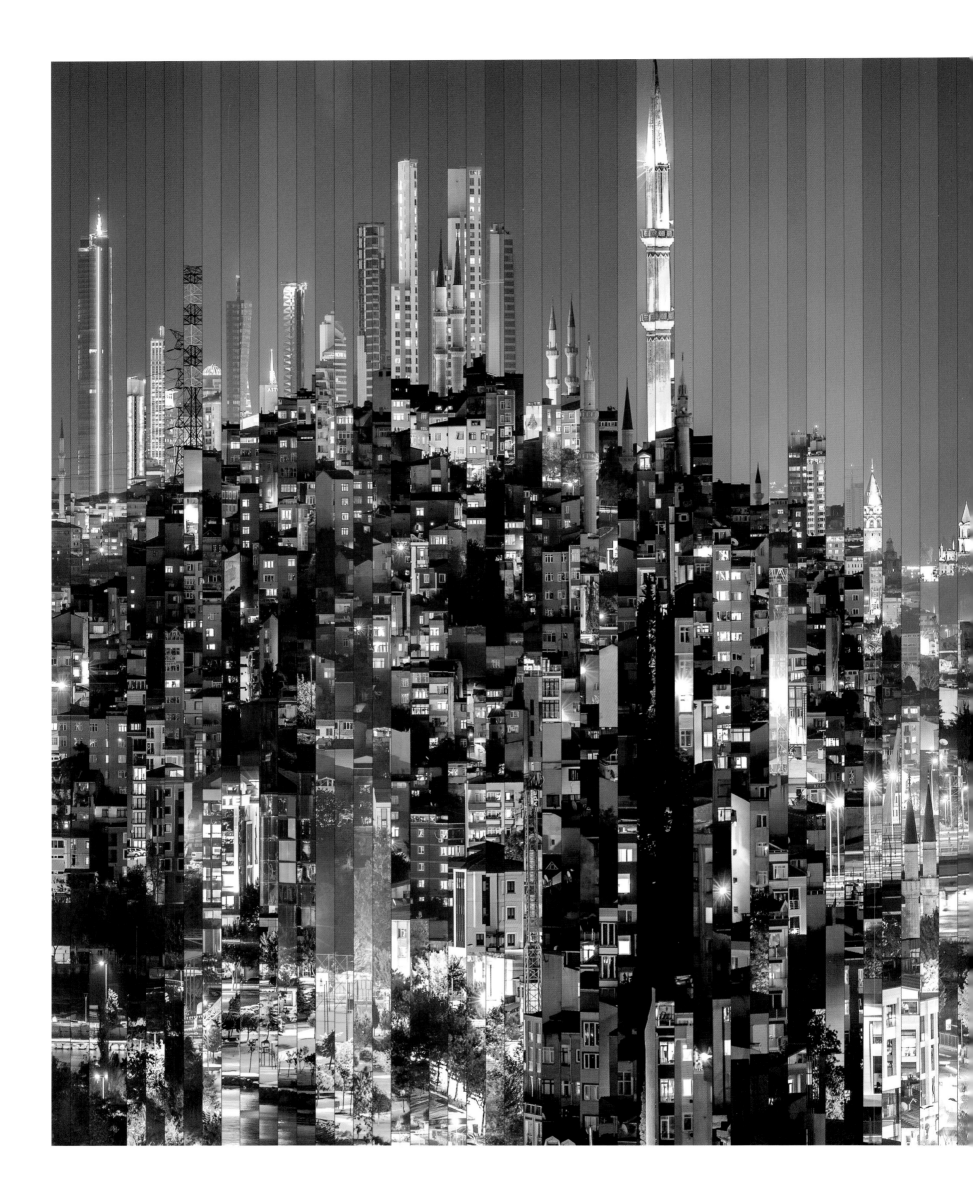

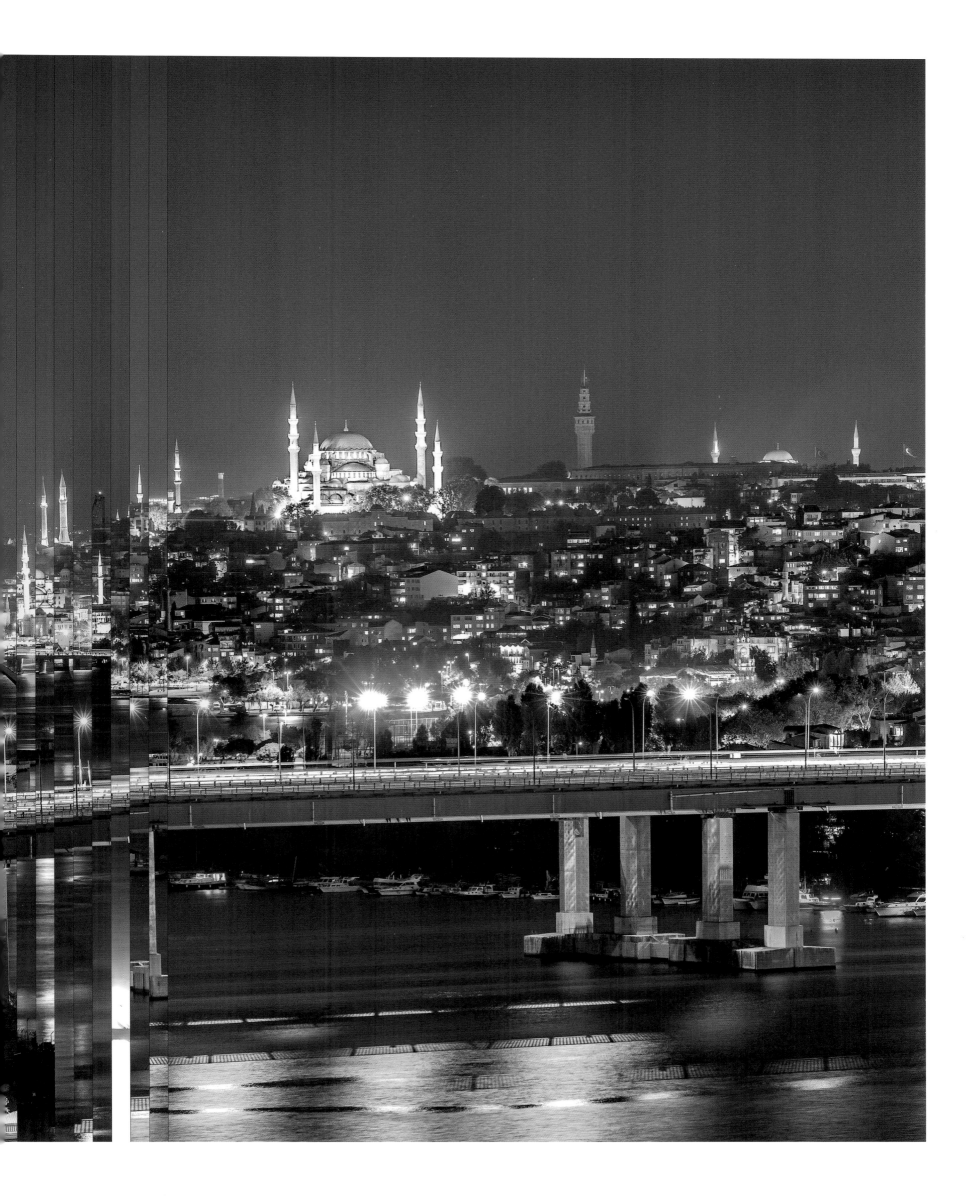

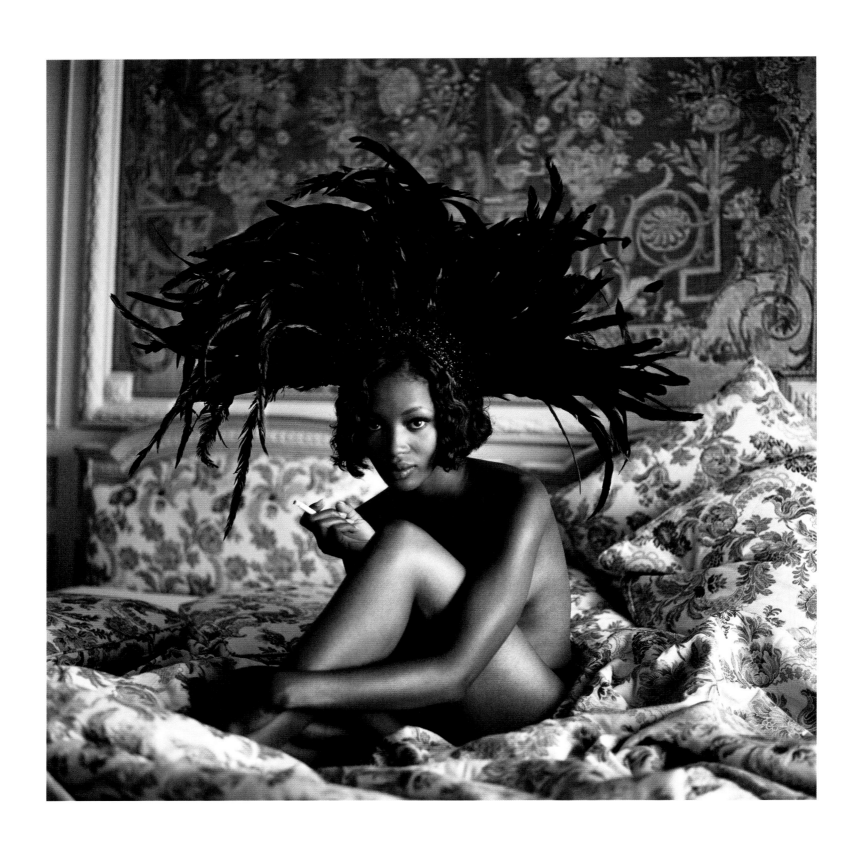

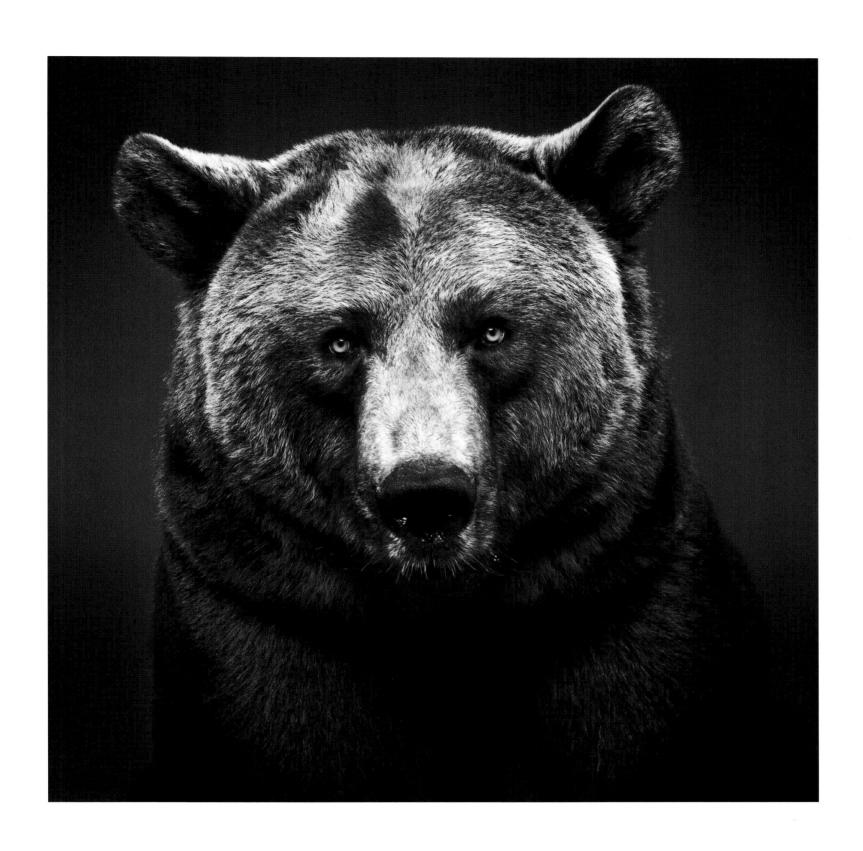

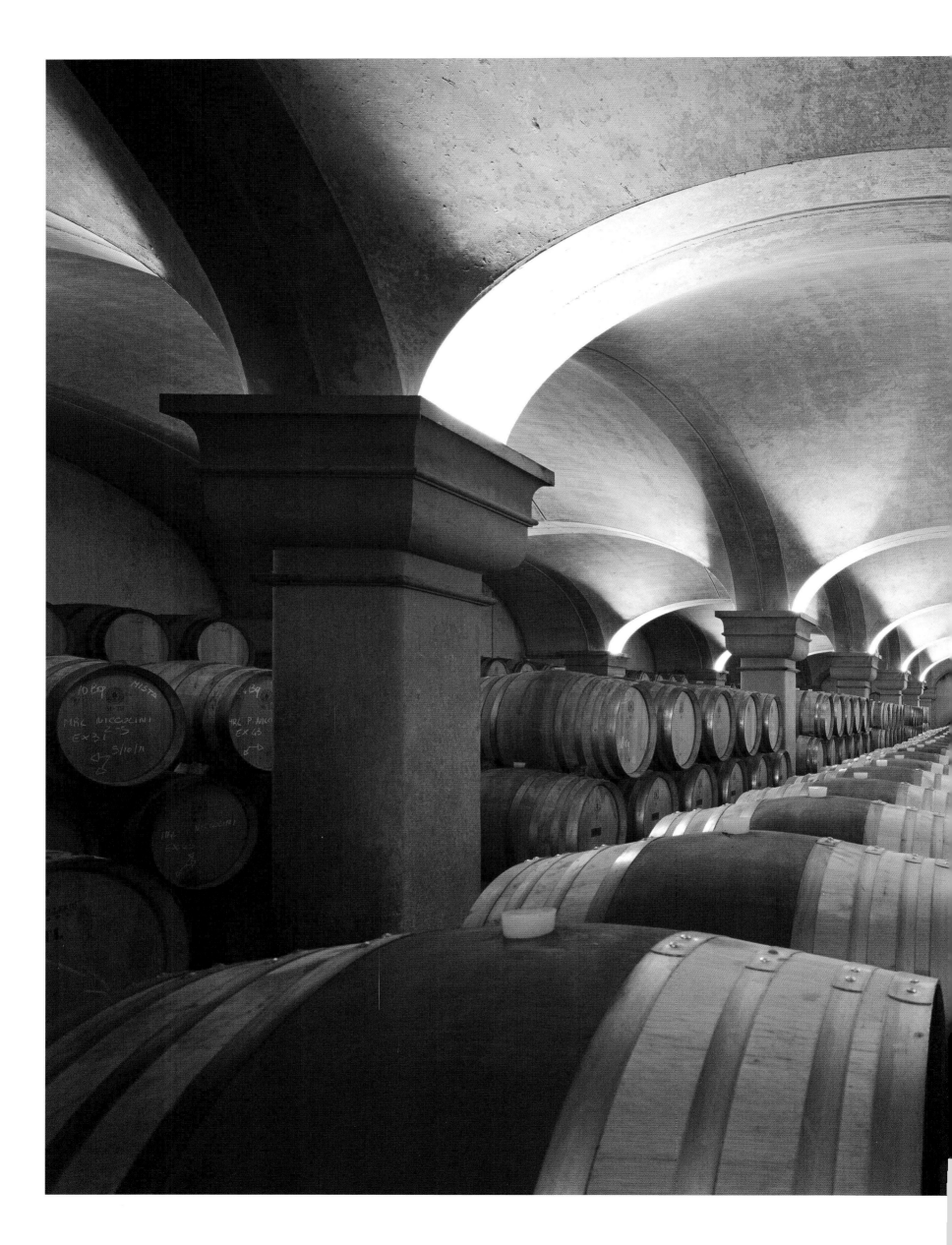

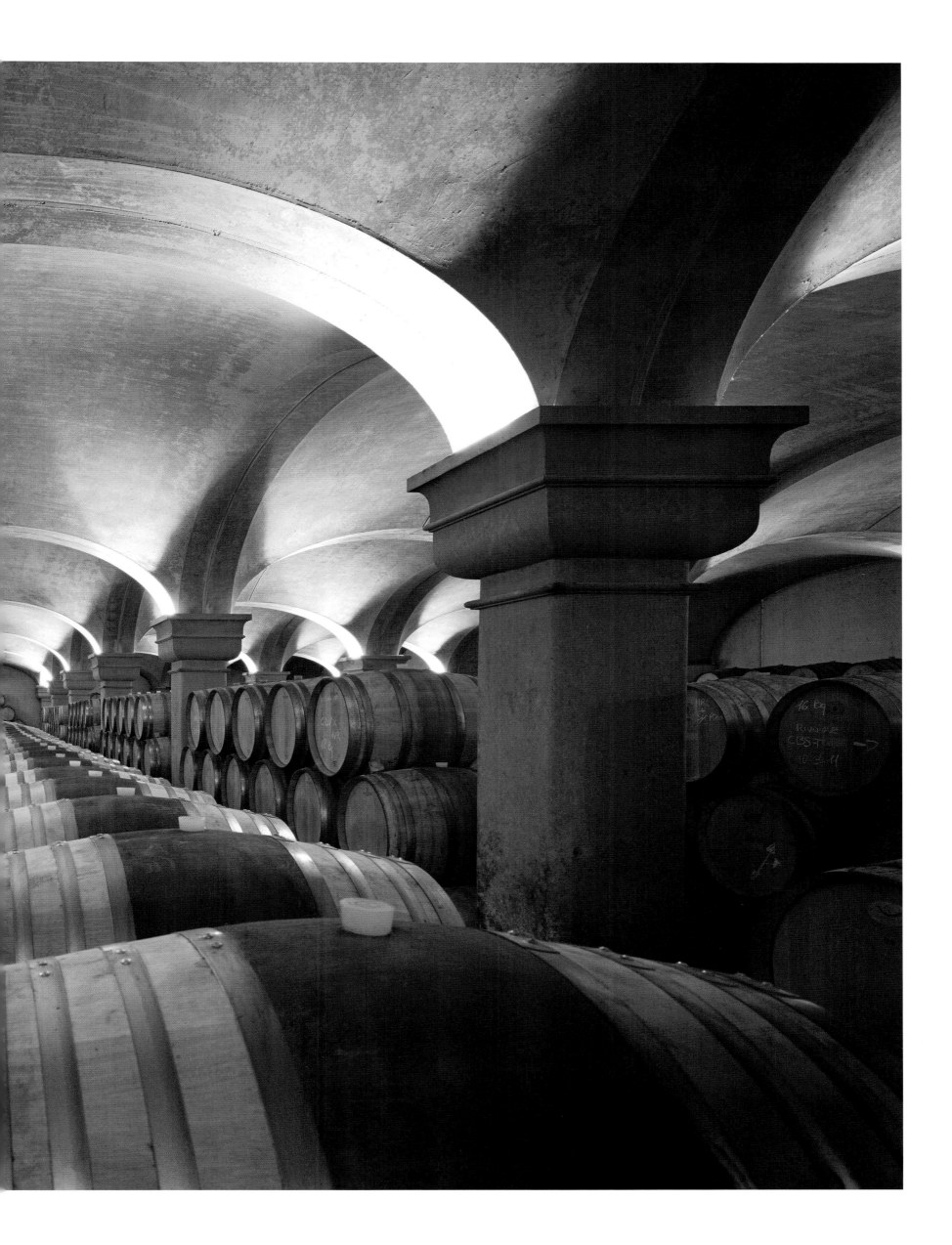

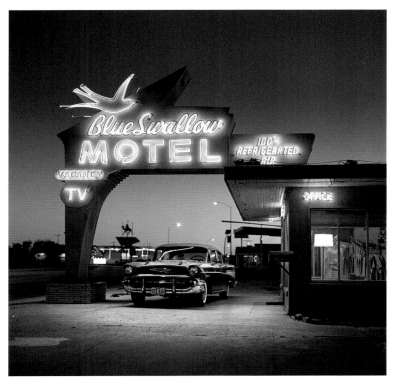
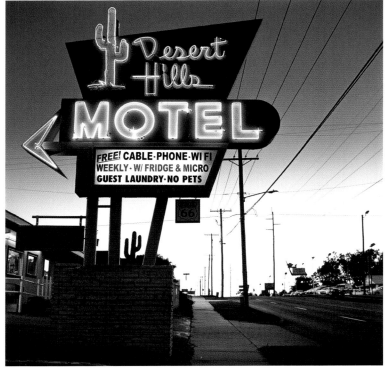
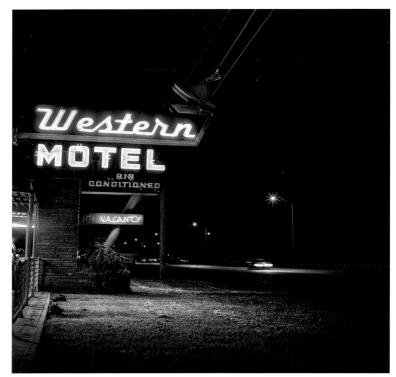
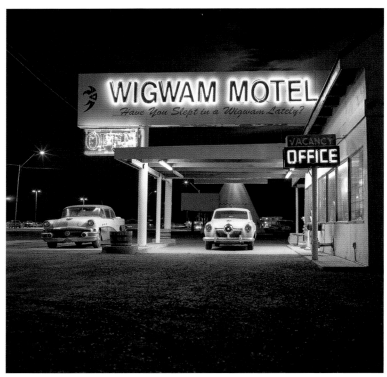

SHANNON RICHARDSON (LEFT)
Blue Swallow Motel, Desert Hills Motel,
Western Motel, Wigwam Motel

BEATRICE HUG (RIGHT)
Red Moai

GEEBIRD & BAMBY (FOLLOWING PAGE)
The Modern Gentleman

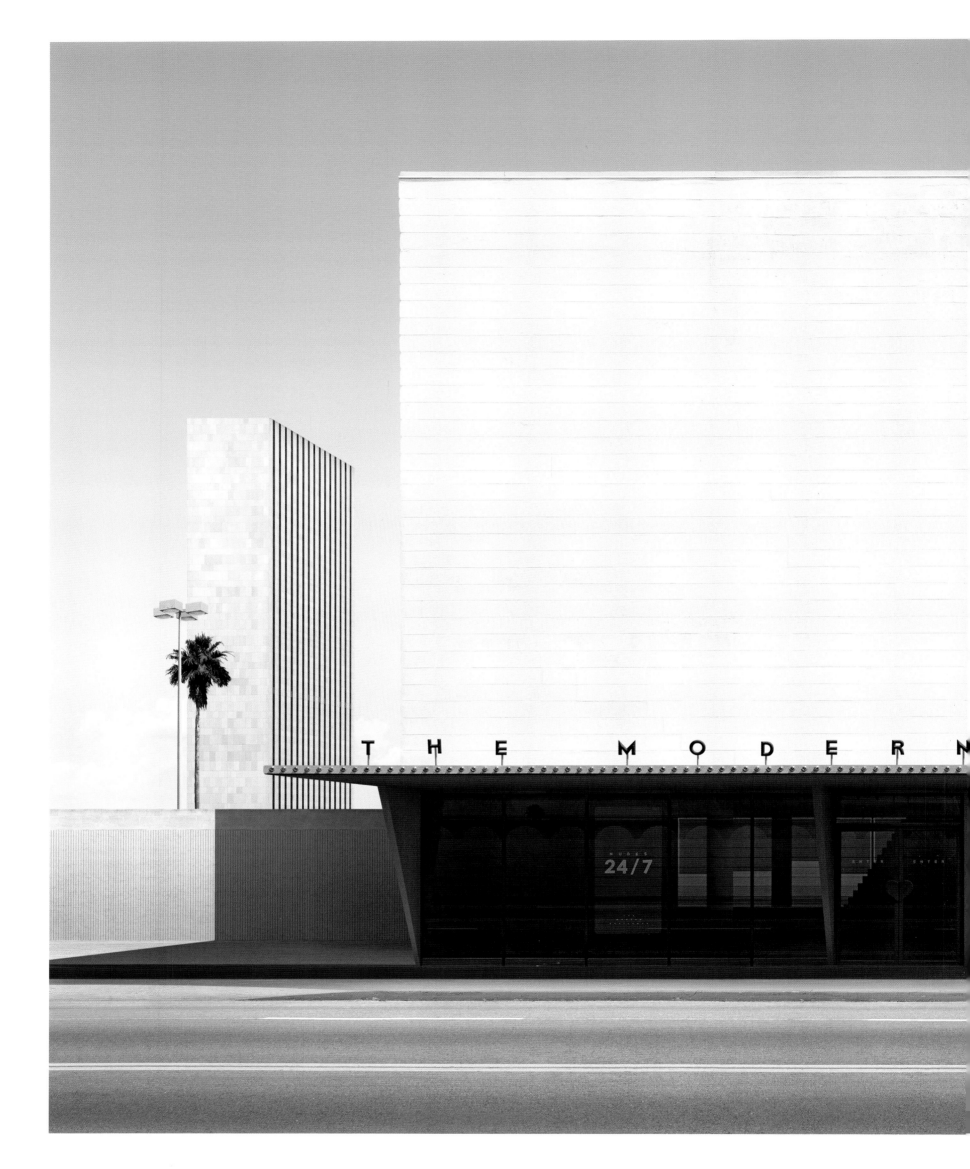

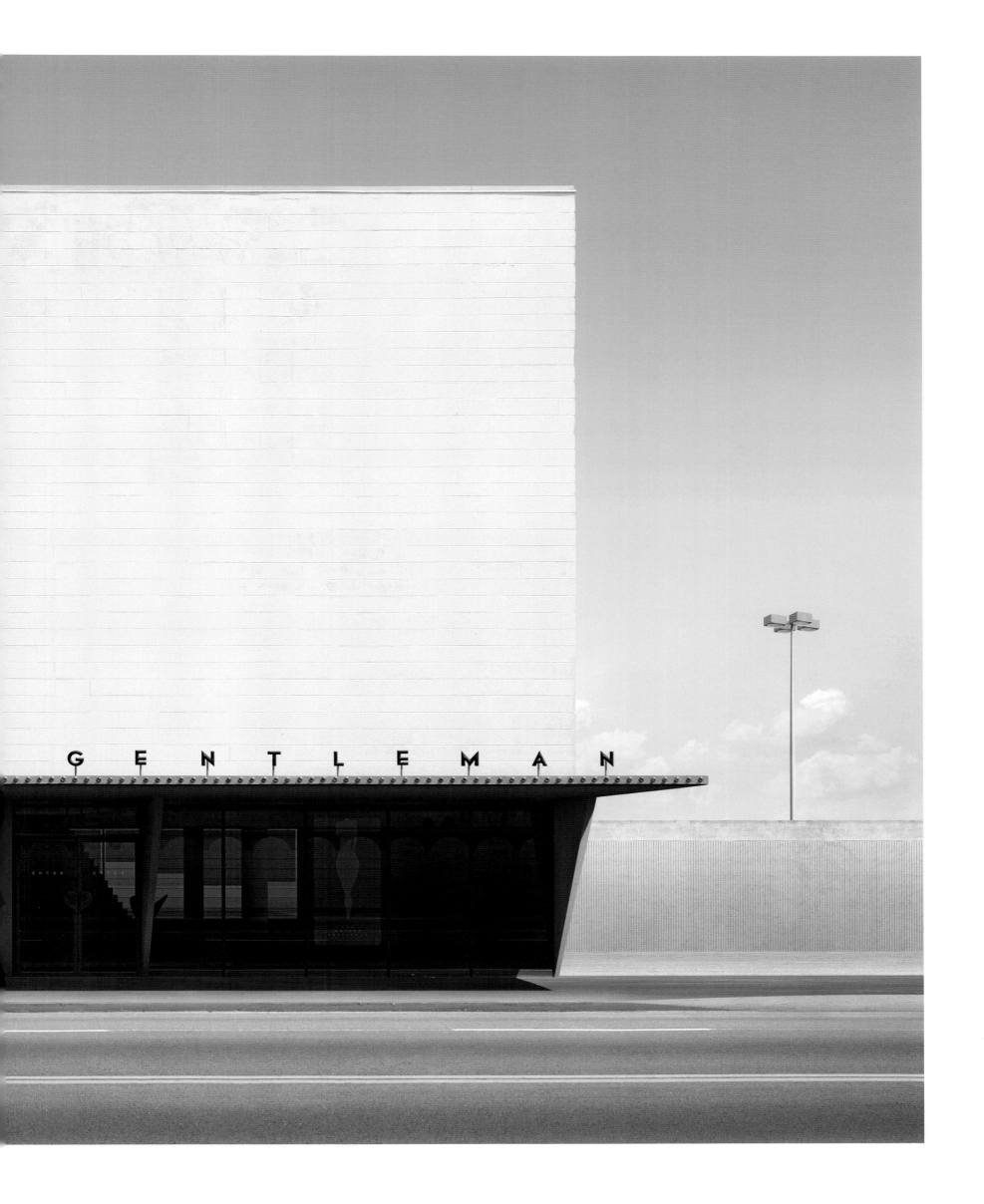

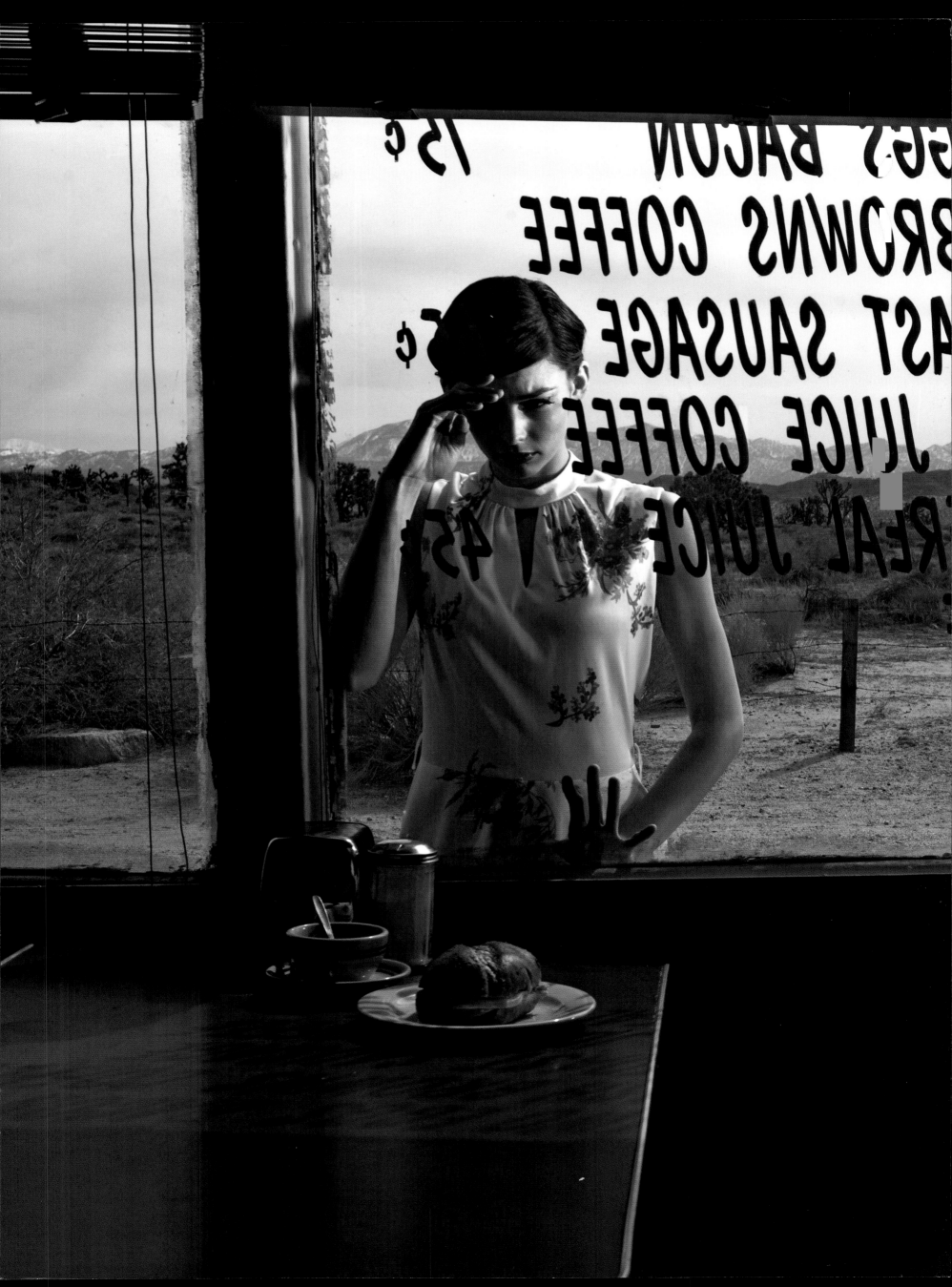

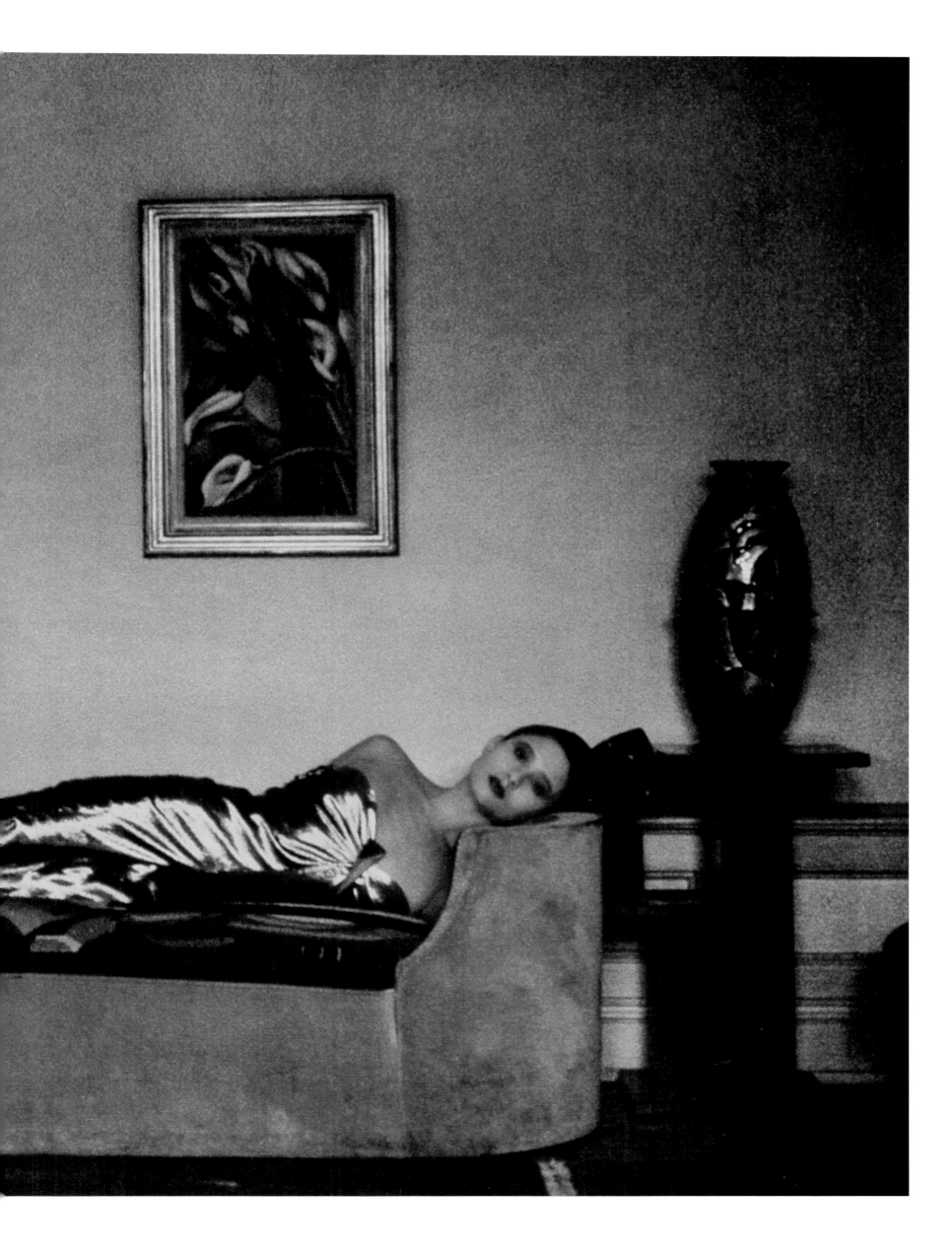

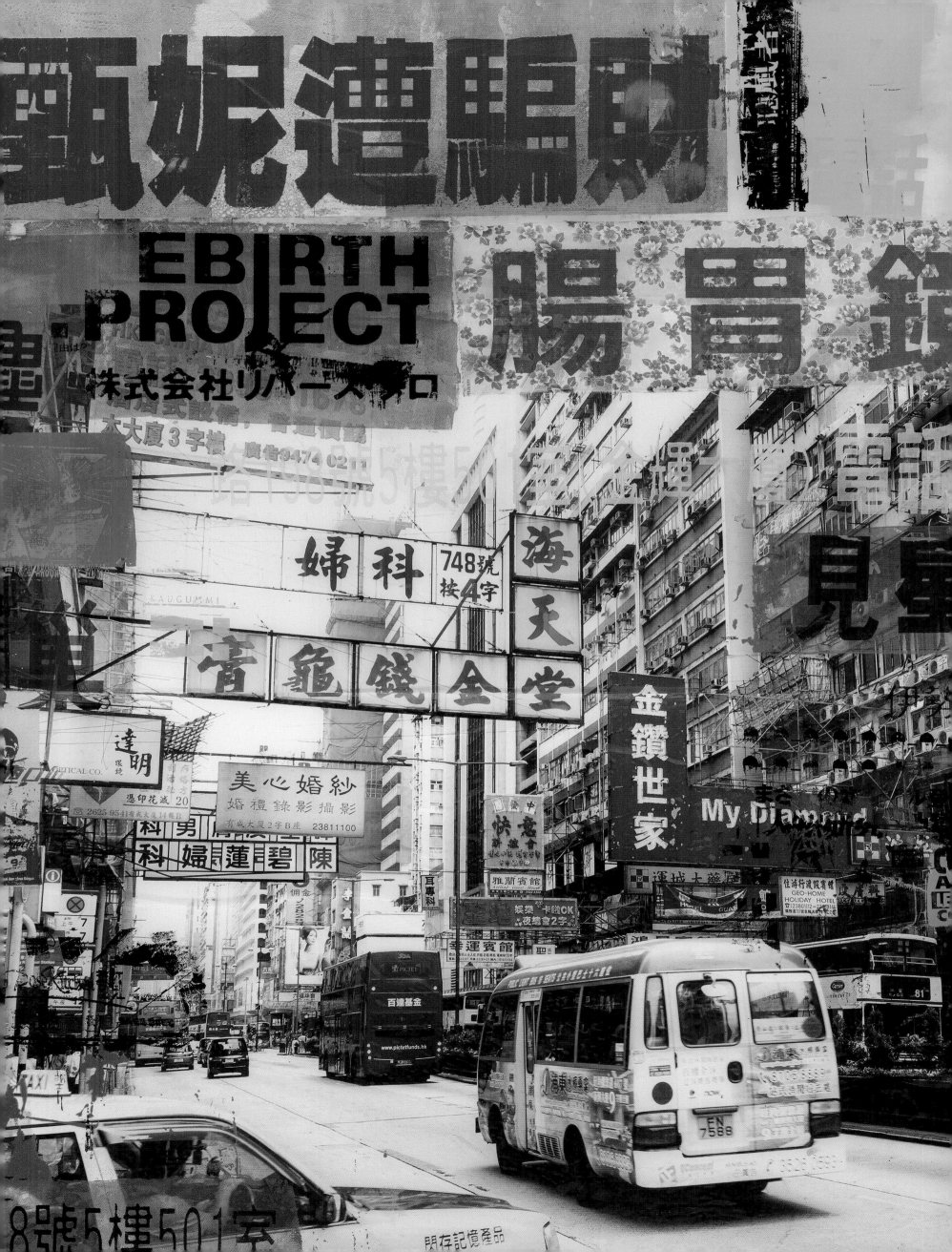

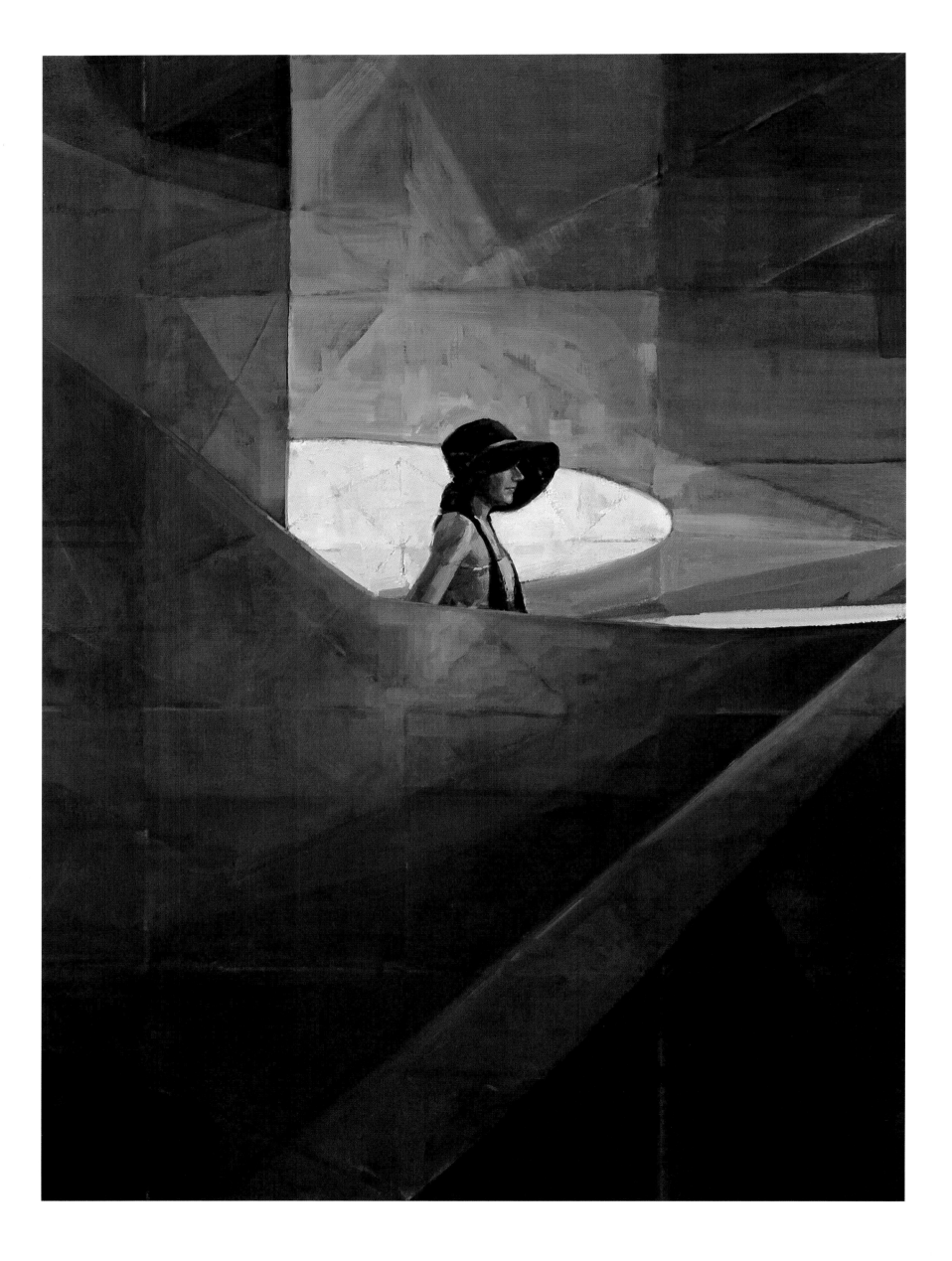

HIROSHI SATO (LEFT)
Stairway

HOLGER LIPPMANN (RIGHT)
Tree V

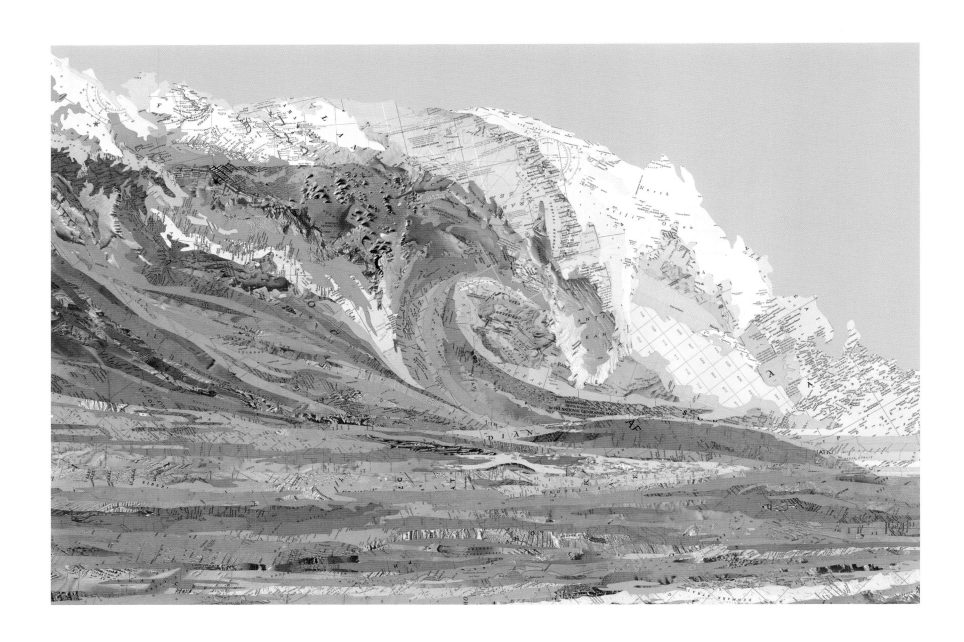

MATTHEW CUSICK (LEFT)
Mylan's Wave

JASON SCHMIDT | TRUNK ARCHIVE (RIGHT)
Love Me Forever, Yves Saint Laurent Atelier

JOE MCDERMOTT (FOLLOWING PAGE)
The Secret (Diptychon)

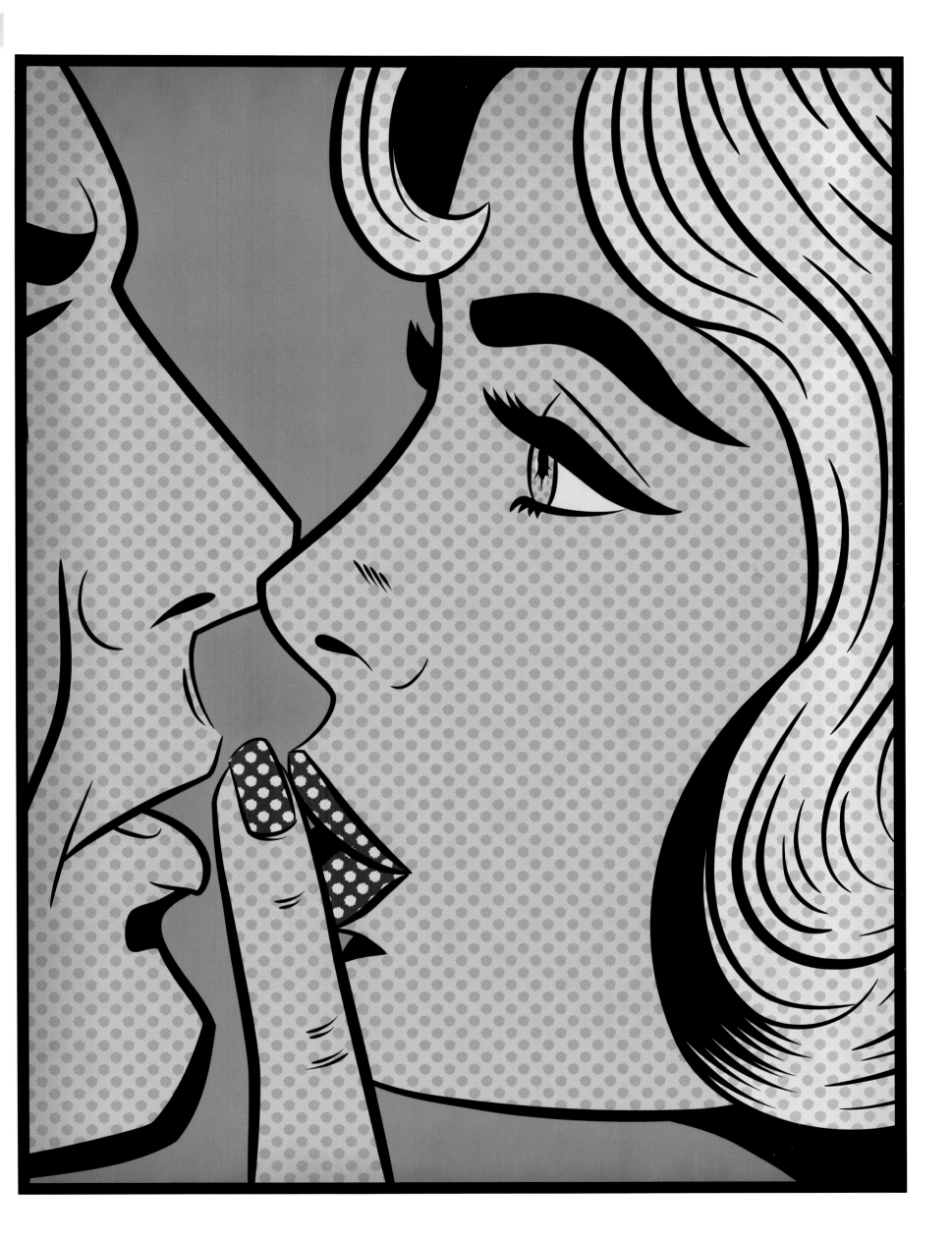

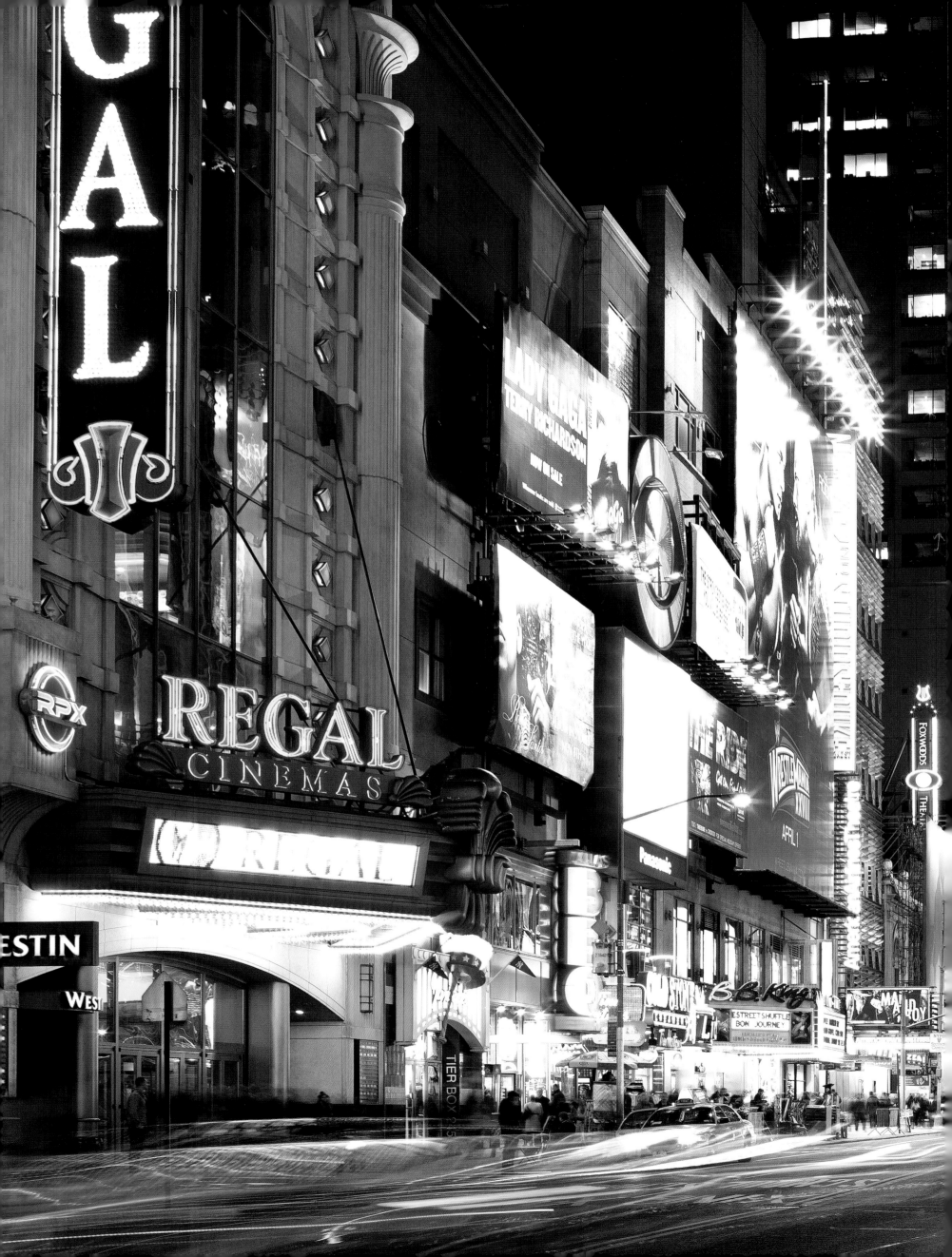

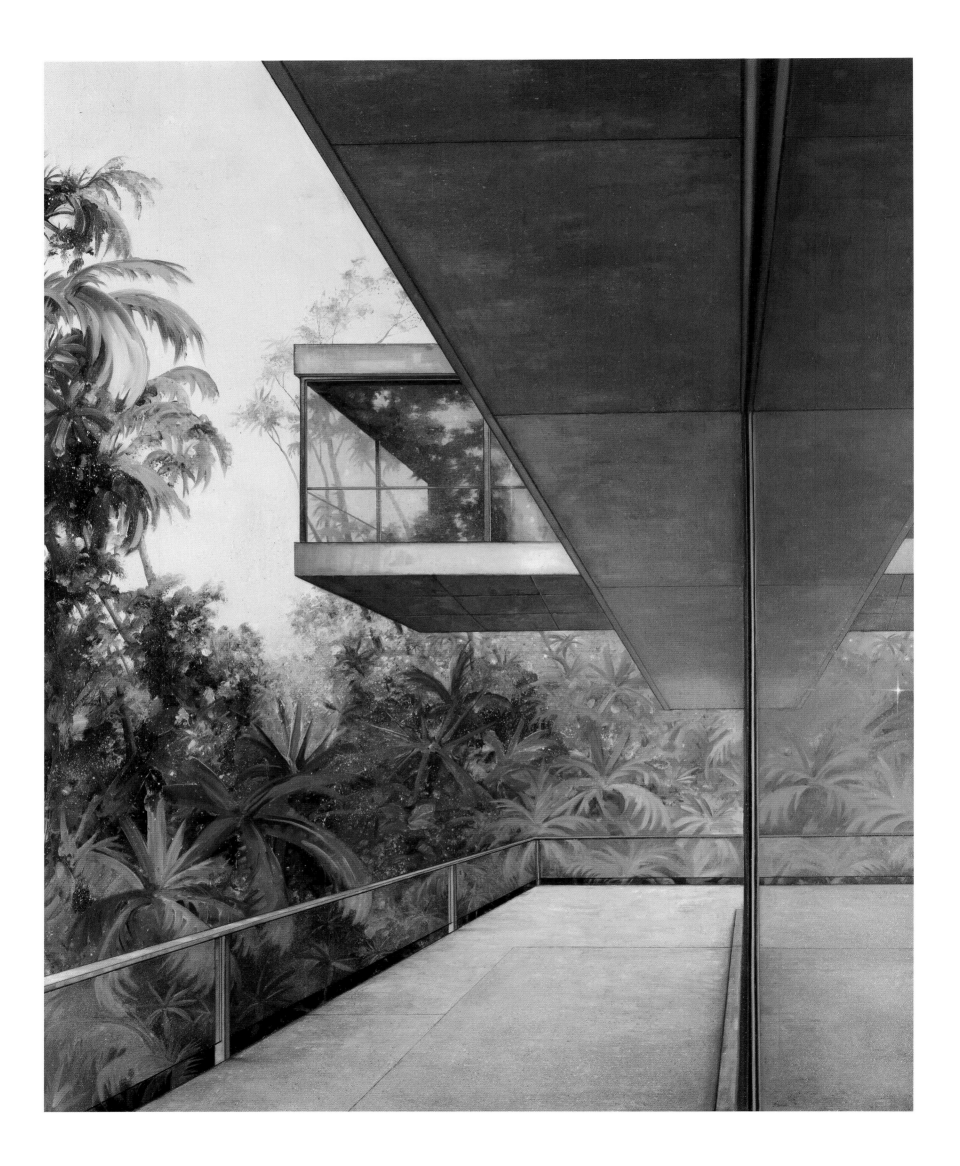

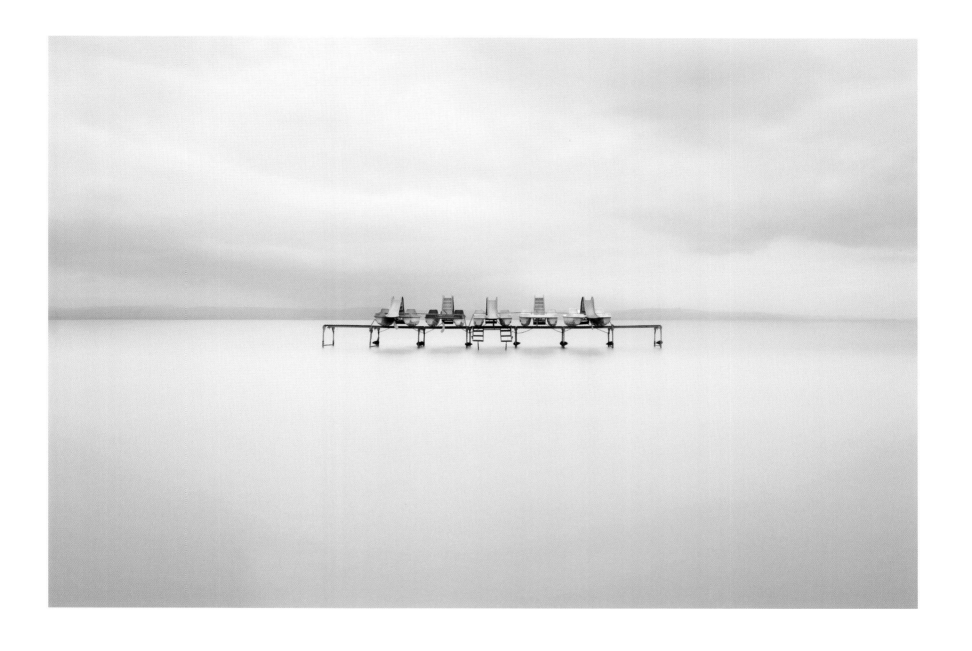

HORST & DANIEL ZIELSKE (PREVIOUS PAGE)
42nd Street

JENS HAUSMANN (LEFT)
Psychology in the jungle

AKOS MAJOR (RIGHT)
Pedalboats

JOSH VON STAUDACH (LEFT)
New Brighton

EDWARD B. GORDON (RIGHT)
Der Blick

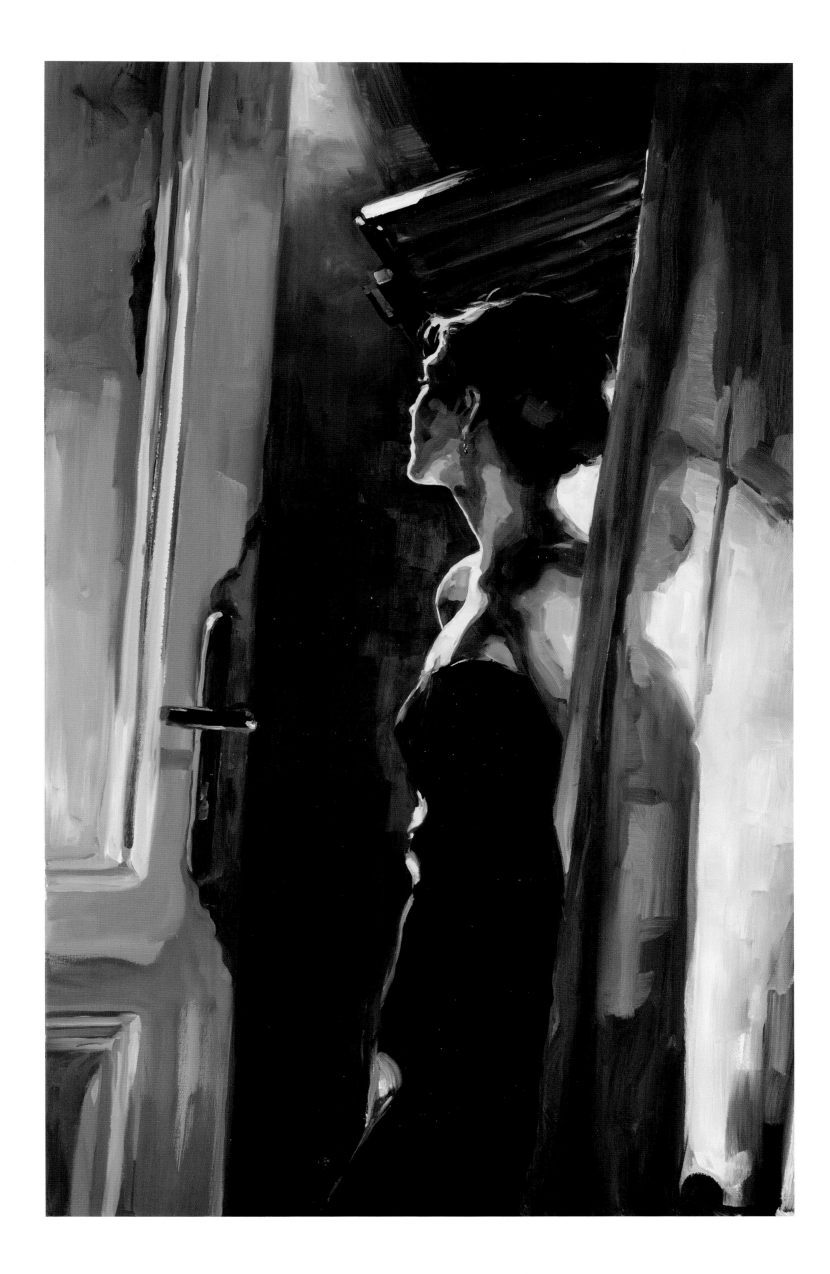

JOERG MAXZIN (LEFT)
Zurich Quai VII

PENELOPE DAVIS (RIGHT)
Volume

MIKA NINAGAWA | TRUNK ARCHIVE (FOLLOWING PAGE)
Untitled, Liquid Dreams 1

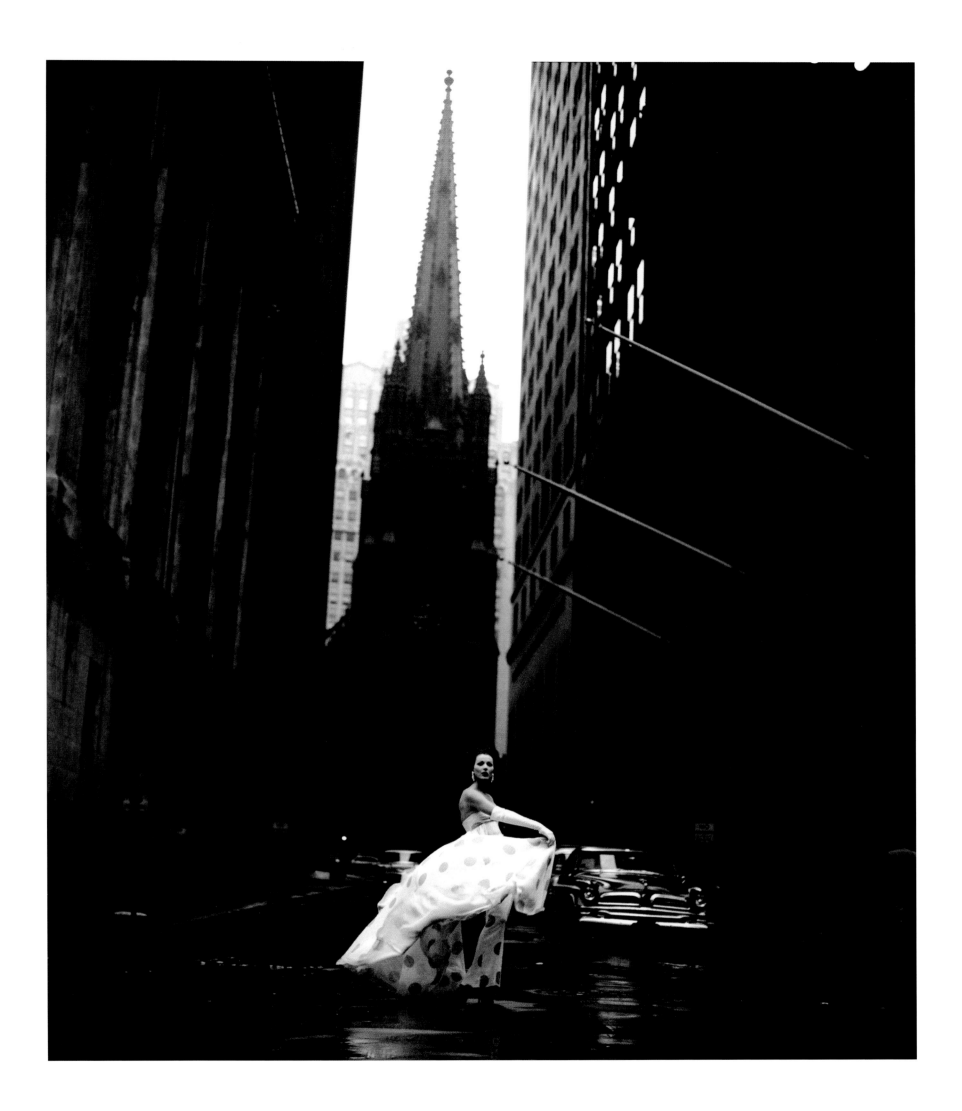

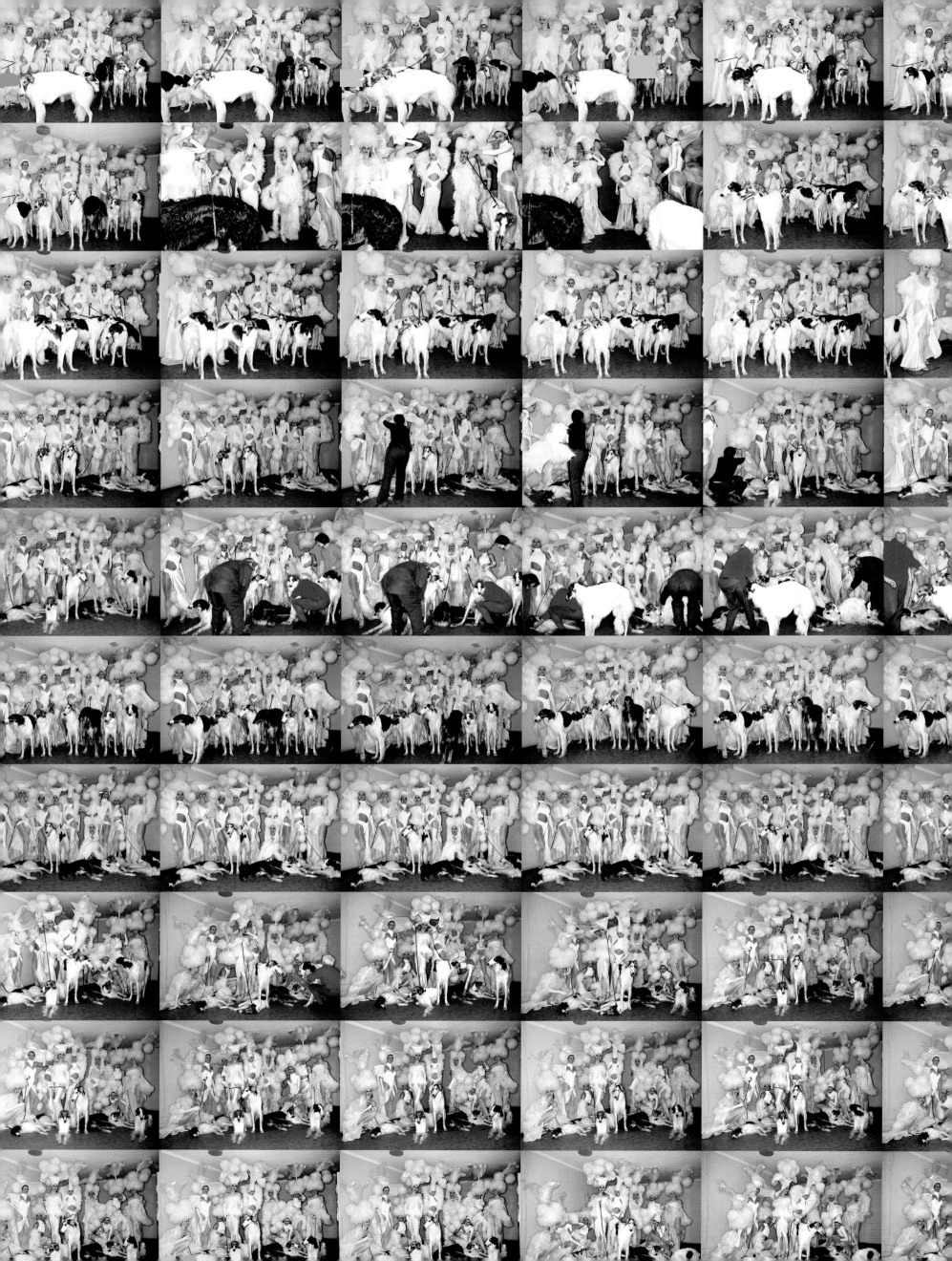

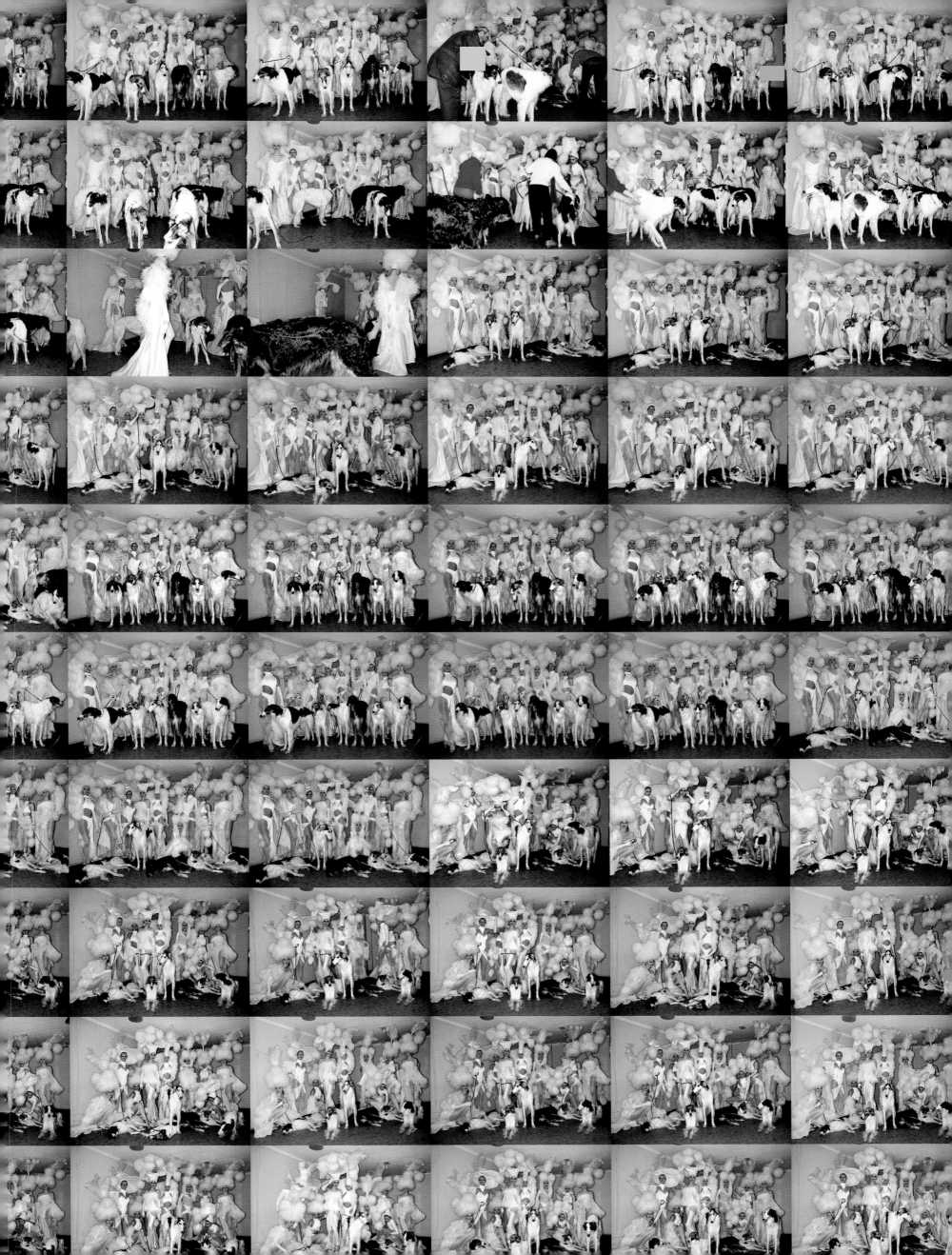

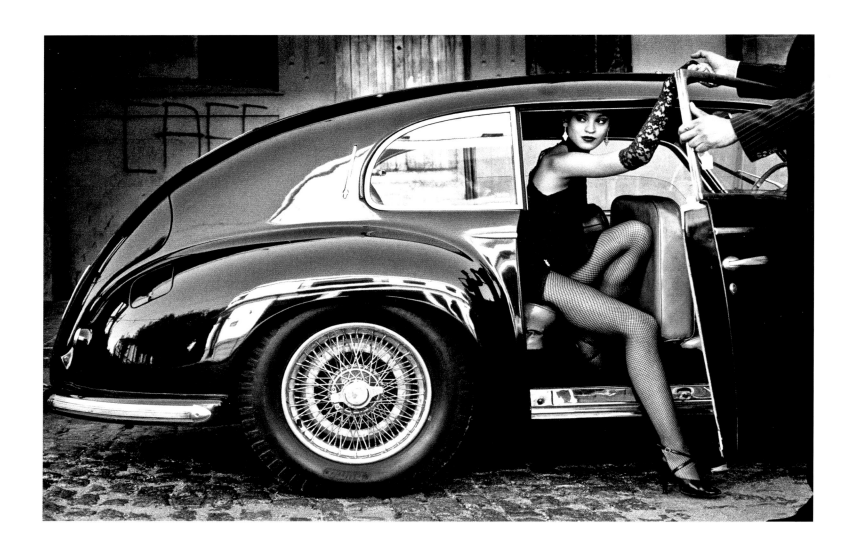

CHRISTOPHER PILLITZ
The Spirit of Tango VII (left)
The Spirit of Tango VIII (right)

ANDRÉ ARMENT (FOLLOWING PAGE)
Misty Morning

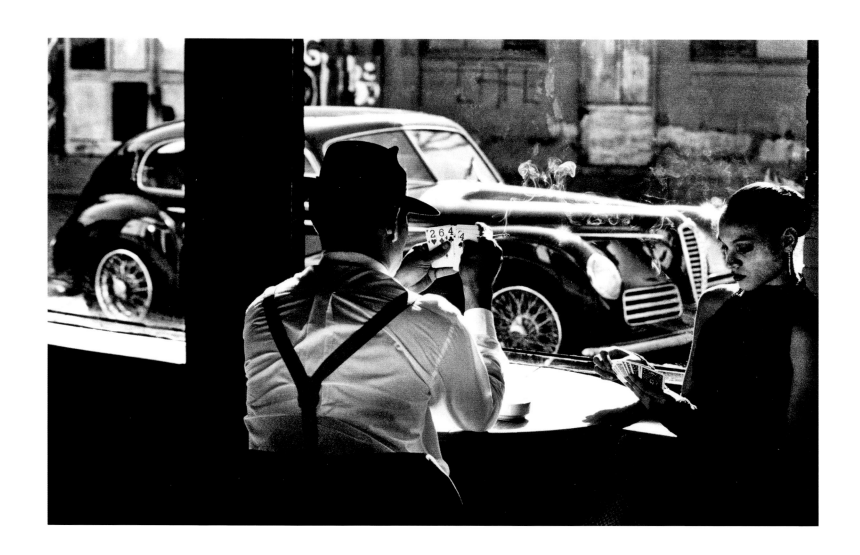

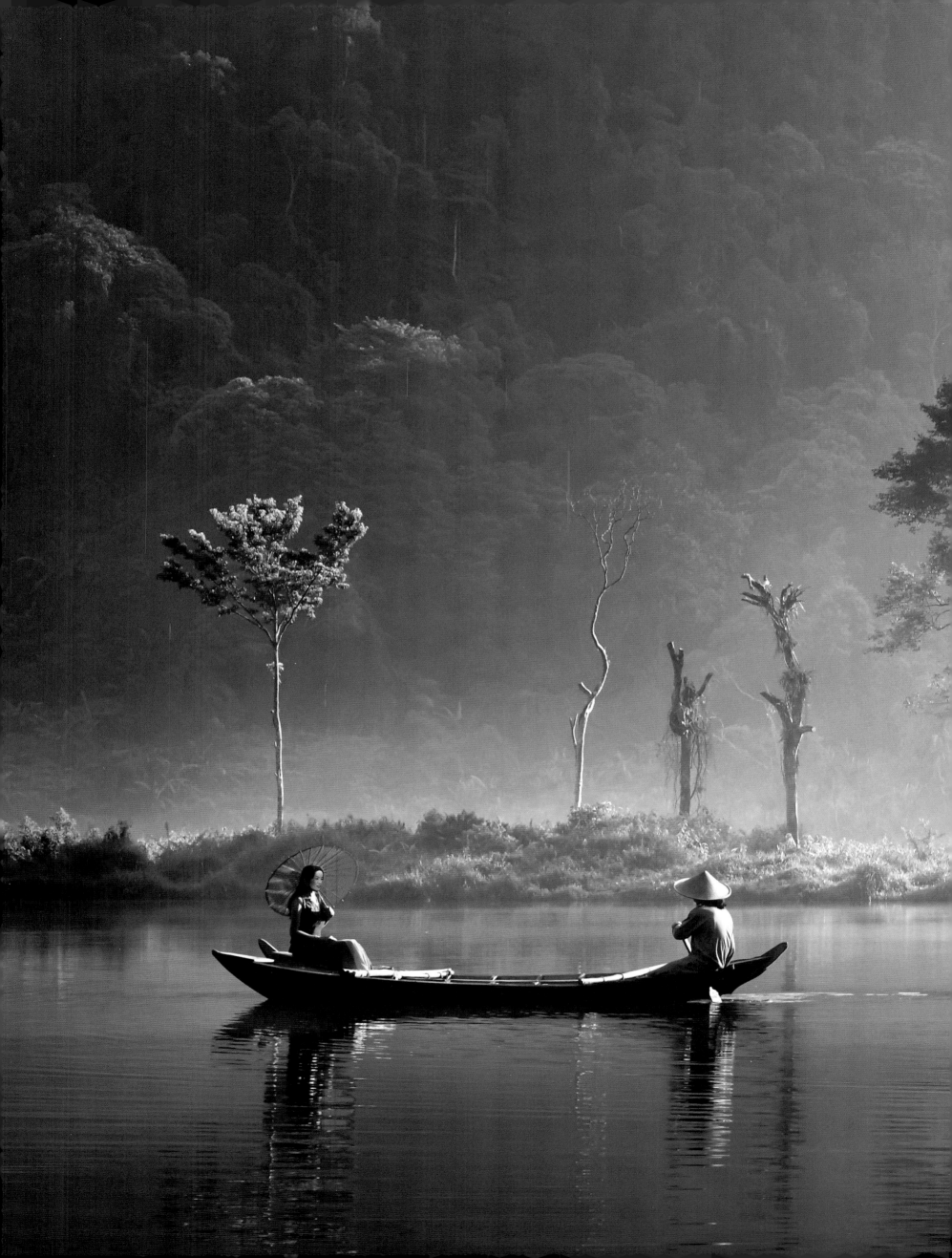

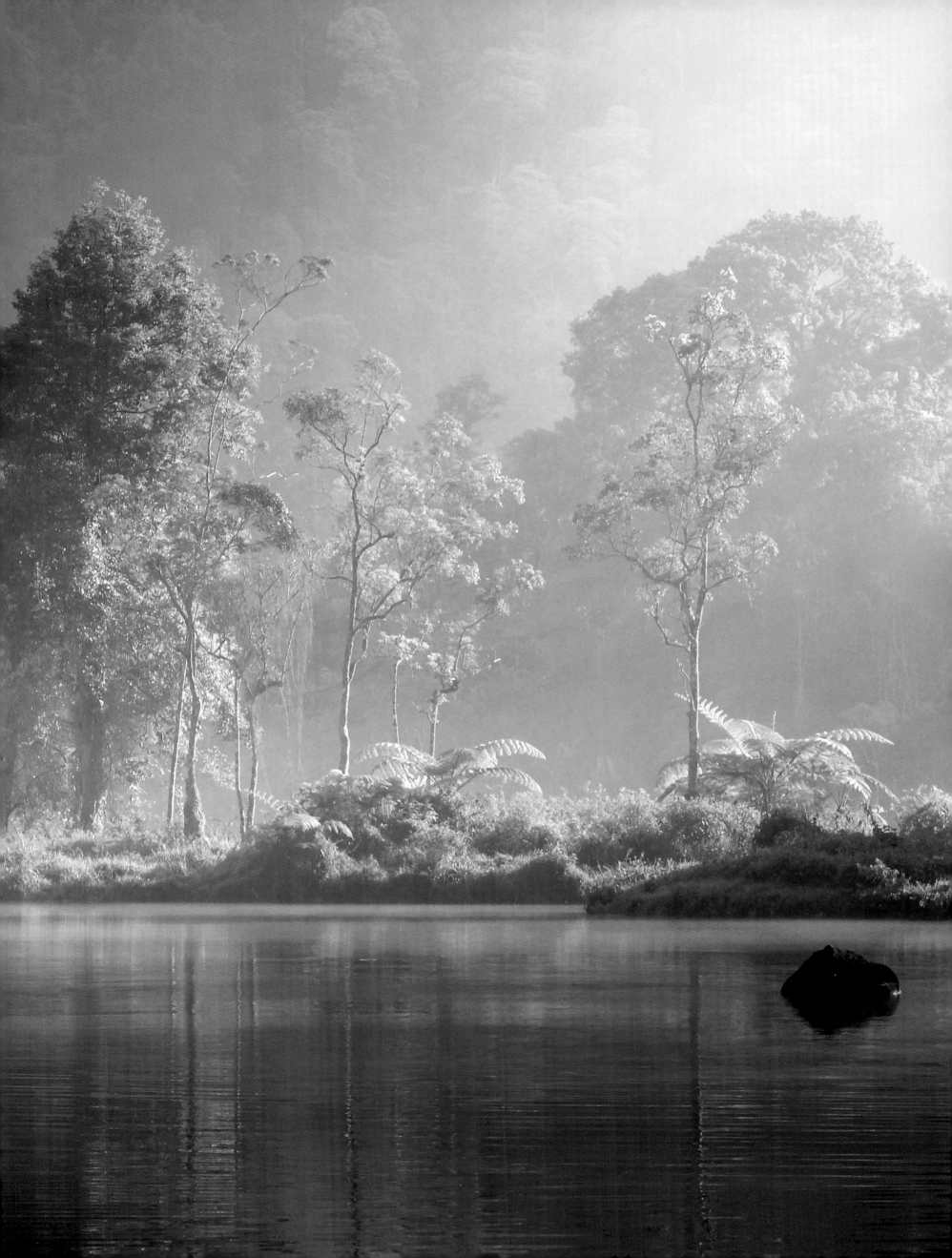

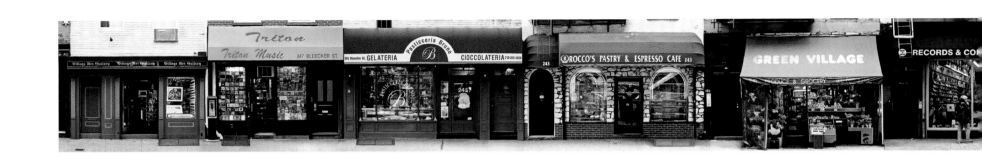

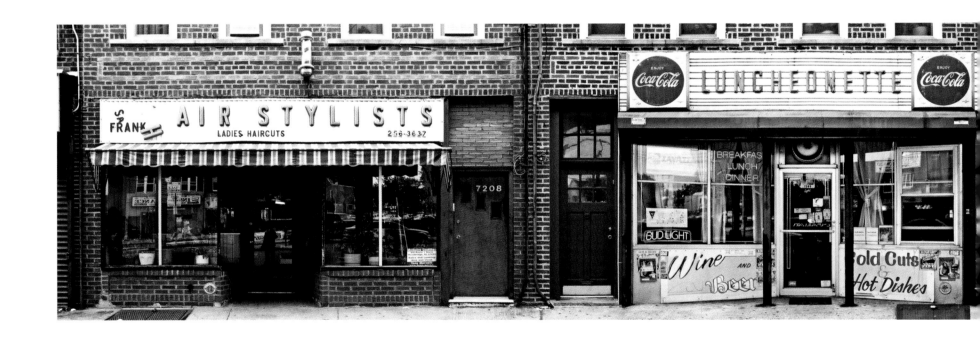

JAMES & KARLA MURRAY
Bleecker St. b/t Leroy & Carmine, Greenwich Village New
Utrecht Ave. at 72nd, Bensonhurst, BK

ROBERT LEBECK (FOLLOWING PAGE)
Romy Schneider, Kontaktbogen

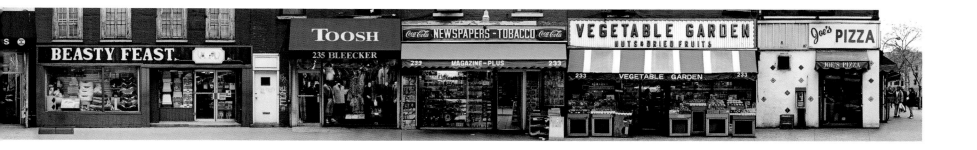

ETY FILM 5063 KODAK SAFETY FILM 5063

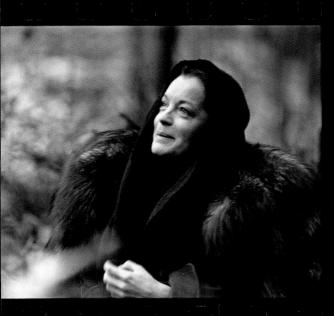 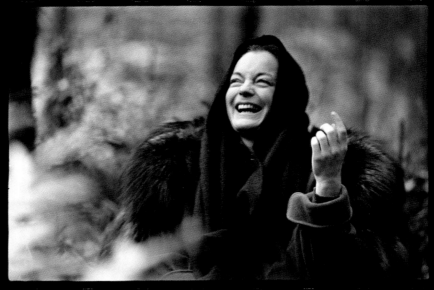

→20A **2** **0** 9 →21A →22

AK SAFETY FILM 5063 KODAK SAFETY FILM 5063

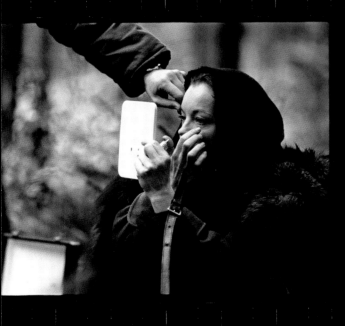 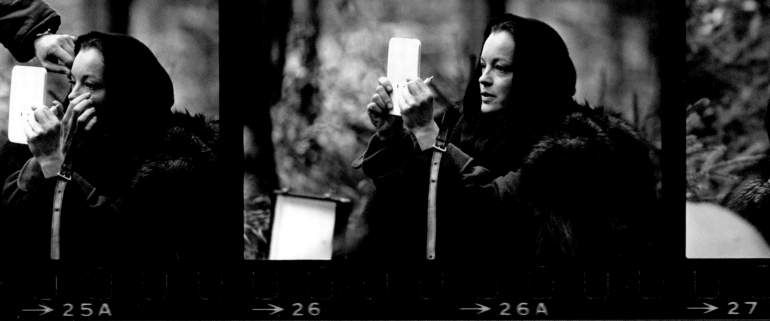

→25A →26 →26A →27

KODAK SAFETY FILM 5063 KODAK SAFETY FILM 5063

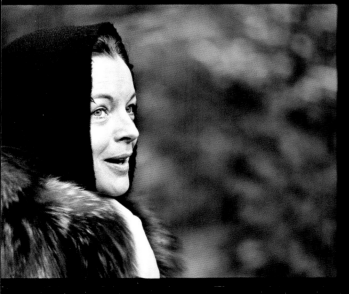 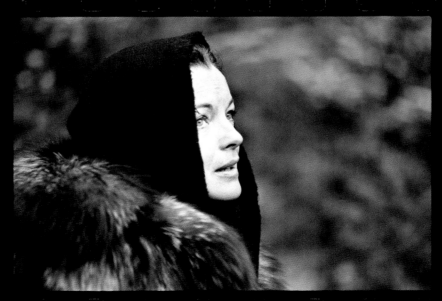 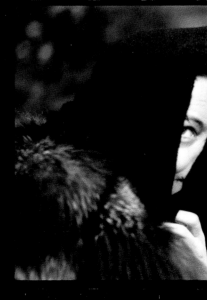

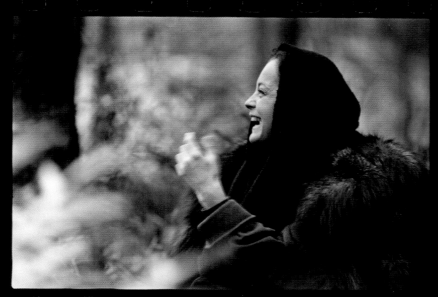
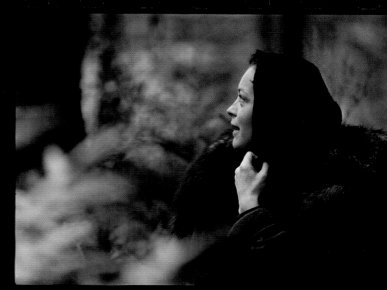

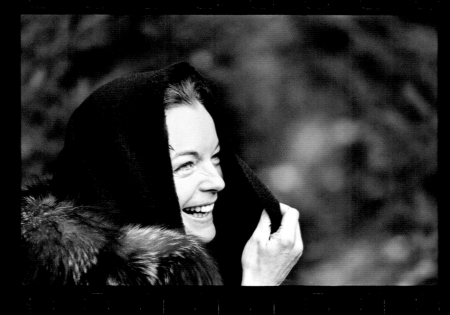
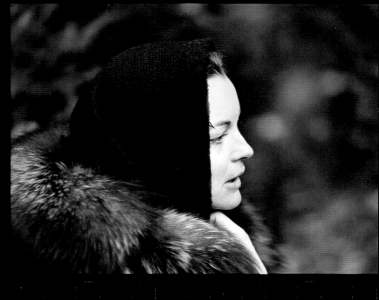

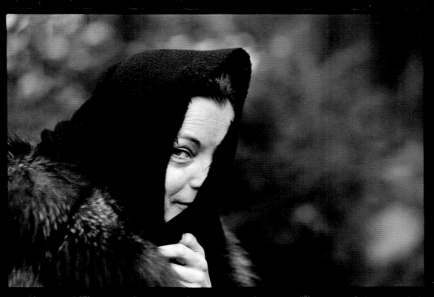
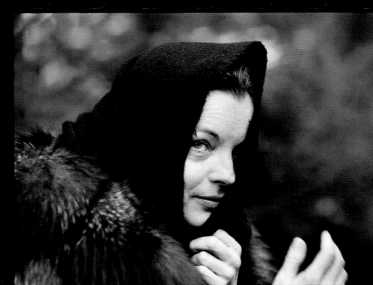

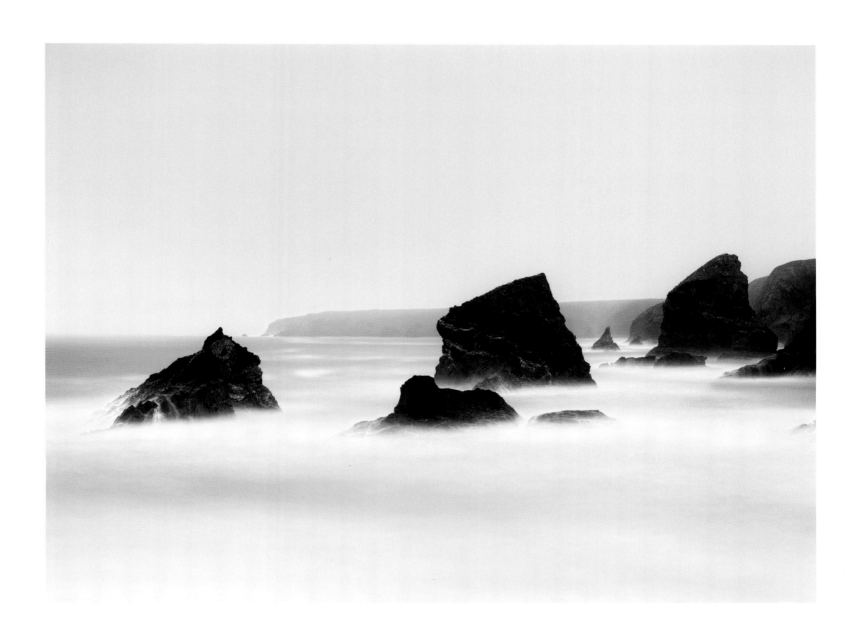

NANCY LEE (LEFT)
Look Left Look Right

MAC OLLER (RIGHT)
Bedruthan Steps

FRANZ BAUMGARTNER (FOLLOWING PAGE)
Italien view

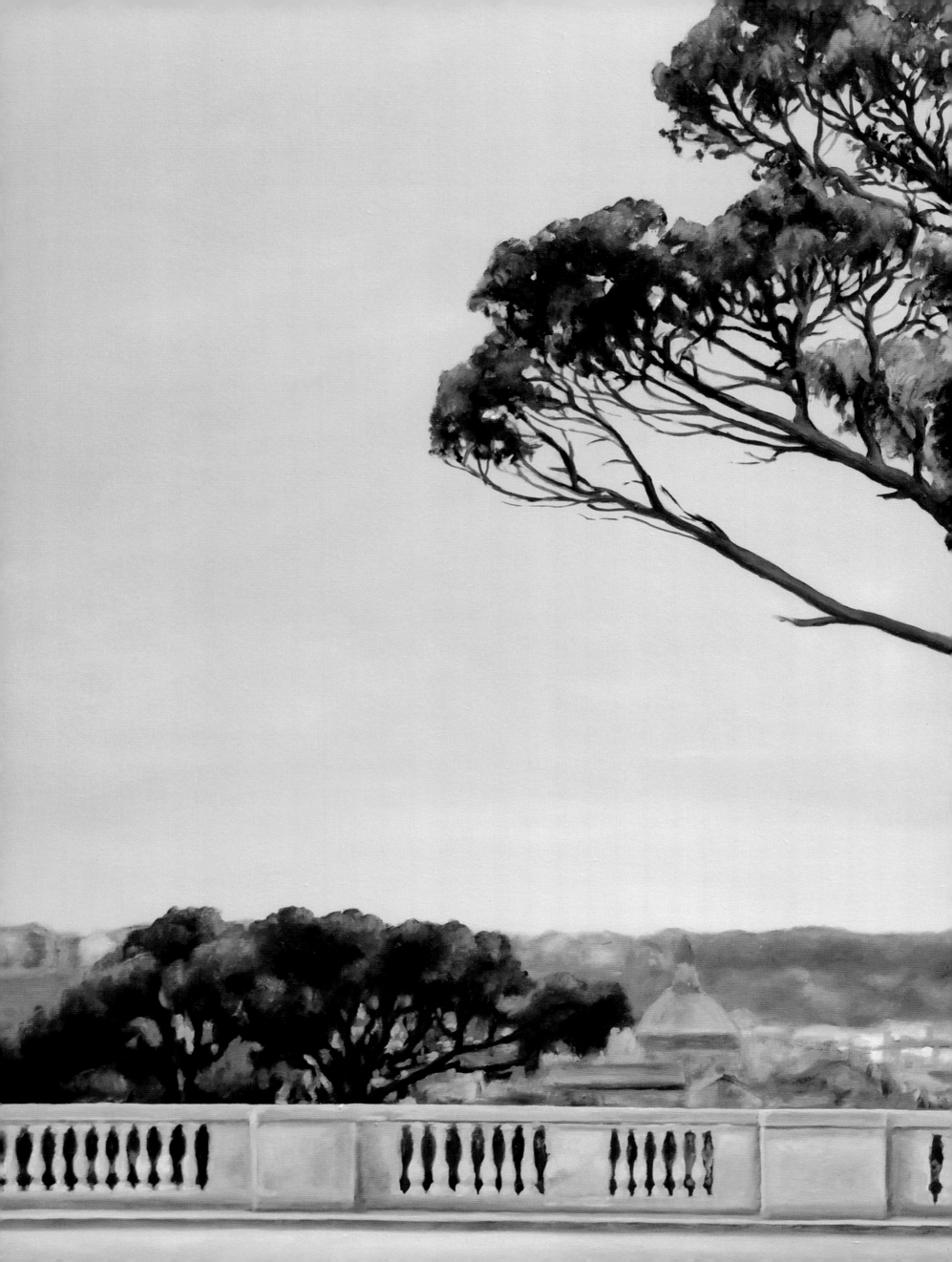

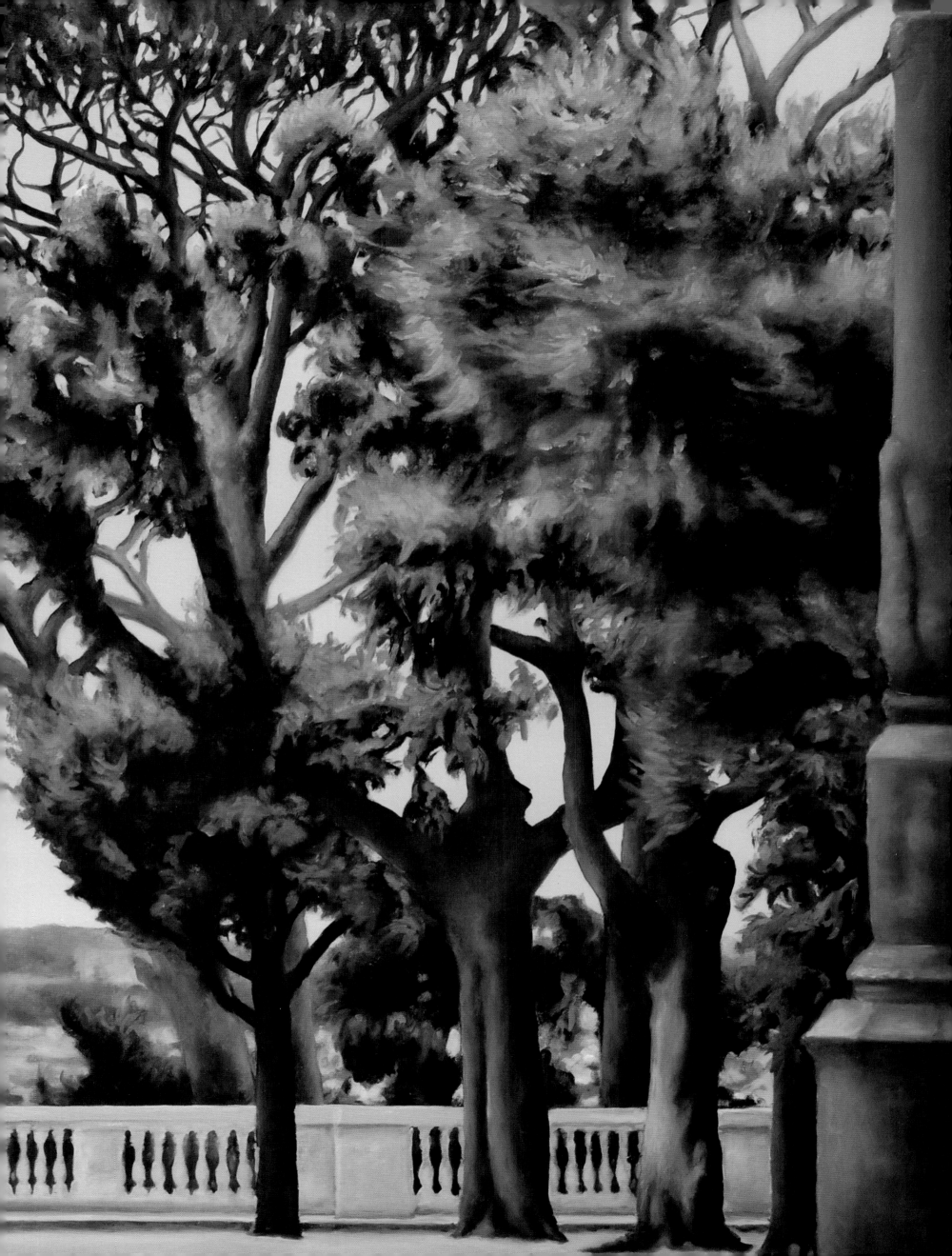

JENNY OKUN
Las Vegas Man Tetraptych

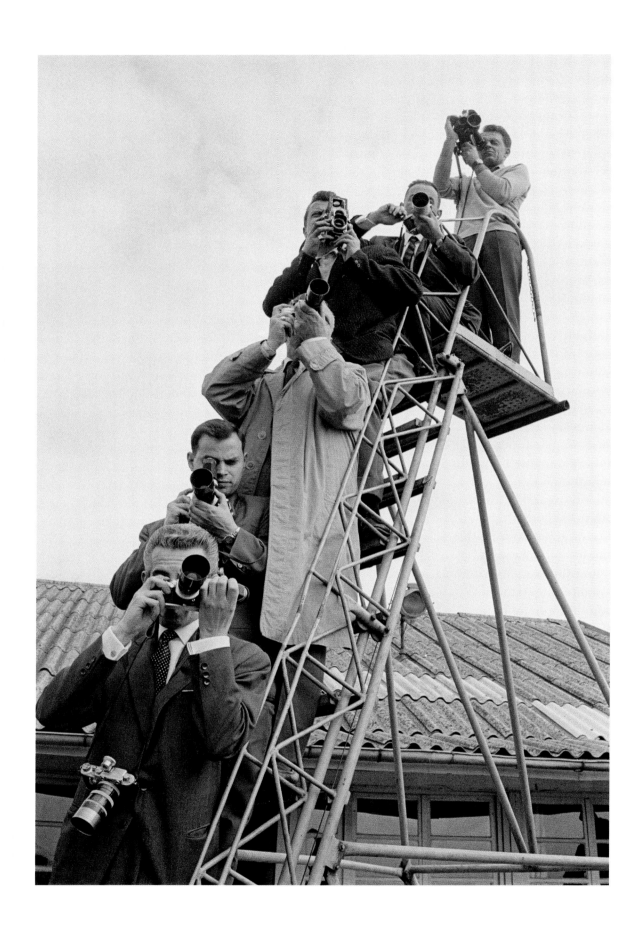

ERICH LESSING
Geplatzte Gipfelkonferenz, Paris (left)
Berlin bleibt frei (right)

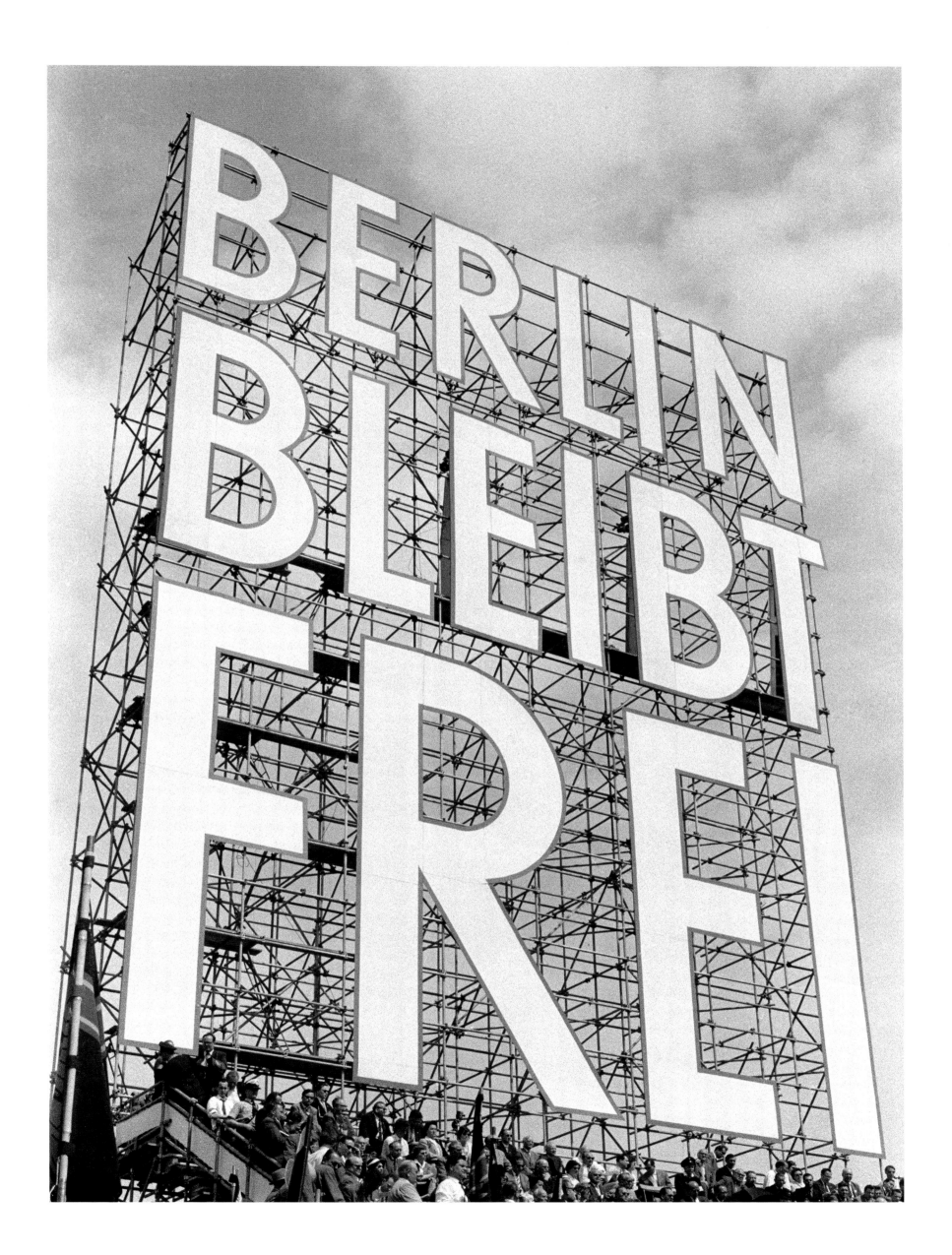

SABINE WILD
Shanghai Projections VII

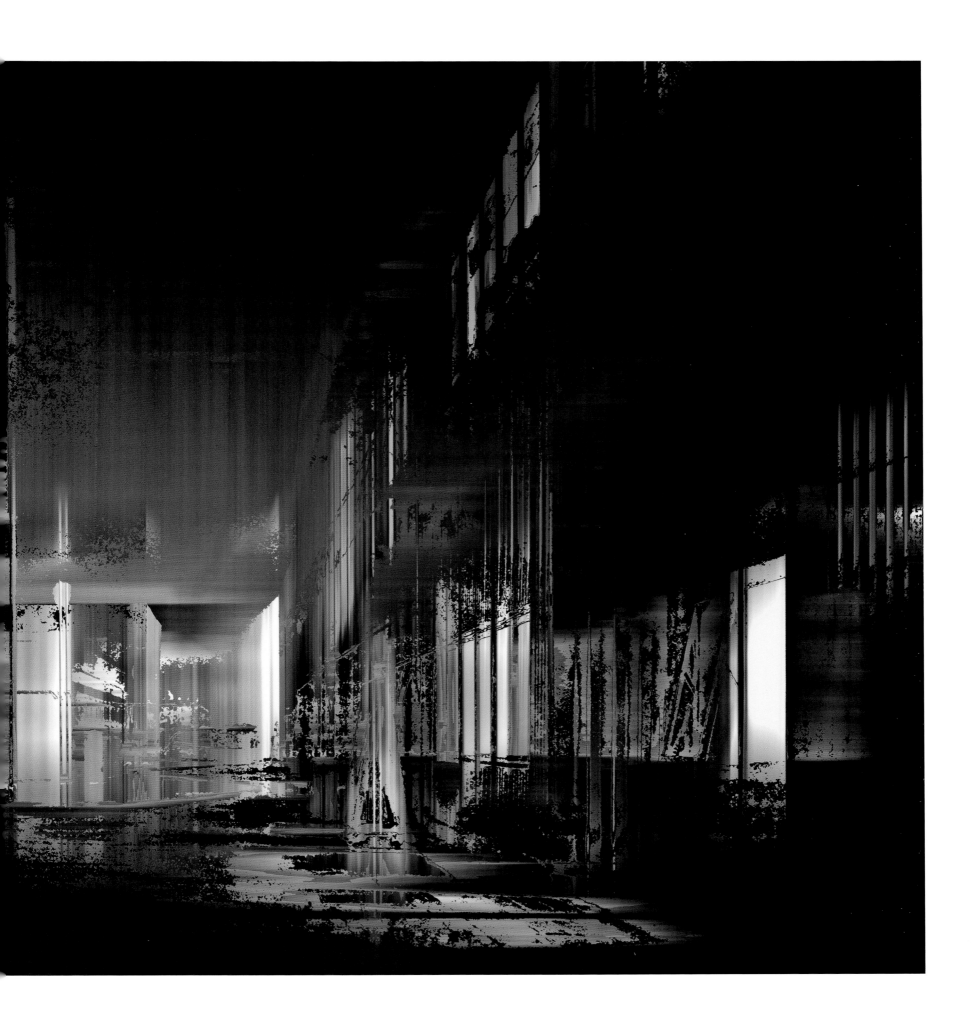

GAZI SANSOY
Lucretia

WERNER PAWLOK (FOLLOWING PAGE)
House of Fefa

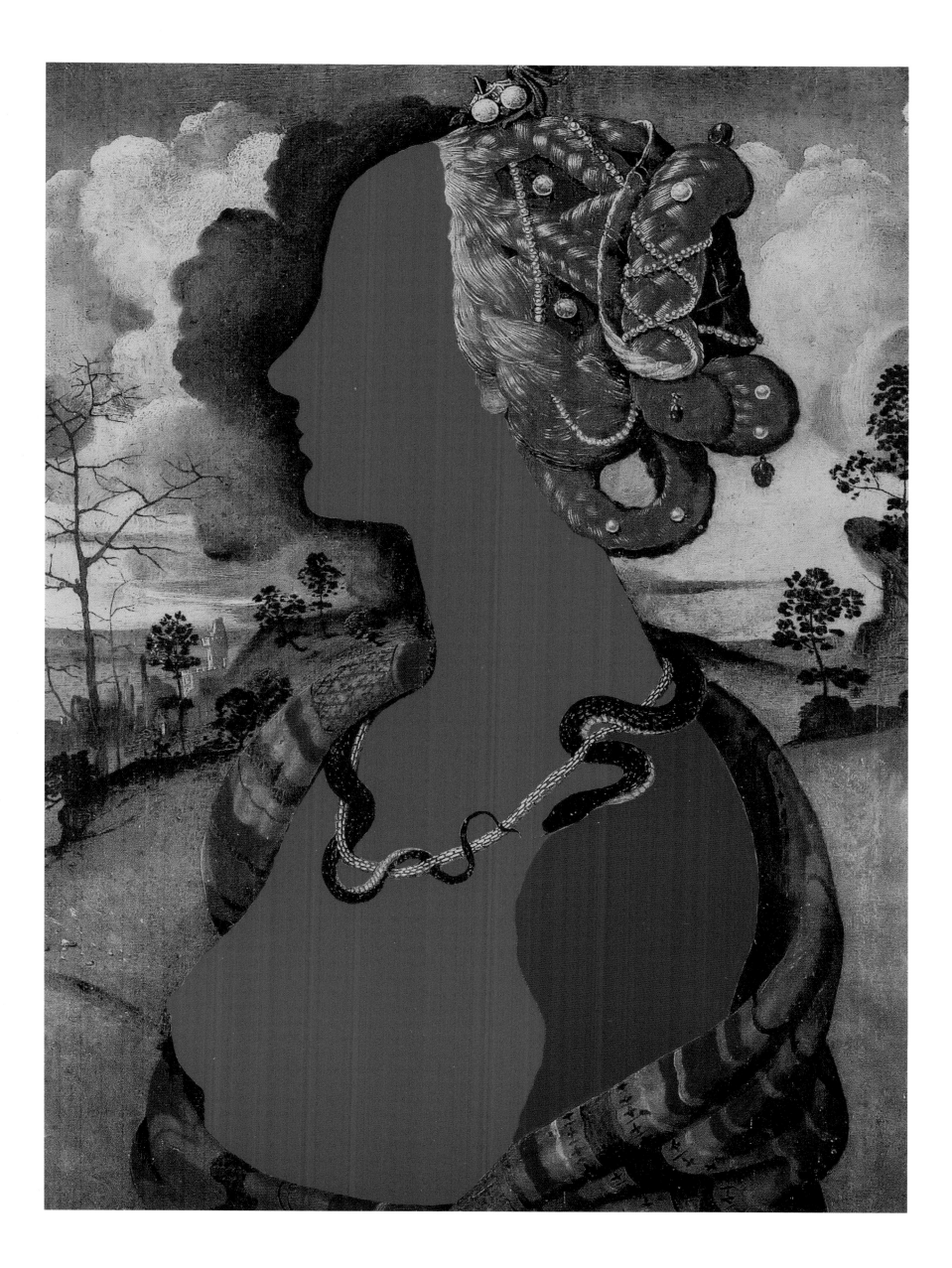

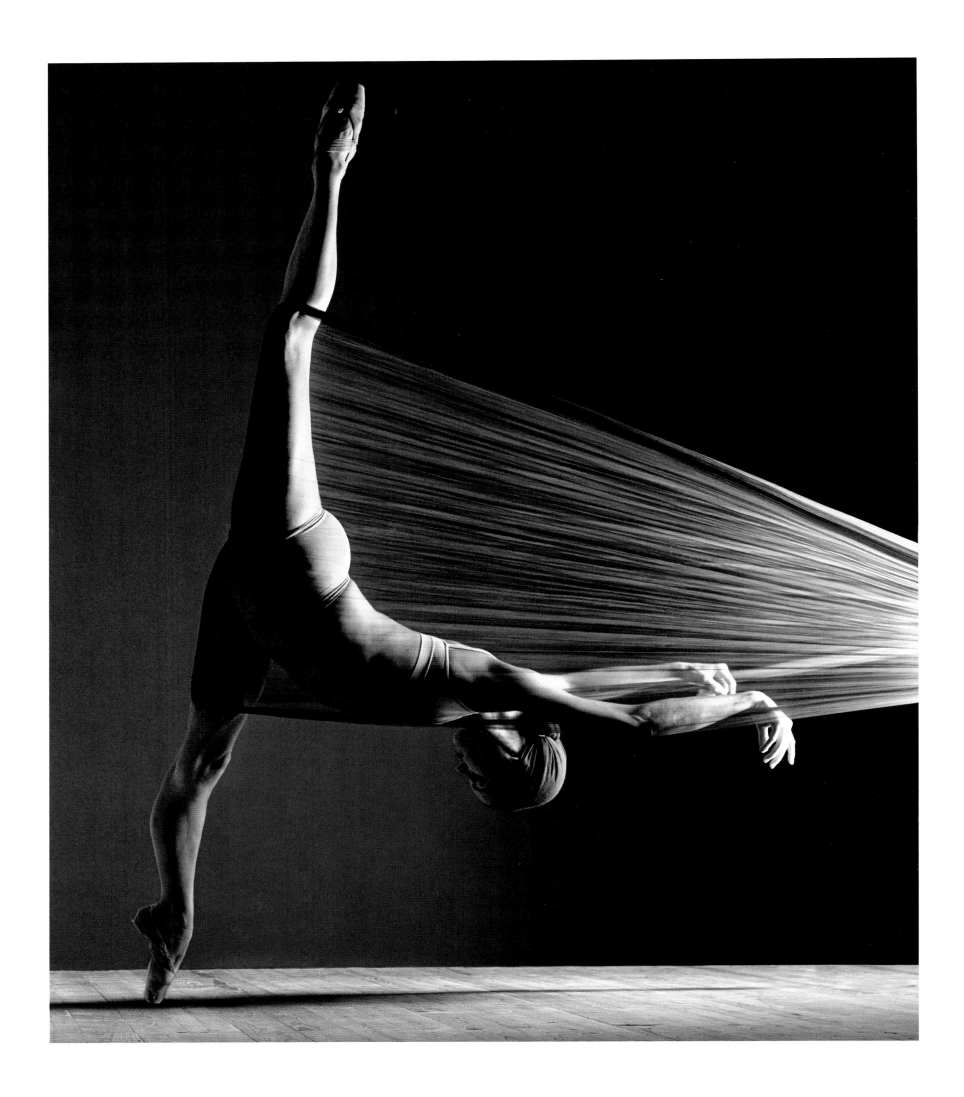

MICHAEL PAPENDIECK (LEFT)
Body network 2

PHILIP HABIB (RIGHT)
Wired-005, Wired-008
Wired-002, Wired-009

LÉO CAILLARD (LEFT)
House VII

MARINO PARISOTTO (RIGHT)
The small Goddess I

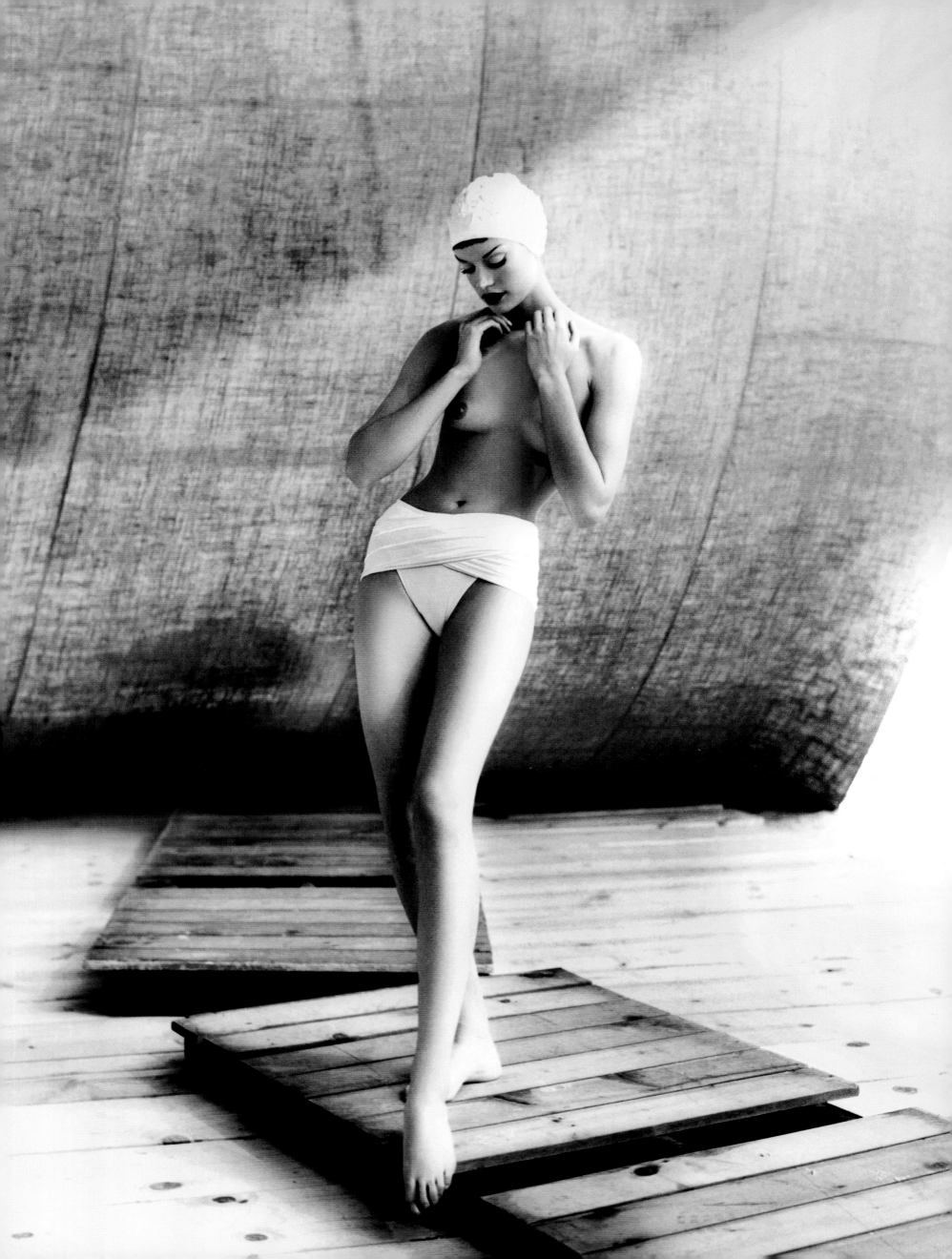

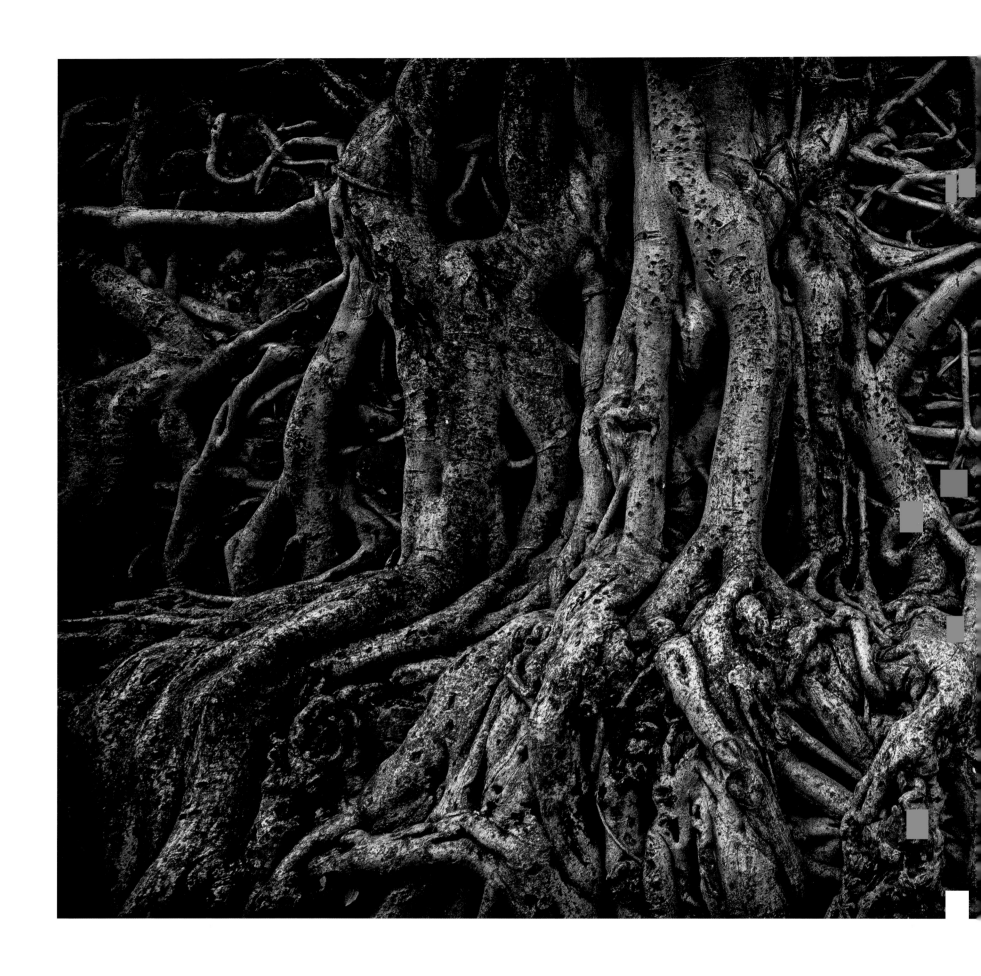

FARIN URLAUB
Banyan Tree

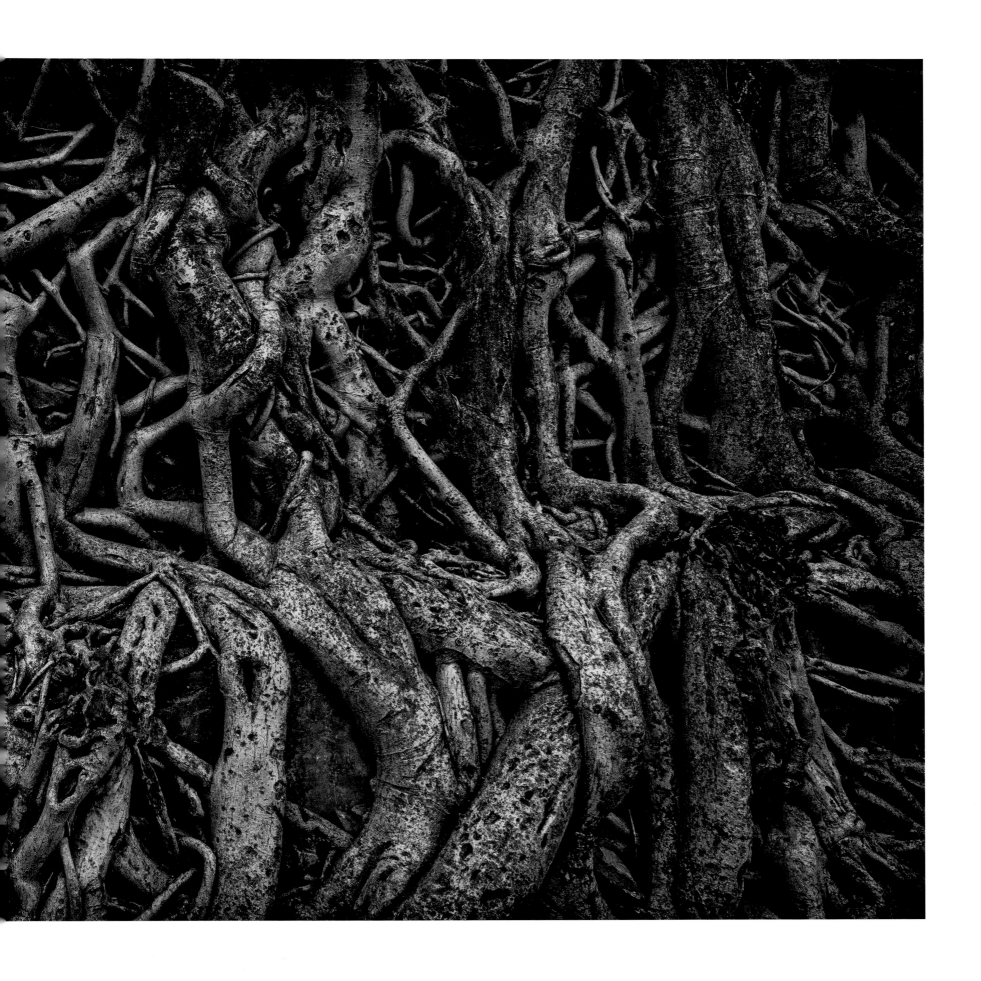

We're beautiful ... diamonds in the sky Shine bright like a diamond
Shine bright like a diamond Oh Shine bright like a diamond Oh Shining bright like a diamond
the warmth, we'll never die We're like diamonds in the sky You're a shooting star I see A vision of
skating in the wrong direction we will call you all of this
So Shine bright tonight you and I We're beautiful like diamonds in the sky
Shine bright like a diamond Oh Shining bright like a diamond We're beautiful like a diamond
We're beautiful like diamonds in the sky Shine bright like a diamond
like a diamond it like a diamond Oh Yeah Shine bright like a d
diamond oh oppan gangnam style gangnam style
Oh oh oppan gangnam style Gangnam style Oh oh oh oh oh oppan gangnam style
hey 사랑스러워 그래 바로 너 hey아름다워
gangnam style Oh oh oh oh oppan gangnam style Eh-Sexy Lady Oh oh oh
You know what I'm saying ohppan gangnam style Eh-Sexy
En Eh En ohppan gangnam style Now and then I think of when we were together Like when you said you felt so happy you could
Like resignation to the end, always the end So when we found that we could not make sense Well you said that we would still be friends But I'll admit that I
that We Were Nothing And I don't even Need Your love
Now You Have Your friends collect your records and then
Somebody that I used to know Now you're just somebody that I used to
somebody that You used to know But you didn't have to cut me off
Need Your Love But you treat me like a stranger and that feels
records and Then change Your number I guess that I don't need
Somebody Now you're just somebody that I used to know
Now I used to know that I used to know I used to know Somebody that's just a girl, and she's on fire Hotter than a
everyone again, this time it's for real saying if you continue to act
She's living in a world and it's on fire Feeling the catastrophe but she knows she can fly away Oh, she got
This girl is on fire this girl is on fire she's walking on fire
This girl is on fire this girl is on fire she's walking on fire This girl
Oh, we got our feet on
Nobody knows She's just a girl, and she's on fire
This girl is on fire oh oh oh oh oh oh oh Chirp tweet Chirp tweet Tweee
Boom boom boom if you want it I'mma be ya va va boom boom if you go
Come and get this va va boom boom HH wanna give you one last option HH
hold on tight and let me do one dance If you want it, I'm gonna be ya va va boom boom
va va boom boom if you got it, you got it, you got that boom boom
said, y'all having a good time
Don't stop the party I'm running through the world like I'm running back Scarface
y'all having a good time Yeah, yeah, que no pare la fiesta Don't stop the party
I said, y'all having a good time out there Yeah, yeah, que no pare la fiesta
Imma give it to ya, ah ah Now give it to me, ah ah Imma give it to ya, ah ah Now give it to me, ah ah Imma give it to ya, ah ah Now give
que no pare la fiesta Don't stop the party Yeah, yeah, que no pare la fiesta
Don't stop the party Yeah, To the sexy people and the place to be yeah, que no pare la fiesta
Ho! I've been sleeping here instead Hey! I've been sleeping in my bed Ho! sleeping in my bed
I don't know where I went wrong Ho! But I can write a song 1, 2, 3 I belong with you,
I don't think you're right for him Look at what it might have been if you Ho! Took a bus to Chicago
you belong with me, you're my sweet Hey! you belong with you, you belong with
sweetheart I belong with you, you belong with me, you're my sweet Ho! Hey! Ho! Hey!
So while you're here in my arms Let's make the most of the night like we're gonna die young Young hearts, out our minds Runnin' like we outta time
touch For sure Looking for some trouble tonight Take my hand I'll show you the wild side Like it's the last night of our
while you're here in my arms, Let's make the most of the night like we're gonna die young
So while you're here in my arms Let's make the most of the night

bright, tonight you and I We're beautiful like diamonds in the sky Eve
We're beautiful like diamonds in the sky Shine bright like a diamond Oh Shine bright like a diamond We're beautiful like diam
TUR TUR TUR TUR TUR TUR TUR TUR OK listen everyone if you keep
when you hold me, I'm alive We're like diamonds in the sky At first sight I felt the energy of sun rays I saw the life inside your
eye so alive We're beautiful like diamonds in the sky Shine bright like a di
Shine bright like a diamond Oh Shine bright like a diamond Oh Shining bright like a diamon
like diamonds in the sky Shine bright like a diamond Oh Shine bright tonight you
mond Oh Shine bright like a diamond Oh Shine bright like a diamond Shin

있는 여자 커피 한잔의 여유를 아는 품격 있는 여자 밤이 오면 심장이 뜨거워지는 여자 그런 반전 있는 여자 나는 사나이 낮에는 너만큼 따사로운 그런 사나이
그래 너 hey 그래 바로 너 hey 지금부터 갈 데까지 가볼까 ohbban gangnam style gangnam styl
Sexy Lady Oh oh oh oh ohbban gangnam style Eh-Sexy Lady Oh oh oh oh 정숙해 보이지만 놀 땐 노는 여자
여자 나는 사나이 점잖아 보이지만 놀 땐 노는 사나이 때가 되면 완전 미쳐버리는 사나이 근육보다 사상이 울퉁불퉁한 사나이 그런 사나이
ohbban gangnam style gangnam style Oh oh oh oh ohbban gangnam style
gangnam style Eh-Sexy Lady Oh oh oh oh 뛰는 놈 그 위에 나는 놈 Baby Baby 나는 뭘 좀 아는 놈 뛰는 놈 그 위에 나는
dy Oh oh oh oh oh ohbban gangnam style Eh-Sexy Lady Oh oh oh oh Eh Eh El

myself that you were right for me But felt so lonely in your company But that was love and it's an ache I still remember You can get addicted to a certain kind
that it was over But you didn't have to Cut Me Off Make out like it never happened
treat me like a stranger and that feels so rough No you didn't Have to
Your Number I guess that I don't Need that though Now you're jus
Now you're just somebody that I used to know and then I think of all the times yo
like it never happened and that We Were Nothing And I don
And you didn't have to Stoop So Low Have your friends collec
though Now we're just somebody that I used to know Somebody
I used to know Somebody Now you're just somebody that I used
longer TUR TUR TUR TUR TUR TUR TUR TUR TUR OK I step
if you can be playing hockey we will call you all off this rin
feet on the ground And she's burning it down Oh, she got her head in the clouds And she's not backin
Looks like a girl but she's a flame So bright, she can burn your eyes Better look the other way You can try but you
And we're burning it down Oh, got our head in the clouds And we're not coming d
rybody stands, as she goes by Cause they can see the flame that's in her eyes Watch her when she's lighting up the
burn, baby This girl is on fire This girl is on fire She's walking on
a boy just met a boy when He could come inside of my play-con Cause he look like a superstar in the making So I think I'm going in for the taking Heard through
eeeee Tweeeeeeeeeeeeeeee he could do the taping Boom, boom, pow, this thing be shaking I ain't even tryna find out who
I'm a runaway eh H I wanna give you one last option H I wanna give you one last chan
I want it I'm gonna be ya ya boom boom you got it you got it you
you got it you got that boom boom Just met a boy just a boy when He could become my little problem Cause
thing so big to Wonder if he could understand my lingo Cause I know that he got a wife at home But I need just one night alone If you ke
give you one last chance if If if you looking for the main attraction Just h
you got it, you got it, you got that boom boom if you want it, I'm gonna
now Don't mind if I do And I can tell you feeling from the jump I wanna ride too You got that hot stuff Boy you blessed Let me feel ya upon
whoo chiro whoo-whoo chiro wiloo-whoo Boom baby let down let me stay down Let me sh
option H I wanna give you one last chance if If if you looking for the main attract
it You got it, you got it, you got that boom boom if you want it, I'm g
loose TJR You don't get the word loose You don't get money move move But I go too You don't get them g
yeah, yeah, que no pare la fiesta Don't stop the party Yeah, yeah, que n
coming back 30,000 people went there on me 50,000 in London away 90,000 Morocco, and I'm just getting warmed up, par
Dale cabron they can't they won't they never will stop the party they can't they won't they never will stop the par
the party Yeah, yeah, que no pare la fiesta Don't stop the party I'm from the c
now, you's true They can't, they won't, they never will, stop the party They can't, they won't, they never will, stop the party
Don't stop the party Yeah, yeah, que no pare la fiesta Don't stop the par
an ah Get funky, get funky Now stop! I said ya having a good time out there Yeah, yea
stop the party Yeah To the money makers and the place to be yeah, que no pare la fie
stop the party Yeah To the money makers and the place to be yeah, que no pare la fiest
Don't stop the party Hey! Ho! Hey! Ho! Hey! Ho! I've been trying to do it right Hey! I've been livi
So show me family Hey! All the blood that I would bleed Ho! I don't know where I belo
ng with me, you're my sw I belong with you, you belong with me, you're my sweet
I'd be standing on Canal And Bowery Hey! Ho! And she'd be standing next to me Hey! Ho! 1, 2, 3! I
love we need it now Let's hope for some So, we're bleeding out I belong with you, you belong with me, you're
to the beat of the drums Oh what a shame that you came here with someone TUR TUR TUR TUR TUR TUR TUR
onna die young We're gonna die young We're gonna die young Let's make the most of the night like we're gonna die
hard just like we should Don't care whose watching when we tearing it up You Know That magic that we got nobo
die young Let's make the most of the night we die I hear your hear be it to the beat of the drums Oh what a shame that you came here with someo
got a crush you know That magic in your pants it's making me blush for sure Looking for so
re gonna die young I hear your heart beat to the beat of the drums Oh what a sh

FREDDY REITZ
New York (Kennedy Material) I (left)
New York (Kennedy Material) II (right)

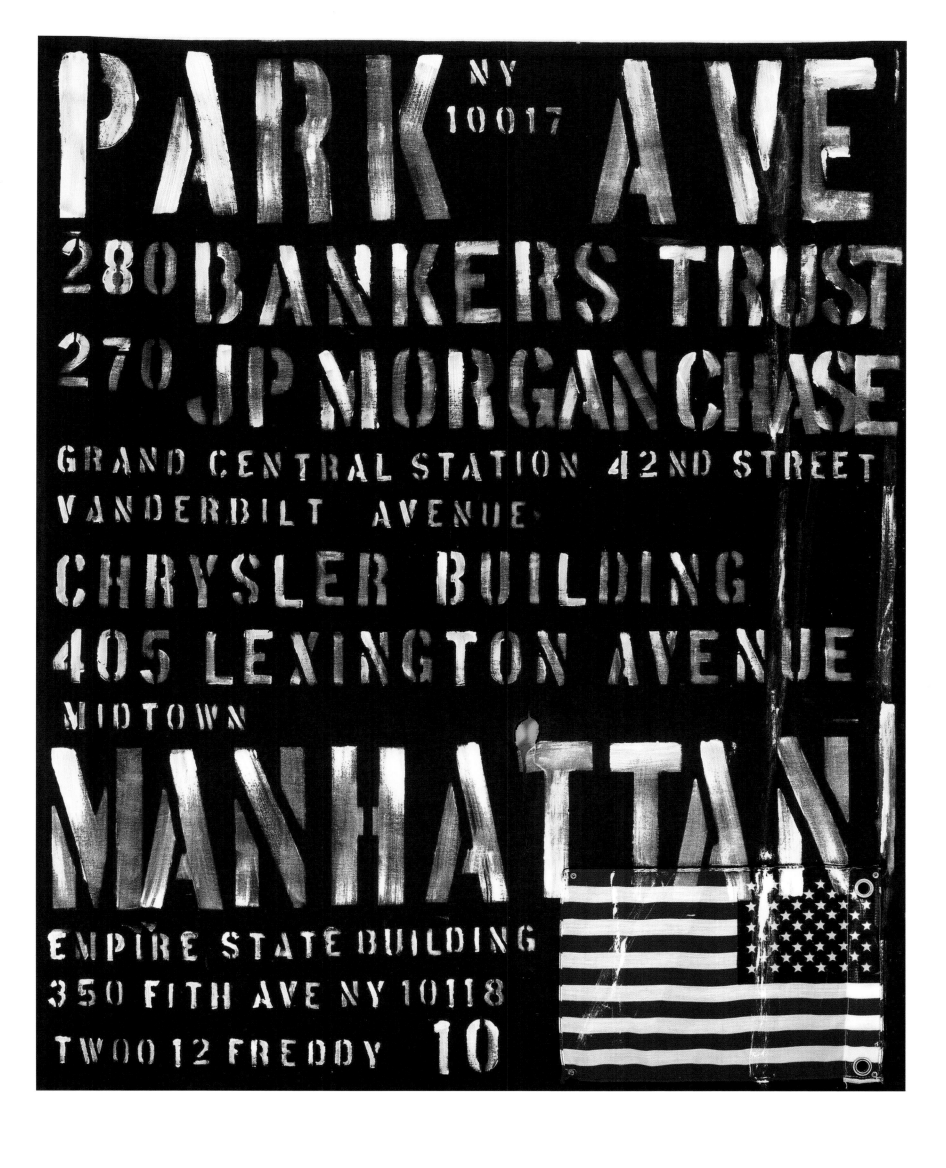

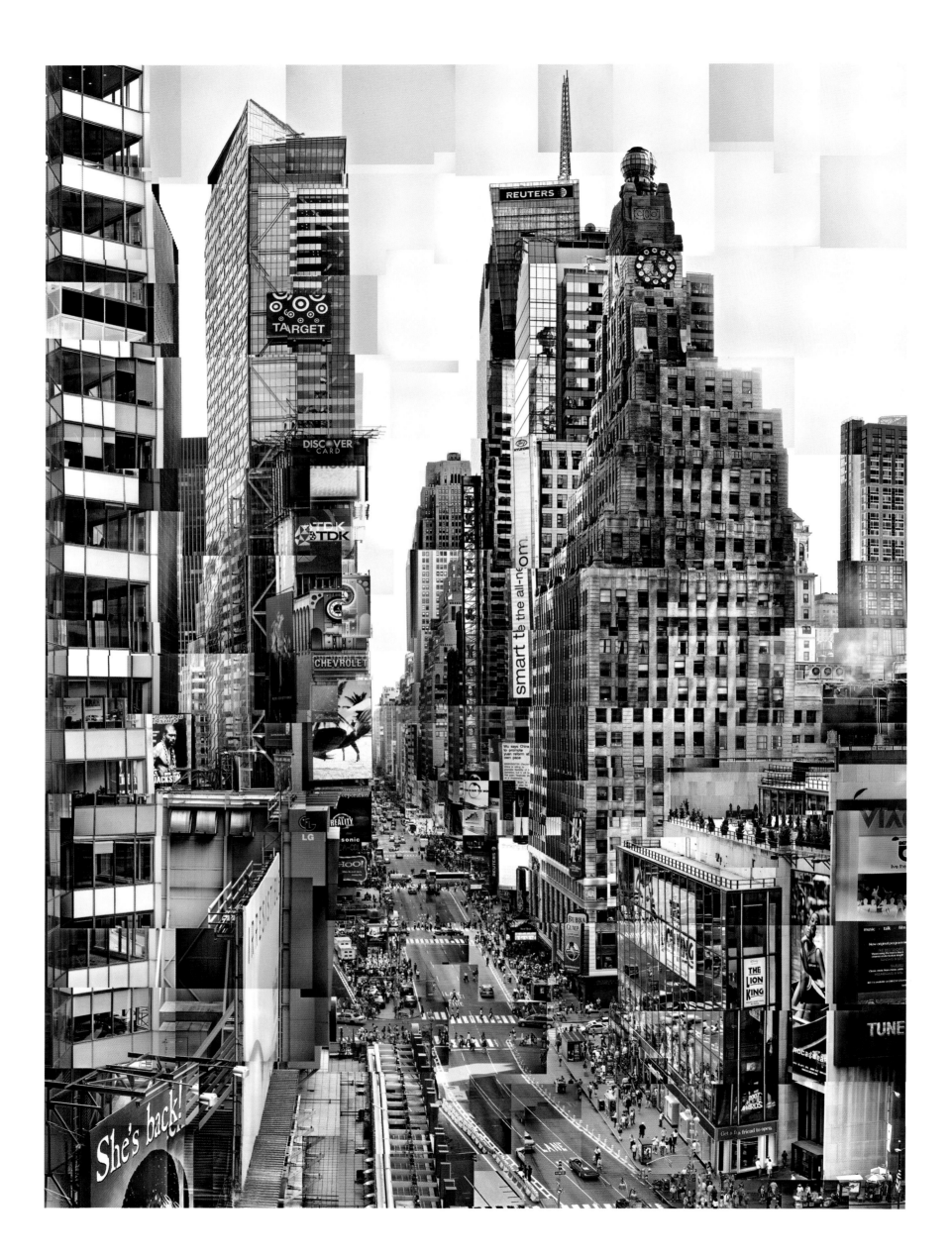

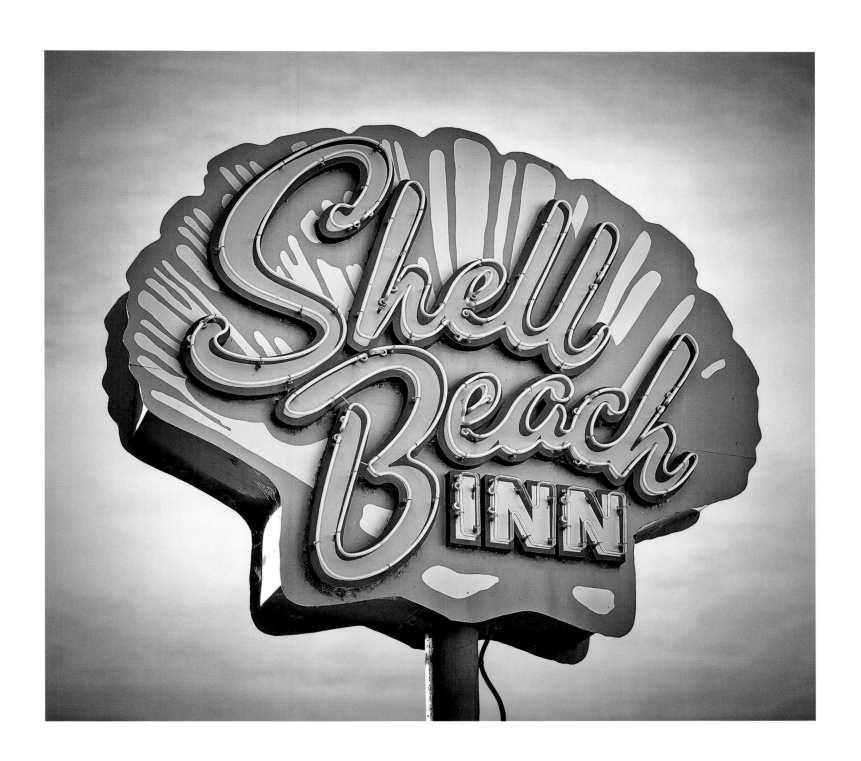

CHRISTOPHE JACROT (PREVIOUS PAGE)
Ruby

PEP VENTOSA (LEFT)
Times Square

MARC SHUR (RIGHT)
Shell Beach Inn

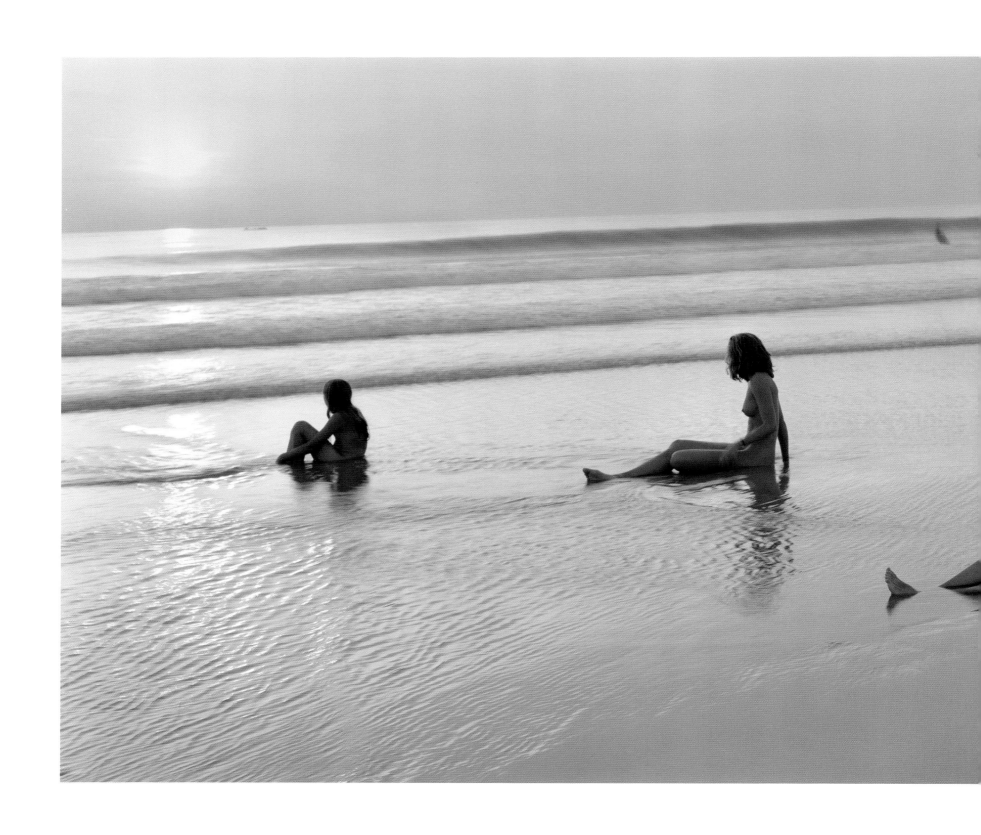

JOCK STURGES | TRUNK ARCHIVE
Allison, Lotte, Miranda, Maia and Vanessa; Montalivet, France, 2001

STEFAN SAALFELD (FOLLOWING PAGE)
Rising

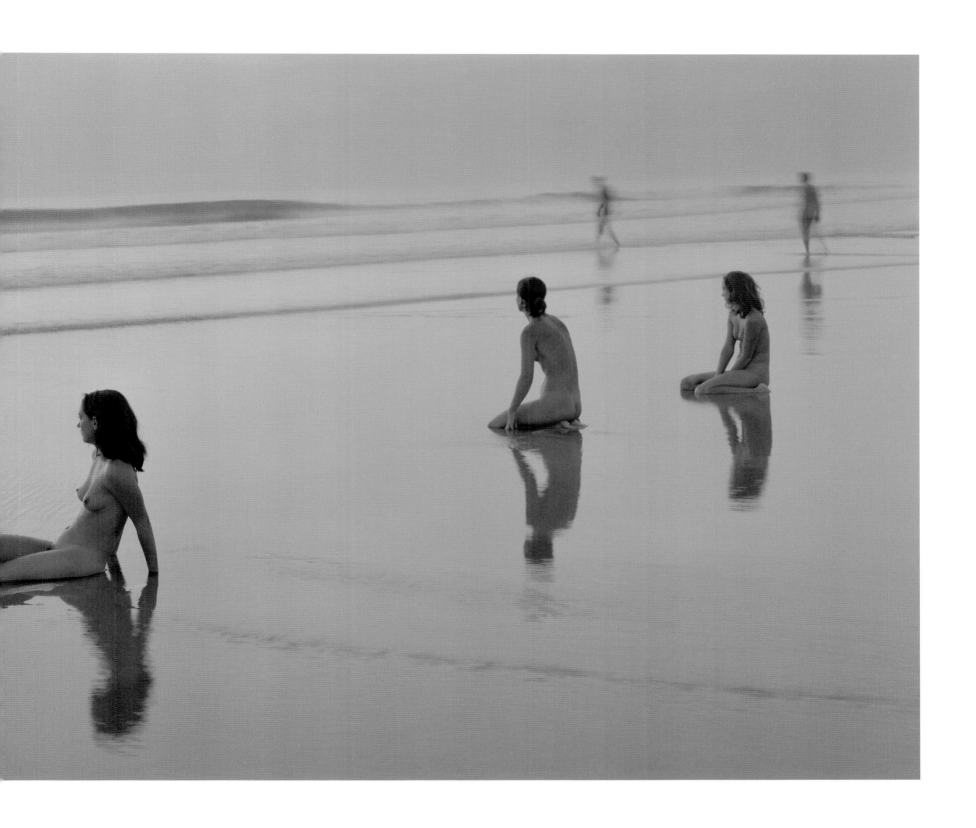

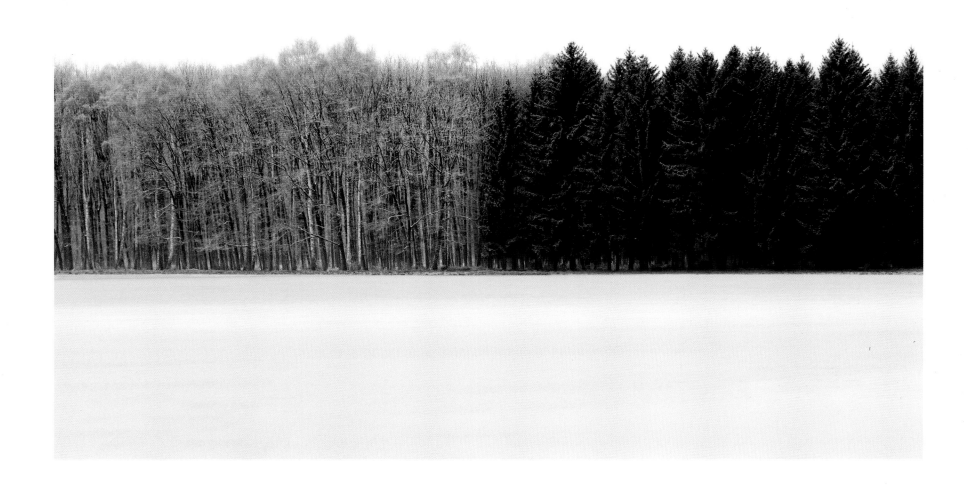

HARTWIG KLAPPERT (LEFT)
Forest 2

LUTZ HILGERS (RIGHT)
Darklight V

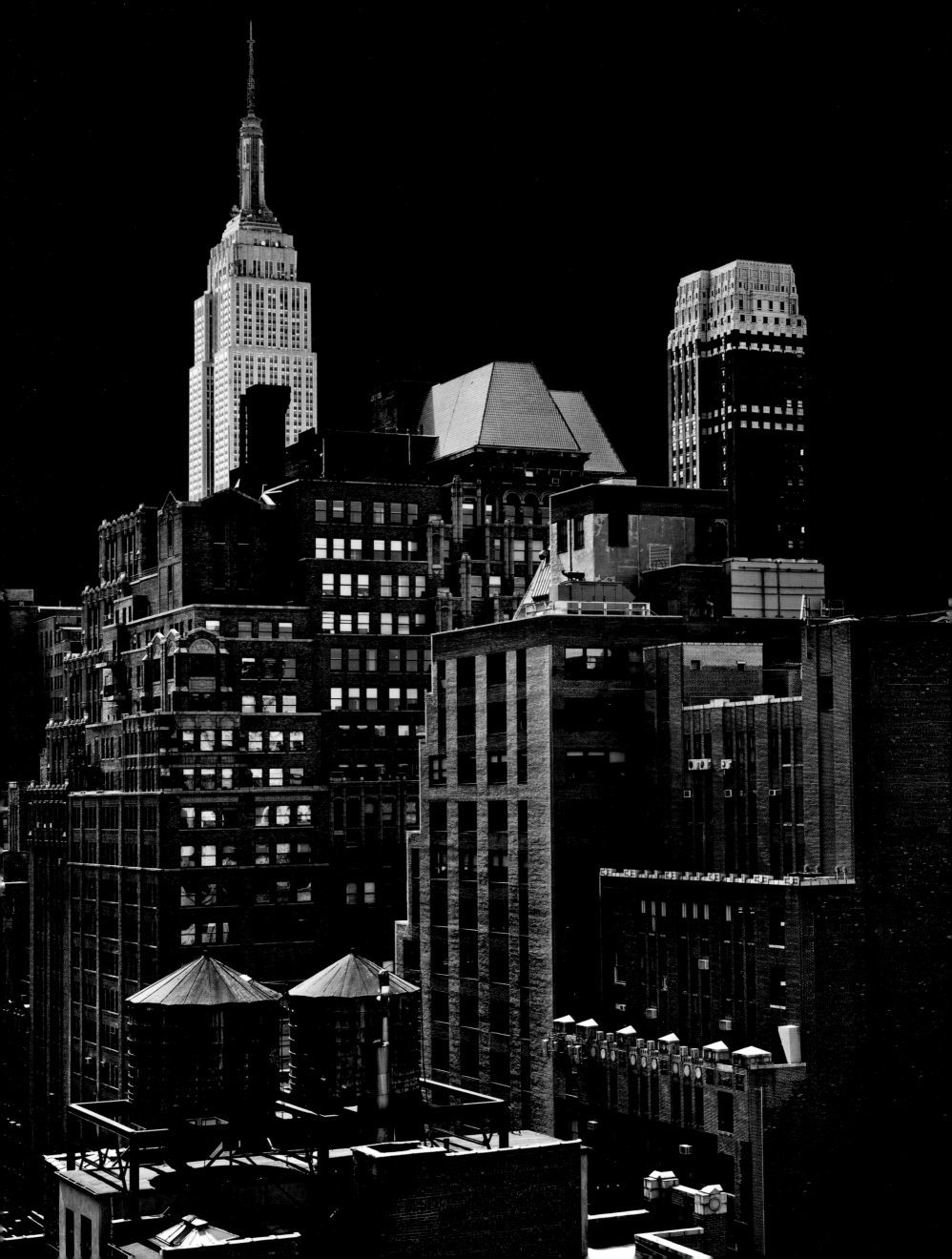

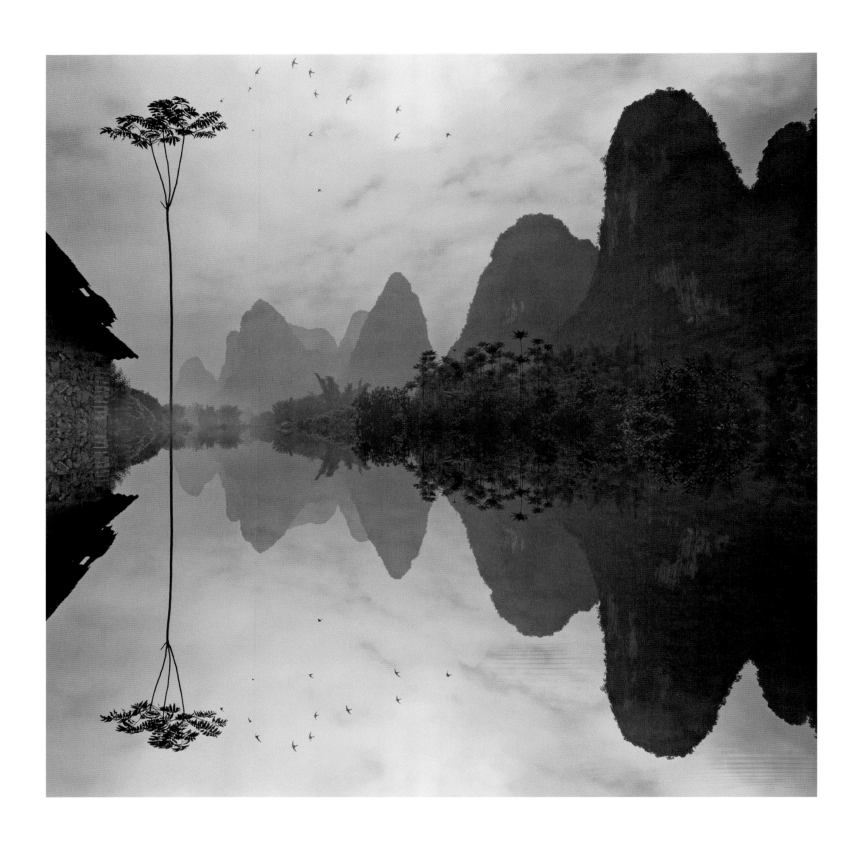

TATIANA GORILOVSKY (LEFT)
Out of Time

ZHANG WANG (RIGHT)
Outside Paradise

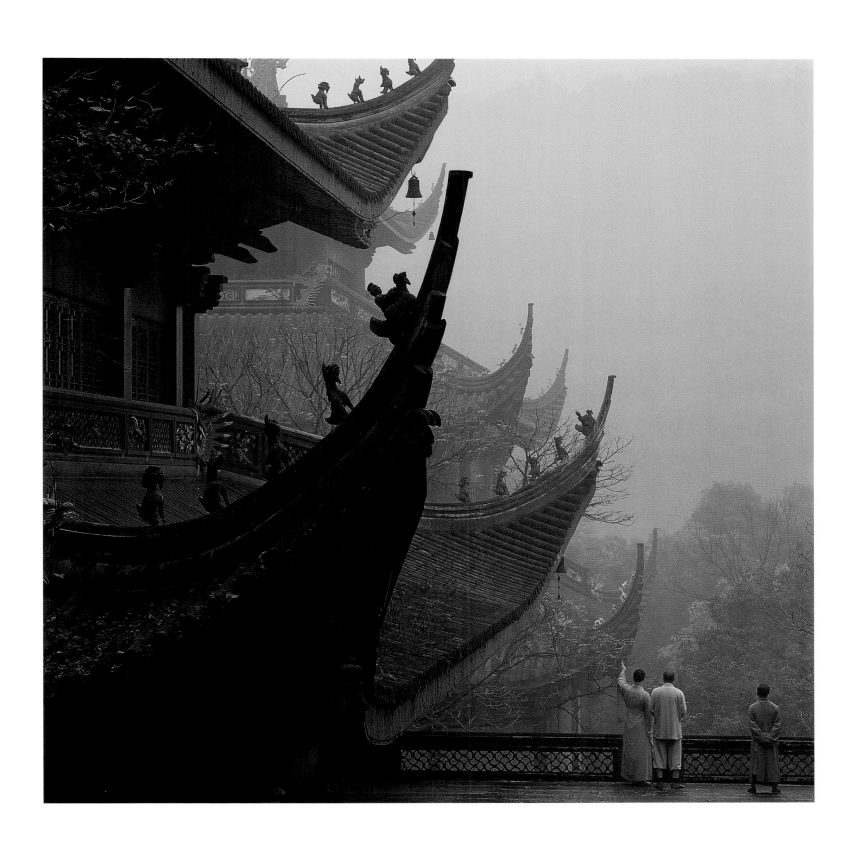

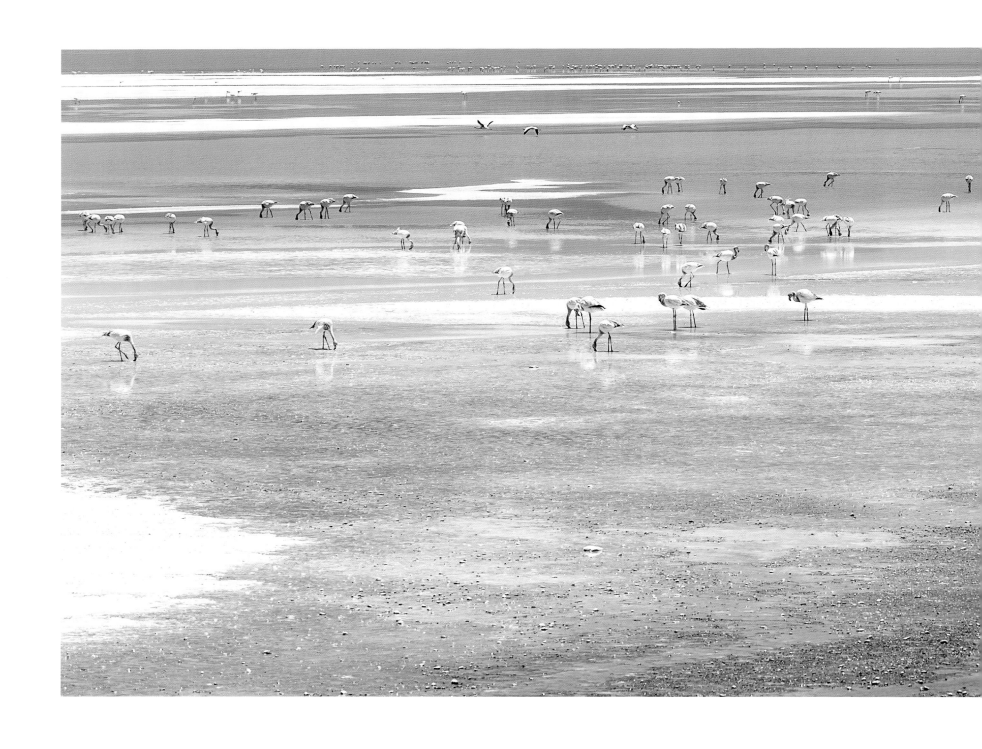

DIERK MAASS
22° 14' 27.071" S 67° 44' 29.933" W

OLAF HAJEK
Black Paradise

*Claudius Seidl, geb. 1959, ab 1983 Filmkritiker bei der „Süddeutschen
Zeitung“, seit 1985 bei der Wochenzeitung „Die Zeit“. 1990 Redak-
tionsmitglied des „Spiegel“, 1996 Wechsel zur „Süddeutschen Zeitung“
als stellvertretender Feuilletonchef. Seit 2001 Feuilletonchef der
„Frankfurter Allgemeinen Sonntagszeitung“.*

Braucht es die Kunst überhaupt?

Die Frage, ob man die Fotografie zu den Künsten zählen darf, ist längst abschließend beantwortet und zwar mit einem riesengroßen „Ja“. Man darf nicht nur, man muss sogar, die fotografischen Bilder hängen in den Galerien, den Museen, sie werden auf der Biennale von Venedig ausgestellt – und damit keiner jene schönen (oder hässlichen), ernsten (oder lustigen) Bilder, welche als Kunst gehandelt werden, verwechsle mit den unüberschaubaren Mengen an schönen oder ernsten Bildern, welche wir, wenn wir nur die richtige App haben, mit unseren iPhones selber machen können, haben die Kunst-Bilder einen schönen, teuren Rahmen. Ein brauchbareres Mittel, die Kunst von der Nicht-Kunst zu unterscheiden, gibt es nämlich nicht.

Die Frage, die schon deshalb nicht abschließend beant-wortet ist, weil kaum einer sie sich zu stellen traut, ist die, ob das denn so gut ist für die Fotografie: Kann es sein, dass all das, was die Fotografie so lebendig macht, gegenwärtig, relevant und vielleicht auch skandalös, im Rahmen der Kunst nur noch abgemildert, gedämpft und abgeschwächt zu haben ist, weil die Kunst in diesem Fall gewissermaßen ein Sicherheitszertifikat ist? Eine Unbedenklichkeitsbescheinigung?

Wenn man auf der Biennale des Jahres 2013 den deut-schen Pavillon betrat stand man vor einer Skulptur des chinesischen Künstlers AI WEIWEI, die aus vielen dreibeinigen Hockern bestand, welche der Künstler zu einer Art schwebendem Schwarm zusammengefügt hatte. Da diese Skulptur offensichtlich nicht auf irgend-etwas Bestimmtes verwies, näherten sich manche dem Werk mit Ehrfurcht, andere mit Humor, alle aber im Bewusstsein der Freiheit, dass man die Schönheit dieser Skulptur durch reine Anschauung erfahren könne. Und was sie womöglich bedeute, das war eine Frage der Zuschreibung. Das ist die Freiheit der Kunst. Der Raum daneben schien eher ihr Gefängnis zu sein. Da hingen Fotografien des Südafrikaners SANTU MOFOKENG, und dieser Fotograf hat, bevor die Kunstwelt ihn entdeckte, für die Zeitung fotografiert. Es gibt eine unabweisbare Schönheit in seinen Bildern, die meistens die Gegenwart seines Heimatlandes zeigen – aber die Schönheit ist hier nicht alles. Es geht um Menschen, um Orte, es geht um Sachverhalte, die er einfach zeigen, um Perspektiven auf seine Welt, die er gewinnen will. Man kann es ganz einfach sagen: In diesen Bildern sind Informationen und Botschaften gespeichert. Das Biennale-Publikum, auf

Kunst gestimmt, schien aber von diesem, quasi journalis-tischem Anspruch überfordert zu sein. Die Leute machten andächtige Gesichter, blieben ehrfurchtsvoll vor den Bildern stehen und schauten so erwartungsvoll auf die Fotografien, als hofften sie, dass die Kunst gleich zu ihnen zu sprechen beginne. Besser hätten sie die Beschriftungen gelesen, den Katalog studiert und sich auf den Informationswert der Ausstellung konzentriert. Viele wirkten enttäuscht, als sie den Raum verließen.

Wenn Fotografie nur Kunst ist, dann ist sie nicht mal das – und wenn wir vor einer Fotografie stehen, die als Kunst präsentiert wird, schadet es nichts, erst einmal zu fragen, was, außer Kunst, dieses Bild sonst noch ist. Hat es eine Information, eine Botschaft, reizt es zum Widerspruch, handelt es von den Dingen und den Menschen, um die es gerade geht? Ist irgendwo ein Datumsstempel zu sehen? Denn jede Kunst war, in ihren besten Zeiten, mehr Medium als Kunst; hier wurden die großen Fragen der Gegenwart verhandelt. Die Malerei war zu allererst eine Technik zur Vermessung des Menschen und zur Speicherung von visueller Information. Das Schöne, das Erhabene, das war der schwer kalkulierbare, nicht messbare Überschuss, und die zeitlose Gültigkeit offenbarte sich eben erst, wenn die entsprechende Zeit vergangen war und das Werk sie überstanden hatte. Insofern ist jede heutige Fotografie, die einen Menschen zeigt, einen Raum ausmisst, ein Geschehen dokumentiert, erst einmal ganz bei sich. Dazu ist die Foto-grafie da, und wenn uns dieses Foto gefällt, wenn es uns inspiriert oder schockiert oder in eine erhabene Stimmung versetzt: umso besser. Womöglich ist es ja Kunst. Wenn nicht, dann hat es wenigstens etwas zu sagen.

Dies ist ein Plädoyer dafür, die Fotografie als das zu lieben, was sie in ihren besten Momenten ist. Unverhoffte Gegenwart, ertappte Zeit, magischer Moment. Das Presse-foto von heute kann das begehrteste Sammelobjekt von morgen sein, der Schuss aus der Hüfte relevanter als die aufwendigste Inszenierung und manchmal sind unscharfe Bilder viel klarer als die scharfen.

Man sollte Fotografien rahmen lassen, man soll sie an die Wand hängen, man soll sich an ihrer Schönheit freuen. Aber zuerst sollte man sich fragen: Wieviel Gegenwart ist in diesem Bild, wovon erzählt es und was hat es vor allem mir zu sagen? Dann sprechen wir vom Sammeln – von der Kunst sprechen wir danach.

Born in 1959, Claudius Seidl started as a film critic for the "Süddeutsche Zeitung" in 1983, for "Die Zeit" in 1985. He became a member of the Editorial Board for "Der Spiegel" in 1990 and moved to the "Süddeutsche Zeitung" in 1996. Since 2001 he works for the "Frankfurter Allgemeine Sonntagszeitung".

What's art got to do with it?

The question of whether photography is a form of art has long been answered, with a resounding "Yes". In fact, not only may we consider photography as an art form, we must. We must hang it on the walls of our galleries and museums, we must display it at the Venice Biennale. Those photographs we consider to be art, whether beautiful or ugly, serious or light-hearted, are given impressive, expensive frames so that we don't confuse them with almost limitless stream of shots we can take with our iPhones – provided we have the right App, of course. For there is no functional means of separating photographic art from everything else.

The question that remains unanswered, perhaps because few trust themselves to ask it, is whether this is good for photography: Could it be that the very essence of photography, that which makes it so vibrant, so contemporary, so scandalous even, is somehow subdued or diluted when presented as "artwork". Labelling a photograph as a work of art may serve as a certificate of authenticity, but does it not also sterilise the soul of the image?

Anyone who entered the German pavilion at the 2013 Venice Biennale was confronted by the giant sculpture of Chinese artist AI WEIWEI, comprised of multiple wooden stools assembled in a flowing spiral. Since the sculpture did not appear to carry a clear meaning, some visitors approached it in awe, others with humour, but all with an understanding of the freedom that anyone can experience the beauty of this sculpture simply by looking at it. The viewer could attribute whatever meaning they wanted to the sculpture. This is the freedom of art.

The exhibition space next door, by comparison, appeared almost prison-like. Here were displayed a series of photographs from the South African photographer SANTU MOFOKENG. Before being discovered by the art world, MOFOKENG had shot images for a newspaper. There is an inescapable beauty in his pictures, which focus on present day life in his home country – but they are much more than their beauty. The images are about people, places, and circumstances, portrayed in a simple style, and they challenge us to see new perspectives. In other words, MOFOKENG's images carry information, they carry messages. The Biennale public, lovers of art, appeared to be overwhelmed by this journalistic challenge. They stood in front of the images in amazement, faces screwed up and deep in thought. They stared at the images with great expectation, almost longing for the art within them to start speaking aloud. It would have been better if they had read the labels, studied the catalogue, and concentrated on the value of the information presented in the exhibition. Many appeared disappointed when they left the room.

If photography is merely art, then it is not even that – and if we stand in front of a photograph presented as a work of art, then it does us no harm to consider whether the image may be something else, something more than just art. Does it contain information, or a message, does it provoke, does it deal with things and people that are contemporary? Is there a date stamp visible somewhere? Art, at its moment of creation, is more a medium than a form of entertainment, a vessel through which the great questions of the present are contemplated. The earliest paintings were a means to record people and capture visual information. The beauty of these images, at first seen merely as excess, only became a timeless quality with the passing of years. Any photograph taken today, whether it portrays a person, reveals a room, or documents an event, is in the first instant simply a record. That is what photography is there for. If we like the photo, if it inspires or shocks us, if it creates feelings of awe and amazement, then much the better. If it is labelled as art, great. If not, at least it has something to say.

This is a plea to love photography for what it is at the instant of creation: An unexpected presence, a magical moment captured in time. Today's press photo may be tomorrow's collector's item, the quick snap from the hip may be more powerful than the most elaborately staged photo shoot, and a blurred image may reveal far more than one that is crystal clear. We should give photography frames, we should hang it on walls and reveal its beauty. But, first of all, we must ask ourselves how much of today is contained within an image. What does it tell us, and what can we learn from it? Then we can talk about collection – and after that, we can talk about art.

*Claudius Seidl, né en 1959, a travaillé comme critique de cinéma
au « Süddeutsche Zeitung » en 1983, au journal « Die Zeit »
en 1985. Il devient membre de la rédaction du « Spiegel » en 1990
et change en 1996 pour la « Süddeutsche Zeitung » où il est
responsable adjoint de la rubrique « Feuilleton ». Depuis 2001,
chef de la rubrique « Feuilleton » au « Frankfurter Allgemeine
Sonntagszeitung ».*

Faut-il vraiment que cela soit de l'art ?

La question de savoir si la photographie a le droit de faire partie des arts est depuis longtemps réglée et ce avec un grand oui. On n'a pas seulement le droit, on doit même accrocher les images photographiques dans les galeries, les musées, elles sont exposées à la Biennale de Venise – et avec ça, sans confondre les belles (ou laides), sérieuses (ou drôles) photos qui sont comprises comme de l'art avec la masse confuse des photos belles ou sérieuses que nous faisons nous-mêmes avec notre iPhones si nous avons la bonne App, les photos d'art ont un cadre beau et cher. Un moyen valable pour différencier l'art du non-art, en effet, il n'en existe pas.

La question, qui finalement reste sans réponse parce que presque personne n'ose vraiment la poser, est de savoir si cela fait du bien à la photographie: se peut-il que tout ce qui rend la photographie si vivante, actuelle, pertinente et peut-être scandaleuse, ne soit dans le cadre de l'art plus qu'atténué, retenu et amorti, parce que dans ce cas dire que c'est de l'art offre en quelque sorte un certificat de sécurité, d'innocuité ?

Lorsqu'on entre dans le pavillon allemand de la Biennale 2013, on se trouve face à une sculpture de l'artiste chinois AI WEIWEI conçue de tabourets à trois pieds que l'artiste a assemblé en une sorte d'essaim flottant. Comme cette sculpture ne fait pas référence à quelque chose de particulier, certains se rapprochèrent de l'œuvre avec respect, d'autres avec humour, mais tous conscients de la liberté avec laquelle on pouvait faire l'expérience de la beauté de cette sculpture simplement à travers la contemplation. Et ce qu'elle signifie, peut-être même, était une question d'attribution. C'est la liberté de l'art.

L'espace d'à côté semblait quant à lui être plutôt sa prison. Ici étaient accrochées des photos du Sud-Africain SANTU MOFOKENG, et ce photographe a, avant que le monde de l'art ne le découvre, photographié pour la presse. Il y a dans ses images qui souvent montrent le présent de son pays d'origine, une beauté impériale – mais ici la beauté n'est pas tout. Il est question d'êtres humains, d'endroits, de faits qu'il montre simplement pour ouvrir à d'autres perspectives sur son monde. On peut le dire clairement: des informations et des messages sont enregistrés dans ces photos.

Le public de la Biennale, conditionné pour voir de l'art, sembla pourtant dépassé par cette revendication quasi journalistique. Les gens avaient des visages de recueil-lement, se tirent respectueusement devant les images et regardèrent les photos plein d'espoir comme s'ils espéraient que l'art se mette directement à leur parler. Ils auraient plutôt lu les cartels, étudié le catalogue et considéré la valeur d'information de l'exposition. Beaucoup eurent l'air déçu lorsqu'ils quittèrent l'espace.

Lorsque la photographie n'est que de l'art, alors cela ne peut pas en être – et lorsqu'on se tient devant une photographie présentée comme de l'art, cela ne fait pas de mal de se demander ce que, à part l'art, cette image est de plus. Contient-elle une information, un message, irrite-t-elle par ses contradictions, traite-t-elle des choses et des hommes dont il s'agit au premier abord ? Peut-on voir quelque part un tampon avec une date ? Car chaque art fut, dans sa meilleure période, plus qu'un médium que de l'art ; ici on traita les grandes questions du présent. La peinture fut premièrement une technique pour arpenter l'homme et enregistrer des informations visuelles. Le beau, le sublime devint un excédent difficilement calculable et non mesurable et la validité éternelle se révéla seulement lorsque le temps approprié passa et que l'œuvre le surmonta.

Dans cette mesure, chaque photographie actuelle qui montre un être humain, prend la mesure de l'espace, documente un événement, est en harmonie avec elle-même. C'est pour cela que la photographie est faite et lorsqu'une photo nous plaît, qu'elle nous inspire ou nous choque ou nous plonge dans une atmosphère sublime, c'est encore mieux. Peut-être même que c'est de l'art. Mais si elle n'en est pas, elle a tout du moins quelque chose à dire.

Ceci est un plaidoyer pour aimer ce qu'est la photographie dans ses meilleurs moments. Présent inattendu, temps suspendu, moment magique. La photo de presse d'aujourd'hui peut être l'un des objets de collection de demain des plus convoités, la photo instantanée plus pertinente qu'une mise en scène élaborée et parfois les photos floues bien plus claires que celles mises au point.

On devrait encadrer les photos, les accrocher au mur et se réjouir de leur beauté. Mais d'abord il faudrait se demander: combien de présent se trouve dans cette image, qu'est ce qu'elle raconte et surtout qu'a-t-elle à me dire. Alors on parle de collection – de l'art on en parlera après.

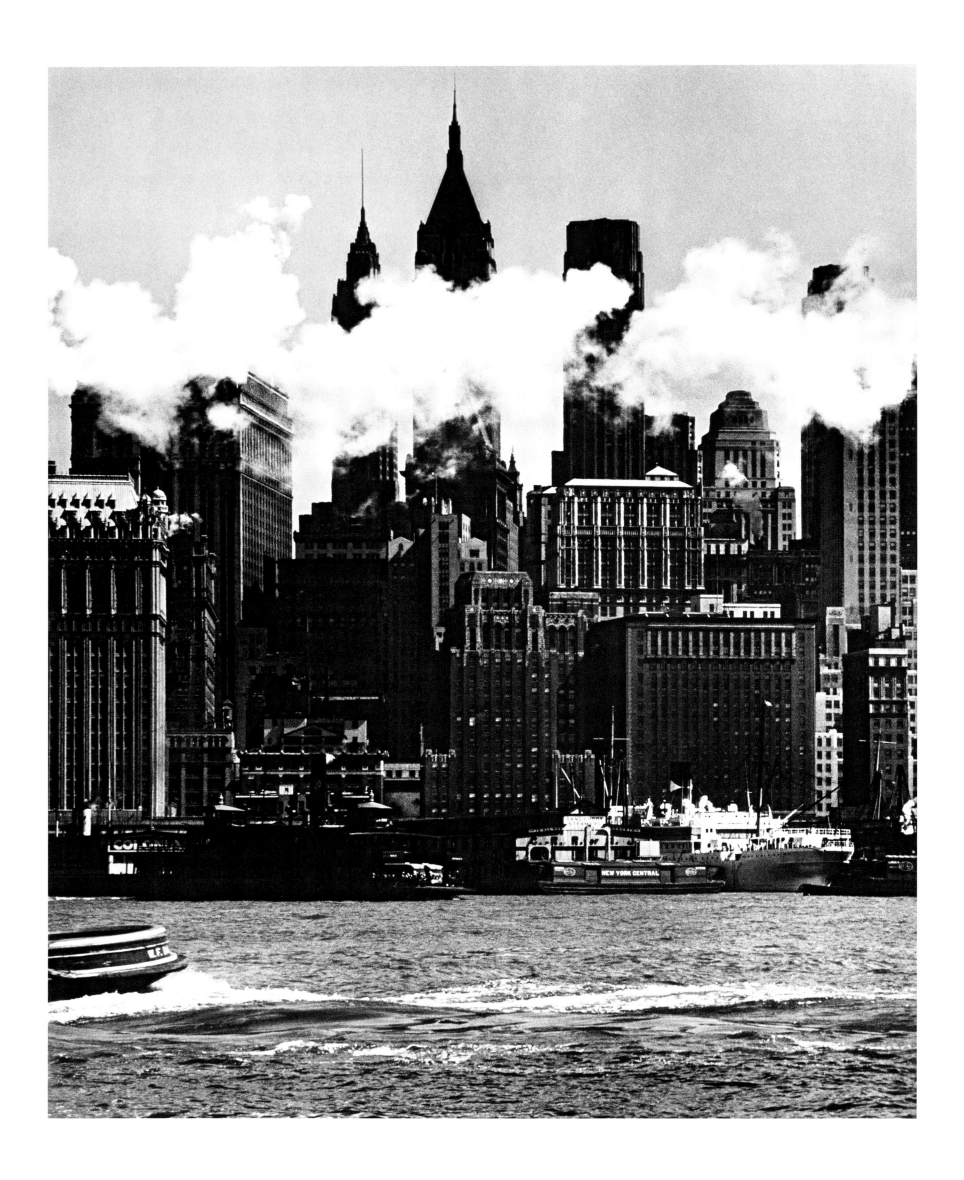

ANDREAS FEININGER
Hudson River waterfront, New York

Jock Sturges im Gespräch mit Tim Morehead

Warum machen Sie Fotos?
Was ist Ihre Absicht?

Fotografien stehen immer für etwas, nicht wahr? Sie geben die Realität nicht wieder, sondern sind einfach nur eine blasse Kopie. Die Wirklichkeit, die sie darstellen, existiert bereits nicht mehr, weil in jeder einzelnen Sekunde der Lauf der Zeit alles wieder auslöscht. Trotz verzweifelter Bemühungen unseres Gedächtnisses verschwinden die Dinge wieder, und das eher früher als später – *es sei denn,* man hatte das Glück ein erfolgreiches Foto gemacht zu haben. In diesem Fall kann ein Bild sogar Teil der Erinnerung *werden.*

Als ich anfing zu fotografieren, studierte ich immer die Arbeit der Fotografen, die ich bewunderte. Ich versuchte herauszufinden, wie sie es gemacht hatten. Damals dachte ich, dass es am wichtigsten wäre, zu verstehen, wie die Bilder *technisch* funktionierten. Aber dann wurde mir sehr schnell klar, dass diese technischen Fragen im Vergleich zu den Absichten und Motiven des Fotografen in seiner Arbeit, eine untergeordnete Rolle spielten. Das „Warum" war wichtig, nicht das „Wie". Natürlich musste das „Wie" da sein, als Handwerk, das man versteht und ständig perfektioniert, aber die wirkliche Geschichte auf den Bildern hat doch etwas damit zu tun, dass der Fotograf weiß, was er vor seiner Kamera hat. Genau an dieser Stelle wurde ihre Arbeit für mich faszinierend, denn ihre Bilder zeigten mir, dass sie etwas wussten, was ich nicht wusste.

Können Sie kurz Ihre Arbeitsmethode beschreiben?

Die Zusammenarbeit mit meinen Models, ist leicht zu beschreiben. Wir sind Freunde, verbringen viel Zeit zusammen und kennen uns, von Familie zu Familie, seit Jahren. Ab und zu machen wir zusammen Fotos. Ich denke, dass nur ein Prozent meiner „Arbeit" als Fotograf darin besteht, dass ich wirklich Bilder mache. Der Rest davon ist einfach die soziale Arbeit, die meine Fotos erst ermöglicht.

Wenn ich arbeite, versuche ich nie, meine Models zu irgendeiner Pose zu bewegen. Die Models, die mich am besten kennen, können das auch am besten. Sie verstehen intuitiv, dass eine sogenannte „Pose" etwas ist, das von

ihnen kommen muss, auf ganz natürliche Weise, und dass es zu ihnen gehört. Das ist vor allem in meinen besten Bildern so.

Wie würden Sie Ihre Beziehung zu den Menschen, die Sie fotografieren, beschreiben? Was unterscheidet Ihre Arbeit von der typischen Beziehung zwischen Fotograf und Model?

Ich *kenne* meine Models sehr gut und das zeigt sich auch in meiner Arbeit. Es ist nicht leicht, das konkret zu beschreiben, weil das in meinen Bildern nur sehr subtil und unterschwellig spürbar ist.

Oft sind es gerade die kleinen Sachen, über die wir den eigentlichen Zugang zu dem Charakter und der Persönlichkeit eines Menschen finden; der *Wahrheit,* die ihn wirklich ausmacht. Man kann so etwas in seiner fotografischen Arbeit nicht wahrnehmen, bevor man seine Models nicht sehr gut kennt und einander vertraut. Das Fotografieren ist ein gegenseitiger Akt der Zusammenarbeit und Zusammenarbeit ist ein sehr wichtiger, wenn nicht der *wichtigste* Begriff in meiner Arbeit. Wir machen die Fotos *zusammen.*

Hat der Erfolg, der Ihrer Arbeit zuteilwurde, Sie auf irgendeine Weise verändert?

Als ich als junger Mann anfing, ernsthaft zu fotografieren, konnte ich mir nicht vorstellen, in der Kunstszene jemals aus der Anonymität herauszutreten. Ich mochte es einfach so sehr, Bilder zu machen, dass es für mich kaum vorstellbar war, einerseits mit so viel Freude zu arbeiten und andererseits auch noch davon leben zu können. Deshalb habe ich nie über Erfolg nachgedacht oder ernsthaft damit gerechnet. Ich arbeitete einfach und hielt mich mit anderen Jobs über Wasser. Jede Sekunde, in der ich nicht arbeitete, verbrachte ich hinter der Kamera oder in der Dunkelkammer – Tag und Nacht, Nacht und Tag. Ich liebte es und tue es immer noch.

JOCK STURGES,
Seattle, 2012

Jock Sturges Interview with Tim Morehead

Why do you make photos?
What is your purpose?

Photographs are a substitute for something, aren't they? They are not the reality depicted; they are a simply a thin copy. The reality depicted doesn't exist any longer because, second by second, time erases everything. Sooner than later all things go away despite memory's best efforts – *unless* of course one has had the good fortune to have made a successful photograph. In that circumstance a picture has the possibility to actually *become* memory.

As a young photographer, I was always studying the work of the other photographers whom I admired in an attempt to understand how it was done. I thought then that it was most important to understand how pictures were made *technically*. But it pretty quickly became apparent to me that the technical engine was far less important than the photographer's larger motivations in making the work in the first place. It was the "why" it was done that mattered, not the "how". The how had to be there – the craft understood and perfected – but the big story in pictures had to do with what their makers knew about what they had before their cameras. That's where their work became fascinating. Their pictures were showing me what they knew that I didn't.

Can you briefly describe your working method?

How I work with my models is simple to describe. We spend time together, know each other, family to family, for years. We are friends. And once in a while we make pictures together. I think that only about 1% of my time spent doing my "work" as a photographer consists of the actual taking of photographs. The rest of the time is dedicated to the simple social work that makes the photographs possible.

Once working, I try never to pose my models at all. The models who know me best do this best. They understand that "pose", as it were, comes from them, from what they do naturally, on their own. This is true of all my best pictures.

Explain your relationship with the people you photograph and what makes your work different from the typical photographer-model relationship.

I *know* my models very well and that knowledge is present in the photographs. It's hard to describe this finally because what's manifest in the images is so subtle, so subliminal.

It is in the smallest of details that we have the most profound access to the character, personality, and *truth* of who people really are. You don't have access to those perceptions in your photographs until you know your models extremely well and you are trusted. Until you trust one another. The act of making photographs is a mutual act; it is collaborative. Collaboration is a very important word in what I do – one of the *most* important. We make pictures *together*.

Has the scale of the success your work has enjoyed changed you in any way?

When I first began to photograph seriously as a young man it never occurred to me that my lot in the art world would improve past anonymity. I frankly liked making pictures so much that it didn't seem imaginable that one could have that much fun working and have it result in any material success in the world. So I never counted on success or even really thought about it. I just worked and held other jobs to keep myself in film and paper. Every second I wasn't working I was shooting or in the darkroom – day and night, night and day. I loved it. Still do.

JOCK STURGES,
Seattle, 2012

Entretien de Jock Sturges avec Tim Morehead

Pourquoi faites-vous des photos ?
Quelle est votre intention ?

Les photographies représentent toujours quelque chose, n'est-ce pas ? Elles ne restituent pas la réalité telle quelle et en sont simplement une pâle copie. La réalité qu'elles représentent n'existe déjà plus car dans chaque seconde de l'écoulement du temps elle s'efface à nouveau. Malgré les efforts désespérés de notre mémoire, les choses continuent à disparaître et cela plus vite que l'on croit – *serait-ce* d'avoir eu la chance de faire une photo réussie. Dans ce cas, elle peut même *devenir* une partie de la mémoire.

Lorsque j'ai commencé à prendre des photos, j'étudiais toujours le travail des photographes que j'admirais. J'essayais de déceler comment il l'avait fait. A l'époque, je pensais que c'était important de comprendre comment les photos fonctionnaient *techniquement*. Mais après un temps, j'ai compris que ces questions techniques jouaient un rôle subordonné par rapport aux intentions et aux motifs du photographe dans son travail. Le « pourquoi » était important, pas le « comment ». Naturellement, le « comment » devait être là en tant que technique que l'on comprend et perfectionne continuellement mais la vraie histoire qui se trouve dans l'image a plus à voir avec le fait que le photographe sait ce qu'il a devant son appareil photo. C'est exactement là que leur travail devint pour moi fascinant car leurs images me montrèrent qu'ils savaient quelque chose que je ne savais pas.

Pourriez-vous rapidement décrire votre méthode de travail ?

Le travail avec mes modèles est facile à décrire. Nous sommes amis, passons beaucoup de temps ensemble et nous connaissons de famille en famille depuis des années. De temps en temps, nous faisons des photos ensemble. Je pense que le fait de faire des photos ne correspond qu'à un pourcent de mon travail de photographe. Le reste du temps comprend le travail social, chose primordiale qui rend mes photos possibles.

Lorsque je travaille, je n'essaie jamais de faire prendre à mes modèles une pose en particulier. Ceux qui me connaissent le mieux prennent également la meilleure pose. Ils comprennent intuitivement qu'une « pose » est quelque chose qui doit venir d'eux-mêmes de façon complètement naturelle et que cela leur appartient. C'est la vérité, en tout cas dans mes meilleures photos.

Comment décririez-vous la relation avec les personnes que vous photographiez ? Qu'est ce qui différencie votre travail de la relation typique entre photographe et modèle?

Je *connais* très bien mes modèles et cela se voit dans mon travail. Ce n'est pas facile de le décrire concrètement parce que ce qui se manifeste dans les images est très subtil et ne se ressent que de façon sous-jacente.

Souvent, c'est justement les petites choses qui nous permettent de trouver l'accès au caractère et à la personnalité d'une personne, à la *vérité* qui est vraiment la sienne. On ne peut pas ressentir quelque chose comme ça dans son travail photographique tant que l'on ne connait pas parfaitement son modèle et qu'une confiance commune s'est établie. La photographie est un acte mutuel de collaboration et la collaboration est un concept très important, si ce n'est *le plus* important dans mon travail. On fait les photos *ensemble*.

Le succès que l'on attribue à votre travail vous a-t-il changé d'une manière ou d'une autre ?

Lorsque j'ai commencé, en tant que jeune homme, à photographier de façon sérieuse, je ne pouvais pas penser sortir une minute, dans la scène artistique, de l'anonymat. J'aimais tellement faire des photos que pour moi ce n'était pas pensable de travailler d'un côté avec autant de joie et de l'autre de pouvoir en plus en vivre. C'est pourquoi je n'ai jamais pensé au succès ou sérieusement compté là-dessus. J'ai simplement travaillé et vivoté avec d'autres jobs. Chaque seconde où je ne travaillais pas, j'étais derrière l'appareil photo ou dans la chambre noire – jour et nuit, nuit et jour. J'aimais ça et j'adore encore ça.

JOCK STURGES,
Seattle, 2012

DAVID ARMSTRONG
Untitled

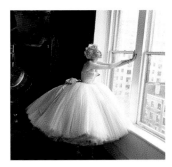

PATRICK DEMARCHELIER / HEARST / TRUNK ARCHIVE

¬ In aufwendigen Fotoshootings und meisterhaften Licht-inszenierungen gelingt es PATRICK DEMARCHELIER, einem der berühmtesten Modefotografen der Welt, die Persönlichkeit und die Schönheit einer Frau zum Strahlen zu bringen. Für seinen Stil der zurückhaltenden, geheimnisvollen Eleganz ist für ihn der Moment zwischen Konzentration und Entspannung entscheidend, in dem das Modell – wie hier Nadja Auermann – sich selbst zu vergessen scheint.

¬ One of the world's most famous fashion photographers, PATRICK DEMARCHELIER brings out the personality and beauty of a woman through exquisite photoshootings with masterful lighting. For his style of conservative, almost secretive, elegance, it is the moment between concentration and relaxation that is decisive. As shown by the image of Nadja Auermann, it is in this precise instant that the model almost appears to forget herself.

¬ Dans ses photoshootings remarquables et ses mises en lumières parfaites, PATRICK DEMARCHELIER, l'un des photographes de mode les plus célèbres au monde, parvient à faire rayonner la personnalité et la beauté d'une femme. Pour son style tout en élégance à la fois mystérieuse et distante, c'est le moment entre concentration et détente qui est pour lui décisif: un moment où le modèle, à l'instar de Nadja Auermann, semble totalement s'oublier.

Ballerina / 104 x 84 cm / Ltd Edition 150 / No. TRN115

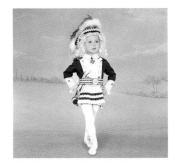

ACHIM LIPPOTH / TRUNK ARCHIVE

¬ ACHIM LIPPOTH bezeichnet seine Projekte als „inszenierte Reportagefotografie". Im Mittelpunkt seiner Arbeit steht das Thema Kindheit. So entstehen Bildreihen und Geschichten, die uns einerseits kindliches Verhalten, andererseits aber auch spontane Äußerungen aufzeigen. Seine international bekannten Arbeiten, werden von den renommierten Galerien Edelman und Yosi Milo Gallery vertreten.

¬ ACHIM LIPPOTH describes his projects as "staged photo-journalism". The central theme of his works is childhood: The result is images that, on the one hand, display quite deliberate childish behaviour yet, on the other, capture actions that are spontaneous and unplanned. LIPPOTH's works have gained international recognition and have been displayed in the famous Edelman and Yosi Milo galleries.

¬ ACHIM LIPPOTH décrit ses projets comme des « reportages photographiques scéniques ». L'enfance est au coeur de son travail. Il en résulte des séries qui, d'un côté, nous devoilent un comportement enfantin tout tracé et, d'un autre, des expressions spontanées. Ses travaux, réputés sur la scène internationale, sont exposés dans deux galeries de renom que sont les galeries Edelman et Yosi Milo.

Boy Soldier / Girl Cadet / Girl Soldier / 120 x 96 cm
Ltd Edition 150 / No. TRN79, No. TRN81, No. TRN83

MIKI TAKAHASHI

¬ Die Serie *Inside* zeigt eine Reihe von Selbstportraits der japanischen Fotografin und Filmemacherin MIKI TAKAHASHI. Der zarte Umriss ihres Profils im milchigen Schimmer eines Fensters gibt Stadtlandschaften und Straßenszenen von Tokio frei. Als vielschichtige Projektionsflächen von Gefühlen und Stimmungen leben ihre melancholischen Bilder vom Spannungsfeld zwischen Innen und Außen, Ruhe und Bewegung, Hell und Dunkel.

¬ The series *Inside* shows a collection of self portraits by Japanese photographer and filmmaker MIKI TAKAHASHI. The gentle contours of her profile, set against the milky shimmer of a window, set free cityscapes and street scenes of Tokyo. As multi-layered projection surfaces for feelings and moods, her melancholy images feed on the tension between inside and outside, stillness and movement, darkness and light.

¬ La série *Inside* présente une série d'autoportraits réalisées par la photographe et metteuse en scène MIKI TAKAHASHI. Le contour délicat de son profil dans le reflet opal d'une fenêtre dévoile des paysages urbains et des scènes de rue de Tokyo. En tant que surfaces de projections complexes de sentiments et d'atmosphères, ses travaux mélancoliques vivent de la tension entre intérieur et extérieur, calme et mouvement, lumière et obscurité.

Warm Rain / 70 x 93 cm / Ltd Edition 150 / No. MTA03

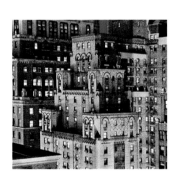

CHRISTOPHER WOODCOCK

¬ Die Aufnahmen von CHRISTOPHER WOODCOCK wirken so vielschichtig, dass man geneigt ist, sie für raffinierte Fotomontagen zu halten. Mit seiner Großbildkamera hält er in eindrucksvollen Kompositionen und aus außergewöhnlichen Perspektiven die verdichteten Räume von Amerikas Metropolen fest. Lange Belichtungszeiten bei Nacht erzielen dabei die intensive Farbigkeit und die leuchtende Brillanz seiner Aufnahmen.

¬ CHRISTOPHER WOODCOCK's photographs appear so complex that one is almost tempted to see them as refined photo montages. With his large format camera, he captures the spatial structures of America's metropolises in powerful compositions, and from extraordinary perspectives. Shot at night with long exposure times, the images display intense colours and luminous brilliance.

¬ Les prises de vues de CHRISTOPHER WOODCOCK font l'effet de compositions tellement impressionnantes que l'on pourrait les prendre pour des photomontages habilement réalisés. A l'aide de son appareil photo grand format, il fixe dans ses compositions impressionnantes aux perspectives originales les structures spatiales des métropoles américaines. Les temps de pose prolongés de nuit permettent d'atteindre la couleur intense et la brillance éclatante de ses images.

7th Avenue & 30th Street, New York / 130 x 104 cm
Ltd Edition 100 / No. CWD03

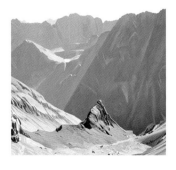

NINO MALFATTI

¬ Im Wechselspiel von Licht und Schatten lösen sich die Felslandschaften NINO MALFATTIS aus ihrer Gegenständlichkeit und werden abstrakt. Der Tiroler, dessen Werk auf der *Documenta* 6 vertreten war, hat diese Gipfel alle selbst erklommen. In seinen Bildern überträgt sich der Blick des Bergsteigers auf den Betrachter, der sich direkt in diese dramatischen Landschaften hineinversetzt fühlt.

¬ Through the interplay of light and shadow, NINO MALFATTI's rocky landscapes are detached from their materiality and become abstract. The Tirolean artist, whose work was exhibited at *Documenta* 6, climbed each of the mountains himself. In his images, the climber's perspective is transferred to the viewers, who feel they have been placed directly into the centre of this dramatic landscape.

¬ A travers l'alternance de la lumière et de l'obscurité les paysages de roches de NINO MALFATTI se détachent de leur signification concrète pour devenir abstrait. Cet artiste originaire du Tyrol et dont l'oeuvre était exposée lors de l'exposition *Documenta* 6 a gravi en personne tous ces sommets. Dans ses travaux, le regard de l'alpiniste se transmet au spectateur qui se sent littéralement transporté dans ces paysages dramatiques.

Mountain with a nose / 90 x 142 cm / Ltd Edition 100
No. NMA02

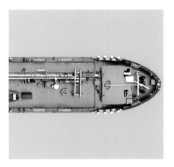

DIRK BRÖMMEL

¬ Mit dem digitalen Foto lässt sich nichts mehr glaubhaft dokumentieren. Deshalb montiert DIRK BRÖMMEL in dem Projekt *kopfüber* Schiffe aus vielen Einzelbildern zu einem fast schon grafischen Konstrukt vor monochromem Hintergrund. Er verortet seine Arbeit an der Grenze zwischen Realität und Fiktion, testet dabei die Glaubwürdigkeit seines Mediums und die Skepsis seiner Betrachter.

¬ Digital photography has caused us to doubt the documentation of anything. In his project *kopfüber (Overhead)*, DIRK BRÖMMEL has created images of ships from multiple different pictures in an almost graphical construct. These are then set on unusual, unrealistic, monochrome backgrounds. BRÖMMEL deliberately situates his work on the boundary of two different genres – reality and fiction – to test our belief in his medium and play with our scepticism.

¬ Avec la photo numérique, plus rien ne se laisse documenter de manière crédible. C'est la raison pour laquelle, dans son projet *kopfüber*, DIRK BRÖMMEL assemble ses bâteaux à partir de multiples images en une construction presque graphique, devant l'arrière-plan monochrome. Il définit ses travaux à la limite de ces deux perspectives que sont la réalité et la fiction. Il questionne en même temps la crédibilité de son média et le scepticisme du spectateur.

Schiff #9 / 50 x 200cm / Ltd Edition 250 / No. DBR09

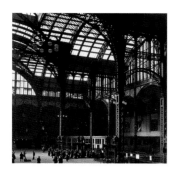

BERENICE ABBOTT

¬ Fasziniert von der Architektur und der Atmosphäre New Yorks, verstand es BERENICE ABBOTT, den Wandel dieser Metropole an der Schwelle zur Moderne festzuhalten. Von 1935 bis 1939 widmete sie sich dem wichtigen und ehrgeizigen Projekt, die Veränderung der Stadt während der Großen Depression zu dokumentieren. Unter dem Titel *Changing New York* entstanden über 300 historisch bedeutende Schwarz-Weiß-Aufnahmen.

¬ Fascinated by the architecture and atmosphere of New York, BERENICE ABBOTT, set out to capture the transformation of this metropolis on the cusp of modernity. From 1935 to 1939 she devoted herself to the ground-breaking project, to document the development of the city during the Great Depression. More than 300 historically significant black and white shots were eventually published under the title *Changing New York*.

¬ Fascinée par l'architecture et l'atmosphère de New York, BERENICE ABBOTT, a su immortaliser le passage de la métropole américaine au seuil de l'ère moderne. De 1935 à 1939, elle se consacra a un projet majeur et ambitieux qui devait témoigner de la transformation de la ville pendant la Grande Dépression. Sous le titre *Changing New York*, ce sont plus de 300 clichés en noir et blanc d'importance historique qui virent le jour.

Penn Station, Manhattan / 64 x 52 cm / Ltd Edition 150
No. BAO10

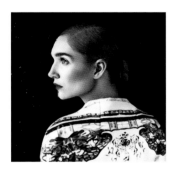

ERIK MADIGAN HECK / TRUNK ARCHIVE

¬ Die extravaganten Entwürfe von Designern wie Kenzo und Mary Karantzou werden von ERIK MADIGAN HECK auf außergewöhnliche Weise umgesetzt. Souverän folgt der amerikanische Fotograf in seinen betont illustrativen Arrangements den Spuren französischer Fauvisten wie Matisse. Er kombiniert Dekor und Fläche und gestaltet sogar die malerischen Hintergründe seiner Bilder selbst.

¬ ERIK MADIGAN HECK brings to life the extravagant plans of designers such as Kenzo and Mary Karantzou with flamboyance and artistic creativity. The American photographer's powerful illustrative arrangements boldly pursue the track previously forged by French Fauves such as Matisse. HECK combines decoration with surface and even paints the picturesque backgrounds of the images himself.

¬ ERIK MADIGAN HECK transforme de manière remarquable les croquis extravagants de designers comme Kenzo et Mary Karantzou en de véritables oeuvres d'art. Le photographe américain suit à la perfection dans ses arrangements ostensiblement évocateurs les traces des fauvistes français comme Matisse. Il associe décor et surface et crée en personne les arrière-plans pittoresques de ses travaux.

Untitled Portrait / 120 x 80 cm / Ltd Edition 150
No. TRN25

MATTHIAS HEIDERICH

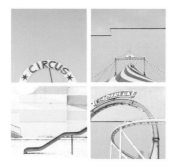

¬ In der Serie *Colouring Berlin* zeigt der Fotograf MATTHIAS HEIDERICH Ausschnitte urbaner Architektur aus der Stadtlandschaft Berlins. Das können strenge Gebäudekonturen, aber auch spielerische Elemente wie eine Achterbahn oder ein Zirkusdach sein. Im Vordergrund seiner Arbeit sieht HEIDERICH vor allem die Ästhetik der Formen und Farben innerhalb einer strengen Komposition, die alles Überflüssige vermeidet.

¬ In his series *Colouring Berlin* photographer MATTHIAS HEIDERICH presents elements of the city's urban architecture. This might be the rigid contours of a building, or more playful elements such as a roller coaster or circustent. Foremost in HEIDERICH's works is the aesthetic of form and colour, which is set within a strict composition that avoids anything superfluous.

¬ Dans sa série *Colouring Berlin* le photographe MATTHIAS HEIDERICH divulgue des extraits d'architecture urbaine de la ville de Berlin. Ce sont des profils tranchants d'immeubles, mais aussi des éléments créatifs comme un grand huit ou un chapiteau de cirque. Au premier plan de ses travaux HEIDERICH place surtout l'esthétique des formes et des couleurs au centre d'une composition rigoureuse qui évite les superflus.

Untitled II / (4x) 55 x 55 cm / Ltd Edition 100 / No. MHD02

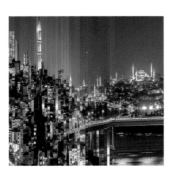

MURAT GERMEN

¬ Der Künstler MURAT GERMEN misstraut der klassischen Fotografie als Medium der Abbildung von Wirklichkeit. In seinen zweigeteilten Städtebildern thematisiert er die bauliche Dichte und Vielfalt der Metropolen dieser Welt. Durch die Montage von 60 Längsstreifen, die er einem ganzen Foto gegenübersetzt, möchte er das vertraute Stadtbild aufbrechen und so neue Wahrnehmungsmuster schaffen.

¬ The artist MURAT GERMEN does not trust traditional photography as a medium for the depiction of reality. Through the divided cityscapes he searches for the architectural poetry and diversity of the metropolises of the world. By creating a montage of 60 strips, juxtaposed against a whole image, he seeks to deconstruct the cityscapes we recognise and to generate new templates for our perception.

¬ L'artiste MURAT GERMEN se méfie de la photographie classique en tant que moyen de représentation de la réalité. Présentant des images de villes en deux parties, il est sur la piste de la densité architecturale et de la diversité des métropoles de ce monde. Par le montage de 60 rayures verticales qu'il surperpose à la photographie, il cherche à briser à créer ainsi de nouvelles possibilités de perception.

Istanbul, Eyup I / 100 x 167 cm / Ltd Edition 100
No. MGR03

GERHARD MANTZ

¬ In den virtuellen, digital entwickelten Landschaften des Künstlers GERHARD MANTZ geht es nicht um eine möglichst genaue Abbildung der Natur. Seine utopischen Idyllen entfalten in ihrer Schönheit eine Magie, der sich der Betrachter nicht entziehen kann, haben jedoch auch etwas Unerreichbares. Der Künstler, fasziniert von den Möglichkeiten digitaler Gestaltung, spielt mit unserem räumlichen Vorstellungsvermögen und setzt bewusst auf Irritationen.

¬ The virtual, digitally created landscapes of artist GERHARD MANTZ are not an attempt to reproduce nature as accurately as possible. Through their beauty, his utopian idylls display a certain magic from which the viewer cannot pull away, and yet they remain somehow untouchable. Fascinated by the possibilities of digital image creation, the artist plays with our spatial preconceptions, deliberately provoking them.

¬ Les paysages numériques virtuels de l'artiste GERHARD MANTZ n'ont pas pour objectif de représenter la nature de manière la plus précise possible. Ses idylles utopiques dévoilent, à travers leurs beautés, une magie qui ne peut échapper au spectateur, même si elles ont aussi en elles quelque chose d'inaccessible. L'artiste, fasciné par les possibilités qu'offre la création numérique, joue avec notre représentation de l'espace et crée délibérément des irritations.

Päpstliche Vernunft / 80 x 128 cm / Ltd Edition 100
No. GMA31

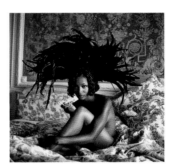

MICHEL COMTE

¬ Der berühmte Schweizer Fotograf porträtierte 25 Jahre lang die schönsten Frauen der Welt für seine eindrucksvollen Mode- und Gesellschaftsaufnahmen. Seine Bilder prägten eine ganz eigene Bildästhetik und zeugen von der großen Einfühlsamkeit, mit der er seinem Gegenüber begegnet. In der Serie *Intimacies* gelingt es ihm erneut, die Persönlichkeit dieser großartigen Models freizulegen.

¬ The famous Swiss photographer has portrayed over the last 25 years the world's most beautiful women for his impressive fashion and society shots. His images are characterised by a distinctive aesthetic and bear witness to the considerable sensitivity with which he approaches his subjects. In the series *Intimacies* MICHEL COMTE is once again able to reveal the personalities inside these great models.

¬ Le célèbre photographe suisse a portraitisé pendant plus de 25 ans les plus belles femmes du monde dans ses impressionnantes photographies de mode et de société. Ses clichés ont influencé toute une esthétique de l'image et témoignent de la grande sensibilité avec laquelle il aborde son prochain. Dans la série *Intimacies*, MICHEL COMTE parvient à nouveau à mettre en avant la personnalité de ces magnifiques modèles.

Naomi Campbell / 100 x 100 cm / Ltd Edition 150
No. MCO33

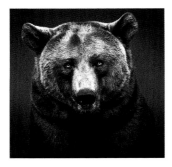

ALEXANDER VON REISWITZ

¬ Die Serie *Animal Stars* ist die Fortführung der außergewöhnlichen Tierportraits, die ALEXANDER VON REISWITZ mit seinen *Zoogestalten* begonnen hat. Ohne Teleobjektiv und lediglich vor einem Papierhintergrund entstehen in einem intensiven Arbeitsprozess diese eindringlichen Schwarz-Weiß-Aufnahmen tierischer Persönlichkeiten, die wie die wirklichen „Stars" der Leinwand, beim Betrachter Ehrfurcht und Bewunderung auslösen.

¬ The series *Animal Stars* is the continuation of the extraordinary animal portraits that ALEXANDER VON REISWITZ had begun with his earlier series *Zoogestalten*. Produced on a simple paper backing, without the use of a telephoto lens, and through an elaborate process, these striking black and white shots allow the personalities of the animals to emerge. Just like the stars of the big screen, they generate in the observer feelings of awe and admiration.

¬ La série *Animal Stars* est la continuation des portraits d'animaux hors-du-commun que le photographe ALEXANDER VON REISWITZ a commencé avec *Zoogestalten*. Sans téléobjectif mais placées tout simplement devant un arrière-plan en papier, les prises de vues en noir et blanc insistantes de ces personnalités animales prennent vie dans un processus intensif de travail. A l'instar des vraies « stars » de la toile elles déclenchent chez le spectateur respect et émerveillement.

Nora / 120 x 120 cm / Ltd Edition 100 / No. ARE41

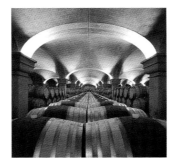

RAFAEL NEFF

¬ In vielen seiner Fotos verneigt sich der Fotograf RAFAEL NEFF vor der Vielfalt unseres handwerklichen und architektonischen Kulturerbes. Jetzt ist er in die Gewölbe der berühmtesten Weingüter der Welt gestiegen, wie zum Beispiel das Marcesi Antinori in Italien oder das Château Cos d'Estournel in Frankreich. Mit diesen Bildern gelingt es ihm erneut, uns den Wert, die Geschichte und die Schönheit dieser Kultur des Genusses nahezubringen.

¬ The images of RAFAEL NEFF are often exaltations to the diversity of our handmade and architectural treasures. Now he has stepped down into the vaults of the world's most famous vineyards, such as the Marcesi Antinori in Italy, or the Château Cos d'Estournel in France. Through these images we can almost taste the value, the history, and the beauty of this refined culture.

¬ Dans nombre de ses clichés, le photographe RAFAEL NEFF s'incline devant la diversité de notre patrimoine culturel artisanal et architectural. A présent, il s'intéresse aux caves voûtées des plus célèbres domaines viticoles du monde comme par exemple le domaine de Marcesi Antinori en Italie ou celui du Château Cos d'Estournel en France. A travers ces photographies, il réussit à nouveau à nous faire découvrir la valeur, l'histoire et la beauté de cette culture du plaisir.

Marcesi Antinori, Tuscany, Italy / 120 x 173 cm
Ltd Edition 100 / No. RNE264

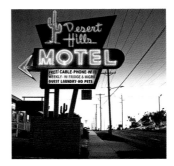

SHANNON RICHARDSON

¬ Die Route 66 von Chicago nach Los Angeles ist in Amerika ein Symbol für den Weg nach Westen. SHANNON RICHARDSON war als Kind in den 1970er Jahren oft mit seinen Eltern auf diesem Highway unterwegs. Mit sicherem Gespür für die Vergänglichkeit der Motels, Diners und Tankstellen an der Route 66 hielt er diese Orte in eindrucksvollen Schwarz-Weiß-Bildern fest.

¬ Route 66, which runs from Chicago to Los Angeles, is an American symbol for the journey West. Back in the 1970s, when he was just a child, SHANNON RICHARDSON frequently travelled along this highway with his parents. As a photographer he returned to capture the motels, diners, and petrol stations along this iconic road in a series of impressive black and white photographs.

¬ La route 66 qui relie Chicago à Los Angeles est aux Etats-Unis un symbole de la ruée vers l'Ouest. Enfant, dans les années 1970, SHANNON RICHARDSON, a souvent sillonné cette autoroute avec ses parents. Avec une inclination certaine pour le caractère éphémère des motels, des diners et des stations-service de la route 66, il a immortalisé ces endroits en des photographies en noir et blanc impressionnantes.

Blue Swallow Motel / Desert Hills Motel / Western Motel
Wigwam Motel / 120 x 120 cm / Ltd Edition 100
No. SRI07, No. SRI01, No. SRI11, No. SRI05

BEATRICE HUG

¬ Das Zusammenspiel der Farbflächen in den informellen Licht-Fotografien BEATRICE HUGS beeindruckt durch seinen Herstellungsprozess. Ausgangspunkt sind labyrinthische und lichtdurchlässige Farbspiele, die von ihr selbst als Stillleben konstruiert werden. Dieses selbstgeschaffene Objekt umkreist sie mit der Kamera, um das flirrende Licht in seinen Farbspektren mit kürzester Tiefenschärfe aufzunehmen.

¬ The interplay of the colours in the photographs of BEATRICE HUG impresses through its unique process of creation. The foundations are complex, overlapping, transparent colour games, created by herself as physical structures. HUG then circles about these self-made objects with her camera to capture the colour spectrums of these blurry lights with the shortest depth of field possible.

¬ L'interaction des surfaces polycolores dans les photographies de lumière informelles de BÉATRICE HUG impressionne de par son processus original de réalisation. Les jeux de couleurs labyrinthiques et translucides forment la base de ces travaux qui sont alors structurés par elle-même comme des natures mortes. Aidée de sa caméra elle fait le tour de l'objet réalisé pour recueillir dans profondeur de champs la plus courte possible la lumière vacillante qui se prend capturée dans le spectre optique.

Red Moai / 150 x 120 cm / Ltd Edition 100 / No. BHU37

GEEBIRD & BAMBY

¬ In der Serie *New World* stellt uns das Duo GEEBIRD & BAMBY eine Abfolge frei erfundener, idealer Gebäude vor, die die zeitlose Eleganz der Nachkriegsmoderne Amerikas aufgreifen. Diese utopischen Idealvorstellungen von Architektur kombinieren ausgesuchte Elemente der Kunst, Fotografie, Architektur und des Films des 20. Jahrhunderts. Ihre Vorbilder sind Julius Shulman, Alfred Hitchcock, Steven Shore und Ed Rusha.

¬ In their series *New World*, the duo GEEBIRD & BAMBY present a series of fictitious, idealistic buildings that draw on the timeless elegance of America's postwar modernity. These utopian architectural ideals combine selected elements of art, photography, architecture and cinema of the 20th Century. Their influences are Julius Shulman, Alfred Hitchcock, Steven Shore and Ed Rusha.

¬ Dans la série *New World*, le duo GEEBIRD & BAMBY nous présente une série de bâtiments idéaux inventés de toutes pièces qui ont pour thème l'élégance intemporelle de la période moderne de l'après-guerre des Etats-Unis. Ces idéaux architecturaux utopiques associent des éléments choisis de l'art, de la photographie, de l'architecture et du film du XXème siècle. Ses modèles sont Julius Shulman, Alfred Hitchcock, Steven Shore et Ed Rusha.

The Modern Gentleman / 100 x 167 cm / Ltd Edition 100
No. GBM01

FORMENTO & FORMENTO

¬ Für die Serie *Circumstance* inszenierte das Künstlerpaar RICHEILLE & BJ FORMENTO ihre Heroinen an Stätten flüchtiger Begegnung wie Diners, Motels oder Parkplätzen. Diese Orte haben schon bessere Zeiten gesehen und so erzählen die Bilder der glamourösen, perfekt in Szene gesetzten Frauen von Erwartung und Enttäuschung und der Melancholie des amerikanischen Traums.

¬ For their series *Circumstance* the artistic pair of RICHEILLE & BJ FORMENTO shot their heroines in settings of fleeting encounters – in diners, motels, and car parks. These locations have seen better days and the images of these glamorous, perfectly posed women tell stories of expectation and disappointment and of the melancholy of the American dream.

¬ Pour la série *Circumstance*, le couple d'artistes RICHEILLE & BJ FORMENTO a mis en scène leurs héroines dans des endroits synonymes de rencontres furtives comme les diners, motels et autres parkings. Ces endroits ont connu des jours meilleurs. C'est ainsi que ces images de femmes glamoureuses parfaitement mises en scène évoquent l'attente, la déception et la mélancholie du rêve américain.

Rachele II / 110 x 165 cm / Ltd Edition 150 / No. FFO16

REINHARD GÖRNER

¬ Die Architekturbilder von REINHARD GÖRNER zeigen in eindrucksvoller Perfektion die Räume des Neuen Museums von August Stüler. Das gleichmäßige Licht und die klare Symmetrie dieser Aufnahmen unterstreichen die klassischen Proportionen, die Ruhe und die Würde dieses Ortes auf der Berliner Museumsinsel. Diese wurde 1999 von der UNESCO als „einzigartiges Ensemble von Museumsbauten" zum Weltkulturerbe erklärt.

¬ The architectural pictures of REINHARD GÖRNER present the space of August Stüler's New Museum in breathtaking perfection. The uniform light and the clear symmetry of these shots emphasize the classic proportions, the calmness, and the grandeur of this building on Berlin's museum island. In 1999 UNESCO declared the area, a "unique ensemble of Museum structures", to be a world heritage site.

¬ Les photographies architecturales de REINHARD GÖRNER dévoilent dans une perfection impressionnante les pièces du Neues Museum de d'August Stüler. La lumière homogène et la symétrie précise de ces prises de vues soulignent les proportions classiques, le calme et la dignité de cet endroit situé sur l'île aux Musées de Berlin. En 1999, celle-ci a été inscrite par l'UNESCO sur la Liste du patrimoine mondial comme « ensemble unique en son genre de musées ».

*Neues Museum II/150 x 100 cm/Ltd Edition 150
No. RGO809*

ERIN CONE

¬ Die Werke von ERIN CONE leben von dem Wechselspiel zwischen Nähe und Distanz, fotorealistischen Details und grafisch-visueller Irritation, die die texanische Künstlerin ganz bewusst als Stilmittel einsetzt. Ihre ungewöhnlich angeschnittenen Portraits zeigen junge Frauen von mädchenhafter Anmut und schmuckloser Eleganz und fangen den Moment einer ganz bestimmten Körperhaltung oder beiläufigen Geste ein.

¬ Texas artist ERIN CONE uses the interplay between proximity and distance, between photo-realistic detail and graphic irritation, as stylistic devices on which her images thrive. The portraits of young women exuding feminine charm and natural elegance are unusually composed, and capture the moment of a deliberate posture of casual gesture.

¬ Les créations d'ERIN CONE se caractérisent par un jeu entre proximité et distance, détails photoréalistes et irritation graphico-visuelle, un jeu auquel l'artiste texane recours délibérément comme moyen stylistique. Ces portraits inhabituels représentent des jeunes femmes à la grâce espiègle et à l'élégance sobre et saisissent ce moment caractéristique d'une attitude toute à fait particulière ou d'un geste fortuit.

Charade/100 x 133 cm/Ltd Edition 150/No. ECO16

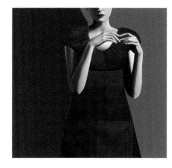

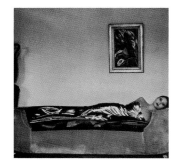

SHEILA METZNER / TRUNK ARCHIVE

¬ Als eine von wenigen Fotografen weltweit arbeitet SHEILA METZNER mit dem Fresson-Verfahren. Bei dieser Bildentwicklung werden die einzelnen Farbschichten aufgesplittert und mit echten Farbpartikeln auf speziellem Baumwollpapier gedruckt. Das Ergebnis sind weiche Übergänge zwischen Licht und Schatten, eine gewisse Großkörnigkeit und eine matte Oberfläche, die sie selbst an Porzellan erinnert.

¬ Only a handful of photographers across the world work with the Fresson process. SHEILA METZNER is one of them. During the development of the photos the individual colour layers are separated and are printed with real ink pigments on special cotton paper. The results are gentle transitions between light and shadow, a distinctive graininess, and a matte surface reminiscent of porcelain.

¬ SHEILA METZNER est l'une des rares photographes au monde à travailler avec le procédé Fresson. Pour le tirage des photographies, les couches de couleurs isolées sont divisées et imprimées avec de vraies particules de couleurs sur le papier de coton. Le résultat donne des transitions délicates entre la lumière et l'ombre, une certaine granulosité et une surface matte qui rappelle la porcelaine.

Art Deco/69 x 102 cm/Ltd Edition 150/No. TRN45

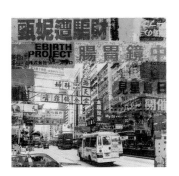

SANDRA RAUCH

¬ Nach ihrer Lehre als Schriftsetzerin studierte SANDRA RAUCH Kommunikationsdesign, Grafik und Malerei. Ihre Verdichtungen urbaner Welten wie New York oder Hong Kong bringt sie in mehreren Schichten auf Acrylglas und verwendet dabei verschiedene Techniken der Fotografie, der Typografie und des Siebdrucks. Auf diese Weise schafft sie neue Wahrnehmungsmuster und prägt ihren eigenen, unverwechselbaren Stil.

¬ After her training as a typesetter SANDRA RAUCH studied communication design, graphics, and painting. Her depiction of urban worlds such as New York or Hong Kong are set onto acrylic glass in multiple layers and employ different techniques from photography, typography, and serigraphy. This approach allows her to create new patterns for perception and distinguishes her unique, unmistakeable style.

¬ Après un formation de typographe, SANDRA RAUCH s'est tournée vers des études de graphisme et de peinture. Ses représentations scéniques de territoires urbains comme New York ou Hong Kong sont montées en plusieurs couches sur plexiglas qui utilise alors plusieurs techniques issues de la photographie, de la typographie et de sérigraphie. De cette manière elle invente de nouveaux modèles de perception tout en imprimant son style unique.

*Hong Kong Nathan road/120 x 120 cm/Ltd Edition 100
No. SRA34*

HIROSHI SATO

¬ Der japanische Künstler HIROSHI SATO möchte mit seinen symbolhaften Gemälden die unterschiedlichen Schichten unseres Bewußtseins offenlegen. Seine Gestaltungsprinzipien orientieren sich dabei an seinen Vorbildern Chuck Close, Jan Vermeer und Andrew Wyeth. Seine Bildfiguren bewegen sich in facettierten, optisch aufgebrochenen Interieurs in einem dynamischen Spannungsverhältnis zwischen Form und Fläche.

¬ Through his images of symbolic characters the japanese artist HIROSHI SATO seeks to reveal the different layers of our consciousness. His stylistic approach is oriented to his predecessors Chuck Close, Jan Vermeer, and Andrew Wyeth. The image subjects move through fragmented, optically disjointed interiors in a dynamic tension between form and surface.

¬ Les tableaux du jeune artiste japonais HIROSHI SATO se caractérisent par leur symbolique. A travers eux, SATO souhaite révéler au grand jour les différents niveaux de notre conscience. Pour leur création, il s'inspire de ses modèles Chuck Close, Jan Vermeer, et Andrew Wyeth. Les personnages de ses tableaux évoluent dans des intérieurs biseautés et visuellement fracturés dans une relation de tension dynamique entre la forme et la surface.

Stairway/100 x 85 cm/Ltd Edition 100/No. HSA02

HOLGER LIPPMANN

¬ Mit selbst programmierten digitalen Zeichentechniken konzentriert sich HOLGER LIPPMANN in seinen „computeraided-paintings" auf klassische Themen aus der Natur. Hier tritt der virtuelle Bildraum in einen fruchtbaren Dialog mit dem Gegenständlichen. In seiner Serie *Recursive Trees* verbinden sich filigrane Strukturen in einem ausgeklügelten Farbgeflecht zu einer Komposition von Leichtigkeit und Eleganz.

¬ The paintings of the artist HOLGER LIPPMANN follow classical themes of nature and are created using selfprogrammed digital painting techniques in a process he refers to as "computer-aided painting". The virtual image space engages in a fruitful dialogue with the image subjects. In his series *Recursive Trees*, delicate structures are combined in a complex colour network to form compositions of gentle grace and elegance.

¬ Avec ses techniques de dessin digitales programmées luimême, l'artiste HOLGER LIPPMANN se consacre dans ses « computer-aided-paintings » sans relâche aux thèmes classiques de la nature. L'espace virtuel de l'image entre ici dans un dialogue constructif avec le figuratif. Dans sa série *Recursive Trees*, les structures filigranes, dans un entrelac de couleurs ingénieux, se transforment en une composition marquée par la légèreté et l'élégance.

Tree V/(3x) 100 x 50 cm/Ltd Edition 100/No. HLI33

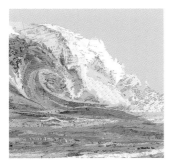

MATTHEW CUSICK

¬ Der Künstler MATTHEW CUSICK collagiert seine Bilder ausschließlich aus passgenau zugeschnittenen Kartenversatzstücken. Farbe, Form und Gestalt der so entstandenen Landschafts- und Wellenbilder erzeugen eine bildgewaltige Idee von der Welt als Mikro- und Makrokosmos. Die besondere Wirkung der Bilder entsteht im Auge des Betrachters, der zwischen räumlicher Perspektive und Landkartenaufsicht wechseln kann.

¬ The artist MATTHEW CUSICK creates his collages using deliberately cut segments taken from atlases and volumes of maps. The colour, form, and format of the landscapes and pictures of waves generate a stunning visual idea of the world as a crosscontinental micro- and macrocosm. The images have a particularly unique effect on the observer, whose perspective can change from art viewer to map reader.

¬ Les créations de MATTHEW CUSICK sont des collages réalisés exclusivement à partir de vieilles cartes géographiques tirées d'atlas et autres recueils cartographiques. Les couleurs, formes et styles qui émergent de ces paysages et de ces vagues génèrent une idée impressionnante du monde comme micro- et macrocosme. L'effet particulier de ces créations prend forme à travers l'oeil du spectateur qui peut se diversifier sa perception entre l'observation de la perspective spatiale et celle des cartes géographiques.

Mylan's Wave / 100 x 152 cm / Ltd Edition 100 / No. MCU11

JASON SCHMIDT / TRUNK ARCHIVE

¬ Mit seiner analogen Großbildkamera erreicht JASON SCHMIDT die große Tiefenschärfe seiner Bilder. Die Serie *Artists*, in der er zeitgenössische Künstler, wie Andreas Gursky, Bernd & Hilla Becher oder Jeff Koons in ihren Ateliers porträtierte, machte ihn international bekannt. In dieser Serie stehen die hell erleuchteten Fenster der Häuser als „Bild im Bild" für einen besonderen Moment.

¬ Photographer JASON SCHMIDT uses a large format, analogue camera to capture the profound depth of field in his images. He first came to international attention through his series *Artists*, where he portrayed contemporary artists such as Andreas Gursky, Bernd & Hilla Becher, and Jeff Koons in their own ateliers. In his current series, the brightly lit windows of buildings represent images within an image, capturing a unique moment.

¬ Avec son appareil photographique numérique à format large, JASON SCHMIDT atteint dans ses clichés une profondeur de champ importante. La série *Artists*, dans laquelle il a portraitisé dans leurs ateliers des artistes contemporains comme Andreas Gursky, Bernd & Hilla Becher ou Jeff Koons, l'a rendu célèbre sur la scène internationale. Dans cette série de tirages, les fenêtres brillamment éclairées des bâtiments, selon le principe de « l'image dans l'image », représentent un moment particulier.

Love Me Forever, Yves Saint Laurent Atelier / 120 x 95 cm Ltd Edition 150 / No. TRN77

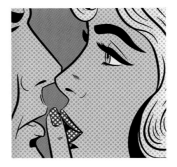

JOE MCDERMOTT

¬ In seiner Serie *Desire & Deceit* thematisiert JOE MCDERMOTT das emotionale Spektrum der Beziehungen zwischen Mann und Frau: Sehnsucht, Begehren, Geheimnis und Enttäuschung. Dabei orientiert er sich unverkennbar an den Pop-Art-Künstlern der 1950/1960er Jahre, besonders Roy Lichtenstein. Die grob gerasterten Punkte der Comics werden nun in seinen digital entstandenen Arbeiten neu interpretiert.

¬ In his series *Desire & Deceit* the artist JOE MCDERMOTT addresses the emotional spectrum of relationships between men and women: Longing, desire, secrecy, and disappointment. His work is unmistakeably oriented toward the pop artists of the 1950s and 1960s, in particular Roy Lichtenstein. The crude patterned dots in the comics, are reinterpreted in his digitally created compositions.

¬ Dans sa série *Desire & Deceit* JOE MCDERMOTT s'interesse à toute panoplie émotionelle des relations entre homme et femme: nostalgie, désir, secret et déception. A cet endroit, il s'inspire de manière frappante des artistes Pop-Art des années 1950 et 1960, notamment de Roy Lichtenstein. Les pointillés des bandes-dessinées réalisés de manière approximative, sont dans ses travaux digitaux interprétés de manière nouvelle.

The Secret (Diptychon) / 120 x 171 cm / Ltd Edition 100 No. JMD05

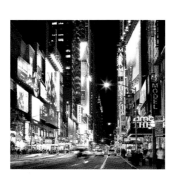

HORST & DANIEL ZIELSKE

¬ Nach den faszinierenden Serien *Megalopolis Shanghai* und *Berlin*, konzentrieren sich HORST & DANIEL ZIELSKE in ihrem neuen Projekt auf New York. In perfekten Kompositionen zeigen sie mit langen Belichtungszeiten die Metropole bei Nacht, wenn Leuchtreklamen, Streifen von Autoscheinwerfern oder schimmernde Bürotürme dem pulsierenden Leben eine ganz andere Dynamik verleihen.

¬ Following their fascinating series *Megalopolis Shanghai* and *Berlin*, HORST & DANIEL ZIELSKE's latest project concentrates on New York. Using perfect compositions, and long exposure times, they present the metropolis at nighttime. Neon signs, car headlights, and shimmering office towers give the pulsating life of the city a fresh and challenging dynamic.

¬ Après leurs fascinantes séries *Megalopolis Shanghai* et *Berlin*, HORST & DANIEL ZIELSKE se concentrent, dans leur nouveau projet, sur New York. Dans leurs parfaites compositions, ils devoilent au terme de temps d'exposition prolongés la métropole de nuit, lorsque les publicités lumineuses, les lumières des phares de voitures ou les tours de bureaux illuminées donnent une toute autre dynamique à cette vie trépidante.

42nd Street / 120 x 186 cm / Ltd Edition 100 / No. HDZ71

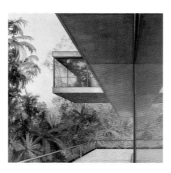

JENS HAUSMANN

¬ Die Bilder von JENS HAUSMANN sind Szenarien der künstlich idealisierter, teils am Reißbrett von Architekten wie Oscar Niemeyer entstandener Projekte für zukünftige Metropolen. Malerei trifft hier auf die klare Beobachtung von Architektur und hebt sich deutlich in ihrer realistischen Darstellung von Beton, breiten, spiegelnden Glasflächen und deren Ausblicken von der umgebenden Landschaft ab.

¬ The images of JENS HAUSMANN are scenes of artistically idealistic projects for future metropolises, conceived in part on the drawing boards of architects such as Oscar Niemeyer. Painting meets the clear examination of architecture. It transcends the genre through the realistic portrayal of materials such as concrete, and broad, reflective glass surfaces, with their views out onto the surrounding landscape.

¬ Les travaux de JENS HAUSMANN sont des scénarios pour futures métropoles issus de projets artificiellement idéalisés qui ont vu le jour en partie sur les planches à dessin d'architectes comme Oscar Niemeyer. La peinture rejoint ici l'observation précise de la architecture et se manifeste distinctement dans le paysage environnant de par ses représentations réalistes de matériaux comme le béton, les vastes surfaces réfléchissantes et leurs vues.

Psychology in the jungle / 120 x 96 cm / Ltd Edition 100 No. JHA01

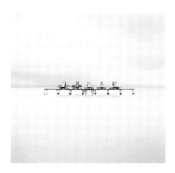

AKOS MAJOR

¬ Die hellen, gleichmäßig monochromen Bilder des ungarischen Fotografen AKOS MAJOR zeigen die Verlassenheit und Stille von Badeorten in der Nebensaison. Wie auf einer Bühne liegen die bunten ausgedienten Tretboote als einsame Zeugen sommerlichen Vergnügens auf einem Steg im Wasser. Umhüllt von lichtem Grau des Himmels und in vollkommener Symmetrie umgibt sie eine Atmosphäre sanfter Melancholie, die sich auf den Betrachter überträgt.

¬ The light, monochrome images of Hungarian photographer AKOS MAJOR represent the abandonment and calm of bathing resorts in the off season. The colourful yet worn pedal boats rest above the water on a frame, like a stage, lonely witnesses to the joys of summer. Surrounded by the light grey of the sky, and set in complete symmetry, they create an atmosphere of gentle melancholy that washes over the observer.

¬ Les travaux monochromes homogènes et purs du photographe hongrois AKOS MAJOR révèlent l'abandon et le calme des stations balnéaires en basse saison. Comme sur une scène, les pédalos multicolores et vétustes, posés sur un appontement au milieu de l'eau, sont les témoins solitaires d'un plaisir estival passé. Enveloppés dans le gris clairsemé du ciel et en parfaite symétrie, une atmosphère de douce mélancolie les embrasse qui se transmet aussi le spectateur.

Pedalboats / 110 x 165 cm / Ltd Edition 100 / No. AMJ01

JOSH VON STAUDACH

¬ Die Bildserie *Great Britain* des Stuttgarter Fotokünstlers JOSH VON STAUDACH widmet sich den vielfältigen Stimmungen und Übergängen zwischen Land, Wasser und Himmel. Ziel seiner farblich ausbalancierten Arbeiten ist es, gleichzeitig Nähe und Weite, Farben und Verläufe, Schleier und Reflektionen einzufangen. In ihrer Komplexität und meditativen Ruhe ziehen sie den Betrachter magisch an und fordern ihn zu neuen Sichtweisen heraus.

¬ The emotive picture series *Great Britain* by photographic artist JOSH VON STAUDACH focuses on the diverse moods and transitions between land, water, and sky. The goal of his colourfully balanced works is to simultaneously capture near and far, colour and progression, mists and reflections. With their complex and meditative calmness the images enchant the viewers, challenging them to consider new perspectives.

¬ La série d'images pénétrante *Great Britain* de l'artiste-photographe originaire de Stuttgart JOSH VON STAUDACH se consacre aux atmosphères et transitions multiples entre la terre, l'eau et le ciel. Le but de ces travaux aux couleurs harmonieuses est de capturer tout à la fois proximité et étendue, couleurs et tracés, voiles et reflets. Dans leur complexité et leur calme méditatif, elles attirent le spectateur par magie et le défie à de nouvelles manières de voir.

New Brighton / (3x) 96 x 64 cm / Ltd Edition 100 / No. JVS47

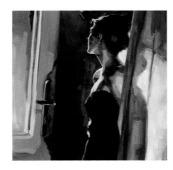

EDWARD B. GORDON

¬ Der Flaneur EDWARD B. GORDON ist ein passionierter Porträtist des modernen Alltags. Was andere mit der Fotokamera durch Drücken des Auslösers praktizieren, erreicht der Augenblicksfänger, der die Farben für seine Ölbilder selbst mischt, auf andere Weise: mit Pinsel und Auge, mal flüchtig und klein, mal ausführlich und in voller Leinwandstärke; immer auf der Suche nach dem besonderen Moment.

¬ The flaneur EDWARD B. GORDON passionately portrays modern everyday life. What others achieve through the opening and shutting of a lens, he captures in a different way: With a brush and the naked eye; at times fleeting and small, at times overwhelming and on a large canvas. The artist, who mixes the colours for his oil paintings himself, is always looking for that special moment.

¬ Le flaneur EDWARD B. GORDON est un portraitiste passionné de la vie quotidienne moderne. Ce que les autres pratiquent avec un appareil photographique en appuyant simplement sur le déclencheur, ce chasseur d'instants qui mélange lui-même ses couleurs pour ses compositions à l'huile, l'obtient d'une autre façon: avec le pinceau et les yeux, parfois de manière rapide et sommaire, parfois de manière plus détaillée et sur toute l'épaisseur de la toile. Il est constamment à la recherche de l'instant particulier.

Der Blick / 100 x 63 cm / Ltd Edition 100 / No. EBG02

JOERG MAXZIN

¬ Dem gelernten Bildhauer, JOERG MAXZIN, ist die Bedeutung von Licht und Schatten sehr bewusst, wenn er die Oberflächen der Figurinen bearbeitet, die ihm danach als Modelle für seine fotografischen Inszenierungen dienen. Diese während des Schaffensprozesses gemachte Erfahrung setzt er gezielt in seinen Aufnahmen um, deren Gestalten sich in den lichtdurchfluteten Räumen wie in einer Vorwärtsbewegung selbst zu generieren scheinen.

¬ Trained as a sculptor, JOERG MAXZIN is fully aware of the importance of light and shadow when shaping the surfaces of his figurines. These figurines also serve as the models for his photographic scenes. The experience MAXZIN acquires through creating his sculptures is deliberately employed in his photographic shots, whose figures appear in the light filled spaces as if about to propel themselves forward in movement.

¬ Ce sculpteur de formation est tout à fait conscient de la signification de la lumière et de l'obscurité lorsqu'il travaille les surfaces de ses figurines qui lui servent ensuite de modèles pour ses mises en scène photographiques. Cette expérience faite durant le processus de création d'une sculpture, il l'applique avec précision dans ses prises de vues dans lesquelles les silhouettes semblent se mouvoir vers l'avant dans des pièces bercées de lumières.

Zurich Quai VII / 25 x 100cm / Ltd Edition 100 / No. JMA77

PENELOPE DAVIS

¬ Alte Bücher bilden das Ausgangsmaterial für die leuchtenden Bilder der australischen Künstlerin PENELOPE DAVIS. Von ihnen erstellt sie Negativformen aus Silikon, die sie anschließend mit Kunstharz ausgießt, um so transparente Abdrücke der Bücher zu erhalten. Erst in der Dunkelkammer entstehen dann die faszinierenden Ergebnisse ihrer Transformation: durch farbige Gels, entsprechende Filter und die kameralose Bildgestaltung, dem Fotogramm.

¬ Old books are the raw material for the glowing images of Australian artist PENELOPE DAVIS. She uses them to create negative moulds of silicon, which she then fills with resin to produce transparent prints of the books. The fascinating result of this transformation first appears in the dark room: with the use of colourful gels, corresponding filters, and camerafree image creation – the photogram.

¬ De vieux livres constituent le matériel de base des tableaux aux couleurs vives de l'artiste australienne PENELOPE DAVIS. De ces derniers elle réalise des moules en silicone qu'elle remplit uniquement de résine synthétique pour obtenir ainsi des empreintes transparentes des livres. C'est dans la chambre noire que prennent alors vie les résultats fascinants de ses transformations: grâce à des gels colorés, des filtres adaptés et un photogramme.

Volume / 160 x 130 cm / Ltd Edition 100 / No. PDA28

MIKA NINAGAWA / TRUNK ARCHIVE

¬ MIKA NINAGAWA, geboren 1972, ist heute die bekannteste Fotografin Japans. Als Künstlerin wird sie von der Tomio Koyama Galerie vertreten, die auch schon den Künstler Takashi Murakami bekannt gemacht hat. In ihren Werken, die vielfach ausgestellt und in zahlreichen Sammlungen vertreten sind, zeigt sie bevorzugt Blumen und Landschaften, aber auch Goldfische, die in Japan als Glückssymbol gelten.

¬ Born in 1972, MIKA NINAGAWA is the most famous photographer in Japan today. As an artist she was represented by the Tomio Koyama gallery, which brought the artist Takashi Murakami to international attention. Her works have appeared in multiple exhibitions and countless collections. They focus on flowers and landscapes, as well as goldfish, a symbol of good luck in Japan.

¬ Née en 1972, MIKA NINAGAWA est aujourd'hui la photographe la plus célèbre du Japon. Artiste, elle est représentée par la galerie Tomio Koyama qui a déjà rendu célèbre Takashi Murakami. Dans ses travaux qui ont déjà été exposé à maintes reprises et qui figurent dans de nombreuses collections, elle privilégie les fleurs et les paysages mais aussi les poissons rouges qui sont, au Japon, considérés comme des porte-bonheurs.

Untitled, Liquid Dreams 1 / 90 x 136 cm / Ltd Edition 150 No. TRN135

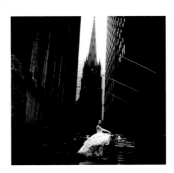

JERRY SCHATZBERG / TRUNK ARCHIVE

¬ Im New York der 1960er Jahre war JERRY SCHATZBERG, ein gefeierter Modefotograf, der in Magazinen wie Esquire und American Vogue veröffentlicht wurde. Er wollte seine Models möglichst natürlich fotografieren und erklärte: „Mein Studio ist die Straße." Damals begegnete er vielen Künstlern am Anfang ihrer Karriere, wie Andy Warhol oder Faye Dunaway, die er in legendären Fotos festhielt.

¬ JERRY SCHATZBERG was a renowned fashion photographer in the New York of the 1960s, his images appearing in magazines such as Esquire and American Vogue. He sought to portray his models as naturally as possible and once said "My studio is the street". At that time he was able to shoot many artists at the beginning of their careers, such as Andy Warhol or Faye Dunaway, preserving them in legendary photographs.

¬ Dans le New York des années 1960, JERRY SCHATZBERG, était un photographe de mode très populaire, qui fut publié dans des magazines comme Esquire et American Vogue. Il cherchait à photographier ses modèles le plus naturellement possible et racontait: « Mon studio, c'est la rue. » A cette époque, il rencontra de nombreux artistes au début de leur carrière comme Andy Warhol ou Faye Dunaway qu'il immortalisa dans ses photos légendaires.

Wall Street / 64 x 64 cm / Ltd Edition 150 / No. TRN04

OLAF MARTENS

¬ Der ostdeutsche Künstler OLAF MARTENS entwickelte während seines Fotografie-Studiums an der Hochschule für Grafik und Buchkunst in Leipzig 1985–92 eine eigene un-verwechselbare Bildsprache. Die Ästhetik seiner vielschich-tigen Bilder zeichnet sich durch ironisch aufgeladene Ge-gensätze und lustvolle Provokationen aus, deren raffinierte Brüche des vermeintlich Schönen den Betrachter irritieren.

¬ The East German artist OLAF MARTENS developed a unique, unmistakeable image style during his photography studies at the Academy of Visual Arts Leipzig from 1985–1992. The aesthetic of his multi-layered images is characterised by ironically charged contrasts and erotic provocation. Although they are supposed to be beautiful, the disjointed portrayal of his subjects causes a feeling of confusion amongst the viewers.

¬ Lors de ses études à l'école supérieure de graphisme et des arts du livre à Leipzig 1985–1992, OLAF MARTENS, originaire de l'Est de l'Allemagne, a développé un langage de l'image unique. L'esthétique de ses tableaux complexes se caractérise par des oppositions empreintes d'ironie et par des provocations sensuelles. Leurs ruptures recherchées de la prétendue beauté provoquent le spectateur.

Revuegirls, Borzoj, St.Petersburg, Music Hall/90 x 136 cm
Ltd Edition 150/No. OMA13

CHRISTOPHER PILLITZ

¬ Den Fotografen CHRISTOPHER PILLITZ führten seine Reisen in über 60 Länder. Dort hat er in den letzten Jahr-zehnten für Magazine die Schönheit und den Schrecken unserer Zeit festgehalten: den Lebenshunger in Brasilien, Rumänien nach dem Sturz der Diktatur. Seine Schwarz-Weiß-Serie *The Spirit of Tango* ist eine Hymne an seine Heimat Buenos Aires und das raffinierte Spiel der Gesten und Blicke zwischen Mann und Frau.

¬ The photographer CHRISTOPHER PILLITZ has travelled across more than 60 countries over the past decade, capturing the beauty and horror of our times: The lust for life in Brazil, life following the fall of the dictatorship in Romania. His black and white series *The Spirit of Tango* is an ode to his hometown Buenos Aires and the refined game of gestures and glances between men and women.

¬ Ses voyages ont emmené le photographe CHRISTOPHER PILLITZ dans plus de 60 pays. Là-bas, il a, ces dernières décennies, immortalisé pour des magazines la beauté et l'horreur de notre époque: la soif de vivre au Brésil, la chute de la dictature en Roumanie. Sa série en noir et blanc *The Spirit of Tango* est un hymne à sa terre natale Buenos Aires et au jeu délicat des gestes, des allusions et des regards entre l'homme et la femme.

The Spirit of Tango VIII/The Spirit of Tango VII
80 x 122 cm/Ltd Edition 100/No. CP127/No. CP125

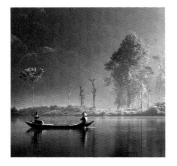

ANDRÉ ARMENT

¬ Im diffusen Licht der Morgendämmerung eröffnet sich dem Betrachter eine türkis schimmernde, in ihrer Schönheit nahezu unwirkliche Flusslandschaft. Wie eine leuchtende Blüte fällt der rote Sonnenschirm des Mädchens in dem sanft dahin gleitenden Boot sofort ins Auge. Dieses feucht-tro-pische Paradies, das in seinem Zauber sofort unsere Sehn-süchte und Träume weckt, liegt in Indonesien, der Heimat des Fotografen ANDRÉ ARMENT.

¬ In the diffuse light of dawn a shimmering turquoise riverscape appears before the viewer. It is almost too beautiful to be believed. Like a bright flower, the red para-sol of the lady in the gliding boat captures our attention immediately. The enchanted nature of this damp, tropical paradise stirs both our passions and our dreams. We are in Indonesia, home of photographer ANDRÉ ARMENT.

¬ Dans la lumière diffuse de l'aube, un paysage de rivières d'un bleu turquoise éblouissant à la beauté presque irrélle s'offre au spectateur. Comme une fleur étincelante, le para-sol rouge de la jeune fille assise dans la barque glissant tout en douceur sur l'eau accroche le regard. Ce paradis tropical et humide, dont le charme éveille immédiatement sentiments nostalgiques et rêves, se trouve en Indonésie, la terre natale du photographe ANDRÉ ARMENT.

Misty Morning/80 x 120 cm/Ltd Edition 150/No. AAR07

JAMES & KARLA MURRAY

¬ Seit den 1990er Jahren dokumentieren JAMES & KARLA MURRAY in einem engagierten Projekt die sogenannten „Mom and Pop Stores" in New York. Mit einer 35 mm Rollfilmkamera fotografierten sie diese bedrohten Läden. Dann fügten sie ihre Bilder zu einer Panorama-Ansicht zusammen und setzten auf diese Weise dem „Gesicht" der Stadt ein Denkmal.

¬ Since the 1990s JAMES & KARLA MURRAY have been undertaking an intensive project to document New York's so-called "mom and pop" stores. Using a 35 mm analogue camera they photographed these threatened shops. The images are then brought together in a seamless panorama, creating a monument of the "face" of the city.

¬ Depuis les années 1990, JAMES & KARLA MURRAY témoignent dans un projet engagé des soi-disants « Mom and Pop Stores » de New York. Avec un appareil photo à bobine de film de 35 mm ils photographient ces magasins menacés. Puis, ils assemblent leurs tirages en une vue panoramique libre et érigent de cette manière une oeuvre commémorative à la mémoire du « visage » de la ville.

New Utrecht Ave. at 72nd, Bensonhurst, BK/26 x 160 cm
No. JKM14; Bleecker St. b/t Leroy & Carmine, Greenwich
Village/17 x 240 cm/Ltd Edition 100/No. JKM03

ROBERT LEBECK

¬ Wie kaum ein anderer hat ROBERT LEBECK den Fotojour-nalismus in Deutschland beeinflusst. Als Bildreporter für den Stern verstand er es, politische Ereignisse zu Bildern zu verdichten, die sich dem kollektiven Gedächtnis einprägten. Seine Portraits, wie die von Romy Schneider, geben einen Einblick in seine „Werkstatt" und zeigen uns den Menschen hinter dem Prominenten.

¬ Few others have had such an influence on German photo journalism as ROBERT LEBECK. As a photographic reporter for German magazine Stern he displayed an instinct for capturing political events with images that shaped the national memory. LEBECK's portraits, such as those of Romy Schneider, offer us an insight into his "workshop" and reveal the people behind the celebrities.

¬ ROBERT LEBECK a influencé le photojournalisme en Alle-magne comme aucun autre avant lui. En tant que photo-graphe de presse pour le Stern, il a compris, comment capter des évènements politiques dans ses photographies qui, aujourd'hui, sont ancrées dans la mémoire collective. Ses portraits, comme ceux de Romy Schneider, nous font entrer dans son atelier et dévoilent l'individu qui se cache derrière la célébrité.

Romy Schneider, Kontaktbogen/120 x 160 cm
Ltd Edition 150/No. RLE50

NANCY LEE

¬ Das Raster fragmentierter Wirklichkeiten spielt in den Bildern der Künstlerin NANCY LEE, die Fotografie in Brasilien und Holland studierte, eine große Rolle. In den Linien und Strukturen ihrer fast grafisch zu nennenden Arbeiten zerfällt das Leben urbanen Alltags und wird zu einer Welt der Zeichen. Durch Zerschneiden und Neu-zusammensetzen entstehen Arbeiten mit einem anderen visuellen Rhythmus und einer neuen Ästhetik.

¬ The pattern of fragmented reality plays a key role in the images of artist NANCY LEE, who studied photography in Brazil and the Netherlands. Through the lines and structures of her almost graphical works our everyday life is deconstructed and turned into a world of signs. By cutting up and putting back together again, Lee produces works that have a unique visual rhythm and a new aesthetic.

¬ La trame des réalités fragmentées a une place impor-tante dans les travaux de l'artiste NANCY LEE qui étudia la photographie au Brésil et en Hollande. Dans les lignes et les structures de ces travaux presque graphiques, la vie quotidienne urbaine se désintègre pour devenir un monde de signes. A travers les découpages et les assemblages nouveaux, ce sont des travaux marqués par un autre rythme visuel et une esthétique nouvelle qui voient le jour.

Look Left Look Right/120 x 80 cm/Ltd Edition 100
No. NLE05

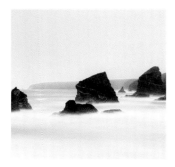

MAC OLLER

¬ Die großartigen, meerumtosten Felsformationen von Land's End in Cornwall bilden den westlichsten Punkt der englischen Küste. Diese zerklüftete Landschaft mit ihren Monolithen ist seit jeher vom dramatischen Zusammenspiel der Elemente gezeichnet. Mit seinen formal strengen Kompositionen versucht der polnische Fotograf MAC OLLER diesen einzigartigen Moment festzuhalten und die individuellen Grenzen der Wahrnehmung zu überschreiten.

¬ The large rock formations of Land's End in Cornwall, surrounded by the roaring sea, represent the western-most point of the English coast. This craggy landscape with its giant monoliths has long been shaped by dramatic meetings of the elements. Through strict, formal compositions Polish photographer MAC OLLER captures these unique moments and crosses the individual boundaries of perception.

¬ Les magnifiques formations de roches de Land's End en Cornouaille que la mer déchaînée vient furieusement frapper forment le point le plus à l'ouest de la côte anglaise. Depuis toujours, ce paysage lézardé est, avec ses monolithes, en proie au jeu dramatique des éléments. Avec ses compositions à la forme précise, le photographe polonais MAC OLLER tente d'immortaliser ce moment unique et de dépasser les frontières individuelles de la perception.

Bedruthan Steps / 120 x 160 cm / Ltd Edition 100 No. MOL15

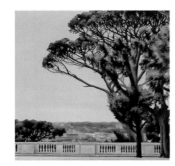

FRANZ BAUMGARTNER

¬ In den Bildern von FRANZ BAUMGARTNER scheint die Zeit still zu stehen. Die kühlen Grau-, Beige- und Grüntöne seiner Landschaften erinnern an Grisaille-Malerei. Italienische Sehnsuchtsorte, wie hier der Blick von der Villa Borghese auf die Stadt Rom, deren Silhouette mit den Hügeln zu verschwimmen scheint, werden zu Orten voll zeitloser Melancholie.

¬ In the images of FRANZ BAUMGARTNER time appears to stand still. The cool greys, beiges, and greens that form the colours of his landscapes are reminiscent of the Grisaille painters. Beautiful Italian scenes, such as the view here from the Villa Borghese to the city of Rome, whose silhouette appears to blur with the hilltops, become places of timeless melancholy.

¬ Dans les travaux du FRANZ BAUMGARTNER le temps semble s'être arrêté. Les couleurs de ses paysages qui se réduisent à des tons froids de gris, de beige et de vert rappellent la peinture grisaille. Les places italiennes empreintes de nostalgie, comme ici la vue de la Villa Borghese sur la ville de Rome dont la silhouette semble s'effacer avec les collines, se transforment en endroit d'une mélancolie éternelle.

Italian View / 85 x 123 cm / Ltd Edition 100 / No. FBA01

JENNY OKUN

¬ Das künstlerische Werk von JENNY OKUN zeichnet sich durch ihre meisterhaften, kubistisch anmutenden Interpretationen von Architektur aus. Diese verdichteten Bilder entstehen durch mehrere Perspektiven, die die Essenz von Formen, Linien und Leuchtreklamen herausarbeiten. Ihre Serien erscheinen uns in ihren Brüchen und Überschneidungen vertraut und fremd zugleich.

¬ The artistic works of JENNY OKUN, are recognisable through her masterful cubiststyle interpretation of architecture. These crowded images emerge through multiple perspectives that present an essence of forms, lines, and lights. The gaps and overlaps of her series seem both familiar and foreign to us.

¬ L'oeuvre artistique et variée de JENNY OKUN se caractérise essentiellement par ses interprétations admirables d'influence cubiste de l'architecture. Ses travaux comprimés prennent forme par le biais de plusieurs perspectives qui font ressortir l'essence des formes, des lignes et des publicités lumineuses. Ses séries qui nous semblent, dans leurs fractures et leurs chevauchements, tout à la fois familières et étrangères.

Las Vegas Man Tetraptych / (4x) 120 x 52 cm Ltd Edition 100 / No. JOK11

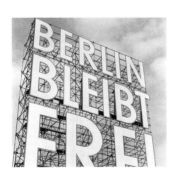

ERICH LESSING

¬ Als Sohn einer jüdischen Familie des Wiener Großbürgertums, musste ERICH LESSING 1939 nach Palästina fliehen. 1947 kehrte er nach Österreich zurück und dokumentierte als frühes Mitglied der Agentur Magnum die politischen Ereignisse der Nachkriegszeit, wie den Staatsvertrag Österreichs 1955 und den Aufstand in Ungarn 1956. Seine Reportagen und Portraits von Staatsmännern prägten sich dem kollektiven Gedächtnis ein.

¬ The son of a wealthy Jewish family in Vienna, ERICH LESSING was forced to flee Austria for Palestine in 1939. He returned in 1947 and, as a member of the Magnum photo agency, documented the political events of the post-war period, including the Austrian State Treaty of 1955 and the Hungarian Revolution of 1956. Lessing's reports and portrayal of public officials had a profound influence on the collective memory.

¬ Fils d'une famille juive de la haute bourgeoisie viennoise, ERICH LESSING a du, en 1939, quitter l'Autriche pour la Palestine. En 1947, il rentra et temoigna en tant que correspondant de l'agence Magnum des évènements politiques de l'après-guerre comme le Traité d'Etat autrichien de 1955 et le soulevement en Hongrie de 1956. Ses reportages et portraits d'hommes d'Etats ont marqué la mémoire collective.

Berlin bleibt frei / Geplatzte Gipfelkonferenz / 64 x 44 cm Ltd Edition 100 / No. ELS07, No. ELS17

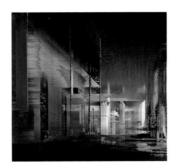

SABINE WILD

¬ Die großformatigen Bilder von SABINE WILD gleichen in ihrem pastosen Duktus und ihrer Haptik den Werken des abstrakten Expressionismus. Die Berliner Künstlerin arbeitet mit digitalen Gestaltungsmitteln wie ein Maler mit Pinsel und Farbe und dekonstruiert urbane Strukturen zu einer Komposition vertikaler und horizontaler Linien und Flächen.

¬ The large format images of SABINE WILD, with their pastose style and haptic effect, are reminiscent of the masterpieces of abstract expressionism. The Berlin artist works with digital techniques just as a painter works with a brush and colours. She uses them to disassemble urban structures into compositions of vertical and horizontal lines and surfaces.

¬ Les travaux grand format de SABINE WILD ressemblent dans leur tracé épais et leur consistance aux oeuvres d'art de l'expressionnisme abstrait. L'artiste berlinoise travaille avec le digital comme un peintre avec ses pinceaux et ses couleurs et déconstruit les structures urbaines en une composition de lignes verticales et horizontales, autrement dit en surfaces.

Shanghai Projections VII / 90 x 180 cm / Ltd Edition 100 No. SWI147

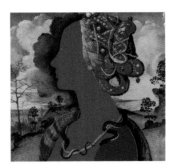

GAZI SANSOY

¬ In den Gemälden der Renaissance verweisen Kleidung und Hintergrund auf den Status des Porträtierten. Doch welche Sichtweisen eröffnen sich, wenn die individuellen Züge einer Persönlichkeit durch neonfarbene Flächen ersetzt werden? Der türkische Künstler GAZI SANZOY setzt in seinen ironischen Bildern natürliche und grelle Farben gegeneinander und hinterfragt, was die Persönlichkeit des Einzelnen ausmacht.

¬ In the paintings of the renaissance the clothes and the background of the image, reveal much to us about the status of the subject. How does our perspective change when the individual characteristics of a person are replaced by a neon-coloured surface? The artist GAZI SANZOY sets natural and garish colours against each other in his ironic images and, forces us to reflect on how we are influenced by the subject's personality.

¬ Dans les tableaux de la Renaissance, les habits et arrièreplans révèlent le statut de la personne portraitisée. Mais quelles perspectives font jour lorsque les traits individuels d'une personne sont gommés pour être remplacés par des surfaces de couleurs fluo? Dans ses travaux ironiques, l'artiste turc GAZI SANZOY fait se cotoyer couleurs naturelles et criardes et remet en question, ce qui fait la personnalité d'un individu.

Lucretia / 140 x 106 cm / Ltd Edition 100 / No. GZA01

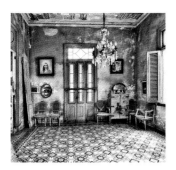

WERNER PAWLOK

¬ Der blätternde Putz und die blinden Spiegel in den Sälen der Häuser der Zuckeraristokratie Havannas erzählen vom Glanz vergangener Zeiten. In seiner berühmten Serie *Cuba Expired* inszenierte WERNER PAWLOK die Melancholie dieser untergegangenen Welt. 1953 in Stuttgart geboren, gründete er 1977 sein erstes Atelier und wurde besonders durch seine *Photography Paintings* und die Serie *Views* bekannt.

¬ The flaking plaster and dulled mirrors in the grand halls of the houses of Havanna's sugar aristocracy tell of past glory. In his famous *Cuba Expired* series, WERNER PAWLOK reveals the melancholy of this forgotten world. Born in Stuttgart in 1953, he opened his first atelier in 1977 and became known through his *Photography Paintings* and the series *Views*.

¬ Le crépi s'effeuillant et les miroirs voilés des salles des maisons de l'aristocratie havanaise du sucre parlent de la splendeur d'une époque passée. Dans sa célèbre série *Cuba Expired*, WERNER PAWLOK mit en scène la mélancolie de ce monde déclinant. Né en 1953 à Stuttgart, il s'installa en 1977 dans son premier atelier et fut surtout reconnu grâce à sa *Photography Paintings* et la série *Views*.

House of Fefa / 140 x 196 cm / Ltd Edition 150 / No. WPA50

MICHAEL PAPENDIECK

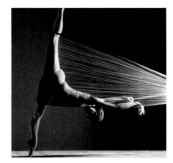

¬ In enger Zusammenarbeit mit der Braunschweiger Tanzszene inszeniert MICHAEL PAPENDIECK seine aufwendigen fotografischen Choreographien. In einem ausgeklügelten Spiel von Licht und Schatten gelingt es ihm, die Bewegungen der Tänzerinnen in einem Zustand höchster Anmut und Perfektion festzuhalten. Mit Leichtigkeit scheinen sie die Gesetze der Schwerkraft außer Kraft zu setzen und damit dem Betrachter einen Moment ungläubigen Staunens zu schenken.

¬ Artist MICHAEL PAPENDIECK staged his intricate photographic choreography in close cooperation with the Brunswick dance scene. Through a complex game of light and shadows he is able to capture the movements of the dances in poses of the utmost elegance and perfection. They appear to defy the laws of gravity with ease, presenting the viewer with a moment of sheer amazement.

¬ En étroite collaboration avec le milieu de la danse de Braunschweig, MICHAEL PAPENDIECK met en scène ses superbes choréographies photographiques. Par le jeu subtil de la lumière et de l'ombre, le photographe réussit à capter les mouvements des danseuses à leur plus haut niveau de grâce et de perfection. Toute en légèreté, elles semblent annuler les lois de la pesanteur et offrent au spectateur un moment unique d'émerveillement.

Body network 2 / 70 x 60 cm / Ltd Edition 100 / No. MPP02

PHILIP HABIB

¬ Seit 30 Jahren ist PHILIP HABIB für seine ungewöhnlichen Stillleben und Werbefotos bekannt. Mit seiner Serie *Wired* wurde er mit dem Lurzer's Archive „200 Best Ad Photographers 2012" ausgezeichnet. Strommasten und Hochspannungsleitungen durchschneiden mit ihren linearen Silhouetten monochrom leuchtende Hintergründe und werden so zu Methaphern des modernen Lebens.

¬ For over three decades PHILIP HABIB has been renowned for his remarkable still life shots and advertising photos. His series *Wired* lead him to be recognised as one of the Lurzer Archive's "200 Best Ad Photographers 2012". The linear silhouettes of the electricity poles and traffic lights in his images cut across monochrome illuminated backgrounds and become metaphors for modern life.

¬ PHILIP HABIB est réputé depuis 30 ans pour ses fascinantes natures mortes et ses photographies publicitaires. Pour sa série *Wired*, il a été récompensé par le magazine Lürzer's Archive par le prix « 200 Best Ad Photographers 2012 ». Des pylones électriques, électriques, des lignes à haute tension avec leur silhouettes linéaires et les intenses arrière-plans monochromes se transforment en métaphores de la vie moderne.

Wired-005 / Wired-008 / Wired-002 / Wired-009 / 120 x 160 cm Ltd Edition 100 / No. PHB09; No. PHB15; No. PHB03; No. PHB17

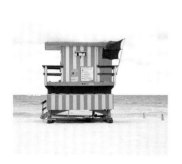

LÉO CAILLARD

¬ Der französische Fotograf LÉO CAILLARD konzentriert sich in seiner Serie *Miami Houses* ganz auf die Life-Guard-Türme des South Beach von Miami. Diese wurden nach dem verheerenden Wirbelsturm Andrew 1995 in Zusammenarbeit mit örtlichen Künstlern wieder neu aufgebaut und gestaltet. Vor der Ruhe des Meers und des bedeckten Himmels entfalten sich diese Häuser in ihrer strengen, seriellen Komposition wie grafische Chiffren.

¬ In his series *Miami Houses* French photographer LÉO CAILLARD focuses on the lifeguard huts of Miami's South Beach. Destroyed by the devastating Hurricane Andrew, the huts were rebuilt and repainted with the help of local artists in 1995. Set against a backdrop of calm seas and overcast skies, the strict, ordered compositions appear almost as a graphic code.

¬ Dans sa série *Miami Houses*, le photographe français LÉO CAILLARD se concentre sur les cabanes de plages de South Beach à Miami. Après le cyclone dévastateur Andrew de 1995, cellesci ont été reconstruits et réaménagées en coopération avec des artistes locaux. Devant le calme de la mer et du ciel couvert, les cabanes se déploient tels des chiffres graphiques en un arrangement séquentiel et appliqué.

House VII / 80 x 120 cm / Ltd Edition 100 / No. LCA07

MARINO PARISOTTO

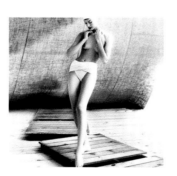

¬ Der italienische Fashion-Fotograf MARINO PARISOTTO, der mit seinen Modefotos und Werbekampagnen große Anerkennung erfuhr, feiert die Frau in all ihrer Schönheit, als ein dem irdischen Leben entrücktes Geschöpf. Sie ist eine selbstvergessene, in sich ruhende „Göttin", die in unseren Träumen lebt und uns an die Vergänglichkeit erinnert.

¬ Italian fashion photographer MARINO PARISOTTO, who achieved widespread recognition with his fashion and advertising campaigns, celebrates the woman in all her beauty, as a heavenly body raptured from life on earth. She is a goddess, oblivious to the world around her, at one with herself, living in our dreams and reminding us of the transience of life.

¬ Le photographe de mode italien MARINO PARISOTTO devenu célèbre pour ses photos de modes et ses campagnes publicitaires, célèbre la femme dans toute sa beauté, telle une créature détachée de la vie terrestre. Celleci est une déesse absente, plongée dans ses pensées qui existe à travers nos rêves et nous rappelle à notre caractère éphémère.

The small Goddess I / 100 x 75 cm / Ltd Edition 150 / No. MPS05

FARIN URLAUB

¬ In seinen Reisefotografien zeigt FARIN URLAUB, dass er Naturlandschaften und symbolische Kulturzeichen in lebendige Erzählungen zu übersetzen versteht. Egal ob in Japan, Afrika oder Australien – der Musiker und Fotograf erfasst Kulturstätten, Menschen und Landschaften meist assoziativ und gibt sie in gekonnten Bildkompositionen wieder, aus denen eine klare Formensprache spricht.

¬ In his travel photography FARIN URLAUB presents a detached perspective through which we can translate and understand natural landscapes and cultural symbols. Whether in Japan, Africa, or Australia – the musician and photographer captures unique cultural symbols, people, and landscapes in an associative style, yet gives them a clear image composition from which emerges a distinct form.

¬ Dans ses photographies de voyages, FARIN URLAUB dévoile une manière de voir libérée de tout présupposé qui parvient à traduire paysages naturels et symboles culturels en récits animés. Que ce soit au Japon, en Afrique ou en Australie, le musicien et photographe saisit souvent par association les lieux singuliers de civilisation, les hommes et le paysage, qu'il traduit alors dans des compositions d'images parfaitement réalisées desquelles s'échappe un langage fluide des formes.

Banyan Tree / 85 x 181 cm / Ltd Edition 100 / No. JVE70

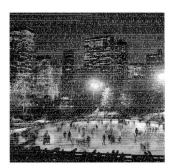

STEPHANIE LEMPERT

¬ Die Arbeiten von STEPHANIE LEMPERT entstehen aus einem Zusammenfügen von Bild, Gesprächsfragmenten und Schrift. Dabei interessiert sie das Verhältnis zwischen Geschichten, unserer Erinnerung und der Art und Weise, wie wir diese mit anderen teilen. Während ihrer Aufnahmen nimmt sie die Gesprächsfetzen des jeweiligen Ortes auf und legt diese als Schrift in digitaler Verarbeitung über ihre Fotografien.

¬ The works of STEPHANIE LEMPERT are produced by combining images with fragments of speech and text. She is particularly interested in the relationship between stories, memories, and the ways in which we share them with others. While taking her shots Lempert records scraps of conversation from the location and, through digital editing, lays them over her photographs as text.

¬ Les travaux de STEPHANIE LEMPERT voient le jour de par un assemblage d'images, de fragments de conversation et de pictogrammes. C'est notamment la relation entre les histoires, nos souvenirs et la manière dont nous les partageons avec d'autres qui l'intéresse. Lors de ses prises de vues, elle enregistre des fragments de conversation de l'endroit en question et intègre, par le biais du traitement numérique, ces derniers dans ces photographies sous formes de lettres.

Wollman Rink in Central Park / 90 x 135 cm Ltd Edition 150 / No. SLE01

CLESS

¬ Absichtslosigkeit und kalkulierter Zufall charakterisieren die Arbeiten von CLESS. Dieser benutzt für seine Bilder alte Zeitungen und Magazine. Seine Collagen haben etwas Selbstverständliches, Leichtes, sind aber das Ergebnis eines komplexen Prozesses des Suchens und Zusammenfügens. CLESS dokumentiert alle Schritte seiner gestalterischen Kreativität und bearbeitet seine Bilder auch digital.

¬ Accident and calculated chance play a significant role in the works of CLESS. His pieces are composed from old newspapers and magazines. The collages have a selfevident, uncomplicated quality, but are the result of a complex process of discovery and composition. CLESS documents each step of artistic creativity and uses digital techniques to edit his works.

¬ Improvisation et hasard programmé ont une place importante dans les travaux de CLESS. Pour ces travaux, ce dernier utilise de vieux journaux et des magazines récupérés. Ses collages ont quelque chose de naturel, de léger, mais sont en fait le résultat d'un processus complexe de recherche et d'assemblage. CLESS documente toutes les étapes de sa créativité féconde, retravaille ses travaux au numérique et a déjà été maintes fois exposé.

Thanks theatrering the theatre is theatrering / 100 x 70 cm Ltd Edition 100 / No. ECL11

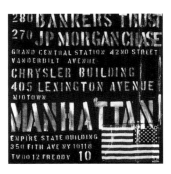

FREDDY REITZ

¬ Die Amerikanerin FREDDY REITZ möchte mit ihren Bildern in einen Dialog mit dem Betrachter treten. Sie bezeichnet ihr Kunstverständnis als „Correspondent Art". Im Spiel mit Schriften und Symbolen entstehen Collagen mit mehreren, sich überlagernden Farbschichten im Spannungsverhältnis zwischen ironischer Plakativität und Subversion.

¬ The American FREDDY REITZ uses her images, which focus on the USA and its politics, to enter into a dialogue with the viewer. The artist describes her approach as "Correspondent Art". By playing with words and symbols she produces collages of overlapping colour layers that represent the tension between ironic campaigning and subversion.

¬ L'Américaine FREDDY REITZ aimerait, avec ses travaux qui ont pour sujet les Etats-Unis et sa politique, entrer en communication avec le spectateur. Elle décrit sa compréhension de l'art comme « un art de la correspondance ». A travers le jeu des écritures et des symboles, ce sont des collages à couches super-posées de couleurs qui prennent forme et qui traduisent la relation de tension entre placativité ironique et subversion.

New York (Kennedy Material) I / New York (Kennedy Material) II / 120 x 96 cm / Ltd Edition 150 / No. FRE23 No. FRE25

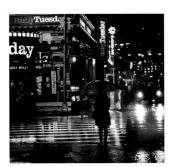

CHRISTOPHE JACROT

¬ Der französische Künstler CHRISTOPHE JACROT ist ein fotografischer Flaneur. Immer wieder taucht er in New York, Paris. London oder Hong Kong zum Fotografieren ab, allerdings nur bei Regen und Schnee. Seine Bilder verströmen eine melancholisch-romantische Aura, ohne je in Düsternis oder Tristesse zu verfallen; jede Metropole schimmert in ihrer eigenen, unverwechselbaren Stimmung.

¬ The French artist CHRISTOPHE JACROT is a photographic flaneur. He repeatedly appears in New York, Paris, London or Hong Kong to take pictures, but does so only in the rain or snow. His images transmit a melancholy, romantic aura, without wallowing in gloom or sadness. Each metropolis glimmers in its own unique atmosphere.

¬ L'artiste français CHRISTOPHE JACROT est un flâneur photographique. Encore et toujours, l'artiste s'échappe à New York, Paris, Londres ou Hong Kong pour réaliser ses photographies, cependant seulement par temps de pluie ou lorsqu'il neige. Ses clichés dégagent une atmosphère mélancolico-romantique sans jamais sombrer dans le vague à l'âme ou la tristesse. Dans leurs atmosphères individuelles, les métropoles brillent de tous leurs feux.

Ruby / 90x135cm / Ltd Edition 150 / No. CJA34

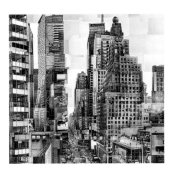

PEP VENTOSA

¬ Als Meister der Zerlegung und des Zusammenführens arbeitet PEP VENTOSA mit hundertfachen Überlagerungen ein und desselben Motivs. Diese gleichen einander wie frottierte Abdrücke und feinste Ziselierungen einer visuellen Klangpoetik, die ihr Motiv in Schwingungen versetzt. Man kann in ihnen durchaus seine zweite Berufung erkennen: Er ist nebenbei Schlagzeuger mit mehreren veröffentlichen Alben.

¬ PEP VENTOSA, is a master of deconstruction and reconstruction. His works are created by overlaying the same image onto itself hundreds of times. The result appears almost like a smudged canvas print, a finely chiselled poetry of sound, through which the image appears to vibrate. The images also reveal his second profession: He is a drummer who has released multiple albums.

¬ PEP VENTOSA est un maître du démontage et de l'assemblage. Ses travaux sont des centaines de superpositions d'un seul et unique motif. Comme des empreintes frottées et des fines ciselures reproduites sur un support d'image souple, ils ressemblent à une poétique sonore visuelle qui fait alors vibrer le motif. A travers eux, on peut d'ailleurs presque reconnaître sa deuxième vocation. Il est bassiste et a déjà sorti plusieurs albums.

Times Square / 120 x 80 cm / Ltd Edition 100 / No. PVE79

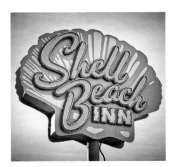

MARC SHUR

¬ Wie kaum ein anderes Medium spiegelt die Werbung den Geist einer Gesellschaft. Diese Leuchtreklamen von Motels, Diners und Tankstellen aus Kalifornien stammen aus den 1950er- und 1960er-Jahren; einer Zeit ungebrochener Wohlstandversprechen. MARC SHUR löst diese Zeugen des „American Way of Life" aus ihrem ursprünglichen Kontext und schickt sie als Chiffren zurück in unsere heutige Wahrnehmung.

¬ Few mediums can reflect the spirit of a society as advertising can. These signs from motels, diners, and petrol stations in California come from the 1950s and 1960s, a time that promised unbroken prosperity. MARC SHUR wrenches these witnesses to the "American Way of life" from their original contexts and sends them back to our current perception as graphic characters.

¬ Comme peu d'autres médias la publicité reflète l'esprit de la société. Ces panneaux et des motels, diners et stations-service de la Californie datent des années 1950 et 1960, une époque marquée par une promesse ininterrompue de bien-être. MARC SHUR libère ces témoins de l'« American Way of Life » de leur contexte original et les transpose en chiffres graphiques dans notre vision contemporaine.

Shell Beach Inn / 120 x 133 cm / Ltd Edition 100 No. MSH05

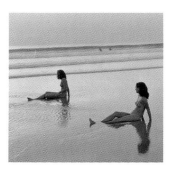

JOCK STURGES / TRUNK ARCHIVE

¬ Für JOCK STURGES muss ein Bild wahrhaftig sein. Über Jahrzehnte begleitete er die Kinder von Freunden und zeigte sie in allen Altersstufen. Im Schimmer des Lichts der französischen Atlantikküste fotografierte er die Schönheit und Freiheit des Menschen. Seine Arbeiten sind im Metropolitan Museum und Museum of Modern Art, New York vertreten.

¬ For JOCK STURGES an image must be authentic. Over a period of decades he accompanied the children of friends, portraying them at different stages of their development. In glow of light, on the French Atlantic Coast, he captured the beauty and freedom of humanity. His works have been exhibited throughout the world and have appeared at the Metropolitan Museum and the Museum of Modern Art, New York.

¬ Pour JOCK STURGES, une image doit être véridique. Sur plusieurs décennies, il a accompagné les enfants des amis et les a révélés dans toutes les étapes de leurs vies. Dans le reflet de la lumière sur la côte atlantique française, c'est la beauté et la liberté de l'homme qu'il a photographiées. Ses travaux et sont exposés à New York au Metropolitan Museum of Art ainsi qu'au Museum of Modern Art.

Allison, Lotte, Miranda, Maia and Vanessa; Montalivet, France, 2001/60 x 151 cm/Ltd Edition 150/No. TRN53

STEFAN SAALFELD

¬ Die Bilder von STEFAN SAALFELD kombinieren digitale Techniken mit malerischen Elementen. Dabei lässt er sich von bekannten und aktuellen Positionen der Kunstgeschichte inspirieren, um diese dann am Computer kreativ zu verwandeln, zu verfremden und zu komplexen Erzählungen zusammenzusetzen. In seinen vielschichtigen grellbunten Abstraktionen und Strukturen liegen bis zu 40 Ebenen übereinander.

¬ The images of STEFAN SAALFELD combine digital techniques with handpainted elements. He takes inspiration from established and contemporary positions in art history, which he transforms on the computer, abstracting and bringing them together in intricate image narratives. The image spaces of his multilayered, coloured abstractions contain up to 40 different overlapping surfaces.

¬ Les images de STEFAN SAALFELD allient les techniques digitales et les « éléments picturaux souples ». Il s'inspire des positions actuelles et célèbres de l'histoire de l'art pour alors transformer ces dernières, pour créer un effet de distanciation de manière créative à l'aide de l'ordinateur en les assemblant en des récits complexes d'images. Dans abstractions composées aux couleurs crues, ce sont jusqu'à 40 niveaux qui se superposent.

Rising/110 x 146 cm/Ltd Edition 150/No. SSA03

HARTWIG KLAPPERT

¬ *Waldinseln* und *Waldfahnen* heißen die Serien von HARTWIG KLAPPERT, der die Wälder Brandenburgs als gefrorene Landschaften fotografiert. Dabei konzentriert er sich ausschließlich auf den Himmel, die Waldkante und den verschneiten Vordergrund. Durch das winterliche Weiß werden seine strengen Kompositionen ganz auf ihre Form und das Licht reduziert und entfalten so ihre strenge Schönheit.

¬ *Waldinseln* and *Waldfahnen* are the names of series by HARTWIG KLAPPERT, who has for many years photographed the forests in Brandenburg as frozen landscapes. He concentrates on the pattern of sky, woodland edge, and snowcovered foreground. Through their winter white, the tone, surfaces, and structures of his formal compositions are reduced to form and light, revealing their severe beauty.

¬ *Waldinseln* et *Waldfahnen* s'appellent les séries du HARTWIG KLAPPERT qui photographie les forêts du Brandenburg comme des paysages gelés. Il se concentre notamment sur la variation du motif composé par le ciel, les bords de forêt et le premier plan enneigé. A travers le blanc hivernal, les tons, surfaces et structures de ses soigneuses compositions se réduisent alors à la forme et à la lumière et déploient ainsi leur beauté sévère.

Forest 2/110 x 160 cm/Ltd Edition 100/No. HKP04

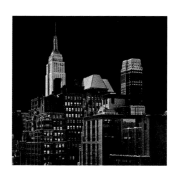

LUTZ HILGERS

¬ In der Serie *Darklight* von LUTZ HILGERS entdecken wir ein seltsam unwirkliches New York, das in der ganzen Vielfalt seiner Linien, Formen und Strukturen in dieser monochromen Dunkelheit zu schweben scheint. Es gibt keine Straßen; niemand ist zu sehen. Nur die Lichter des riesigen Häusermeers und das helle Empire-State-Building erzählen uns von den Bewohnern dieser Stadt.

¬ In the series *Darklight* by Düsseldorf photographer LUTZ HILGERS we discover a New York bathed in black, with a strangely surreal appearance. Through the diversity of its lines, forms, and structures the city appears to shimmer in this monochrome darkness. There are no streets, and not a person in sight. Only the lights from the vast sea of houses and the bright Empire State building in the background tell us the city is inhabited.

¬ Dans la série *Darklight* du photographe de Düsseldorf LUTZ HILGERS, c'est un New York étrangement irréel, plongé dans un noir profond que l'on découvre et qui, dans la multiplicité de ses lignes, formes et structures, semble planer dans une obscurité monochrome. Ni rues, ni passants: seules les lumières que forment l'énorme océan d'habitations et l'Empire State Building en arrièreplan nous parlent des habitants de cette ville.

Darklight V/150 x 100 cm/Ltd Edition 100/No. LHI09

TATIANA GORILOVSKY

¬ In ihrer Fotoserie *The Magical Light of China* führt uns TATIANA GORILOVSKY die in ihrer Schönheit fast schon unwirklichen Landschaften Süd-Chinas vor Augen. Die Farben und Umrisse der Hügel überlagern sich im diffusen Licht der Dämmerung. Ihre Formen und Strukturen spiegeln sich im Wasser des Flusses Li, das Licht bricht sich und macht diese Landschaft zu einer der schönsten der Welt.

¬ In her series *The Magical Light of China*, TATIANA GORILOVSKY reveals to us the beautiful, almost surreal landscapes of South China. The colours and contours of the hills cross over one another in the diffuse light of dawn. Their forms and structures are reflected in the water of the Li river, while the breaking light produces scenery that is amongst the world's most beautiful.

¬ Dans sa série de photographies *The Magical Light of China* TATIANA GORILOVSKY nous dévoile les paysages de la Chine du Sud qui, dans leur beauté, semblent presqu'irréels. Les couleurs et les contours des collines interfèrent dans la lumière diffuse du crépuscule. Leurs formes et leurs structures se reflètent dans l'eau du fleuve Li, la lumière se réfracte et fait de ce paysage l'un des plus beaux au monde.

Out of Time/80 x 80 cm/Ltd Edition 100/No. TGO03

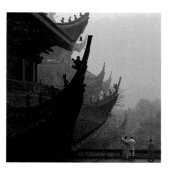

ZHANG WANG

¬ In *The Footprints of Buddha* dokumentiert der Fotograf und Buddhist ZHANG WANG das Leben und die religiösen Riten der Mönche in den Klöstern seiner Heimatregion Tiantai. Hier wurde in dem berühmten Guoqing-Tempel im 6. Jahrhundert die Tiantai-Schule gegründet. Noch heute kommen Schüler und Pilger aus ganz China hierher, um die Philosophie dieser buddhistischen Schule zu studieren.

¬ In *The Footprints of Buddha* photographer and Buddhist ZHANG WANG documents the lives and religious rituals of the monks in the cloisters and temples of his home region Tiantai. Here the Tiantai school was founded in the 6th Century, in the famous Guoqing Temple. School children and pilgrims from across China still travel here to study the philosophy of this Buddhist school.

¬ Dans *The Footprints of Buddha*, le photographe et bouddhiste ZHANG WANG rend compte de la vie et des rites religieux des moines dans les monastères de sa région natale Tiantai. C'est dans ce paysage que l'école de Tiantai fut fondée au 6ème siècle dans le célèbre temple Guoqing. Aujourd'hui encore, il attire élèves et pèlerins de toute la Chine qui viennent y étudier la philosophie de l'école bouddhiste.

Outside Paradise/100 x 100 cm/Ltd Edition 100 No. WZH01

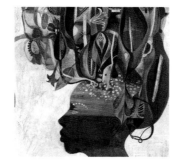

DIERK MAASS

¬ Für DIERK MAASS ist Fotografieren Zeichnen mit Licht. Als passionierter Bergsteiger erforscht er immer wieder abgelegene Welten von karger Schönheit. Die Laguna Colorada, ein Salzsee in den Anden auf 4200 Metern Höhe, ist die Heimat Tausender Flamingos. Bestimmte Algen bewirken die rötliche Färbung des Wassers, das sich durch Überbelichtung in eine abstrakte Fläche verwandelt.

¬ For DIERK MAASS photography is like drawing with light. As a passionate mountaineer he explores ever more remote regions of the world that possess a raw beauty. The Laguna Colorada, a salt lake in the Andes at an altitude of 4200 meters, is home to thousands of Flamingos. Certain types of algae produce the red hues of the water that, through overexposure, are transformed into a abstract surface.

¬ Pour DIERK MAASS photographier s'apparente à dessiner tout en lumière. Alpiniste passionné, il aime explorer les endroits reculés à la beauté sobre. La Laguna Colorada, lac salé des Andes à plus de 4200 mètres d'altitude, est le repère de milliers de flamands roses. Certains types d'algues contribuent à la coloration rouge de l'eau qui se transforme en raison de sa surexposition au soleil en une surface abstraite.

22° 14' 27.071" S 67° 44' 29.933" W/60 x 169 cm/Ltd Edition 150/No. DMS15

OLAF HAJEK

¬ Der zwischen Berlin, London und New York pendelnde OLAF HAJEK ist der Shootingstar unter den Illustratoren. Der fabulöse Geschichtenerzähler lädt den Betrachter mit dem Detailreichtum seiner Sujets zum Spurenlesen ein. Wie ein Magier verbindet er Farben und Formen, ornamentale Blüten und fauvistische Stile. Von anderen Kulturen inspiriert, treffen bei ihm ungewöhnliche Motive spannungsreich und gekonnt aufeinander.

¬ The shooting star of illustrators, OLAF HAJEK divides his time between Berlin, London, and New York. A remarkable storyteller, his detailed subjects invite viewers to follow their clues. Like a magician he intertwines colour with form; ornamental flowers with fauvist styles. Inspired by different cultures, the unusual patterns in his works interact with one another skillfully and excitingly.

¬ OLAF HAJEK, qui navigue entre Berlin, Londres et New York, est l'étoile montante des illustrateurs. Ce fabuleux conteur d'histoires invite le spectateur, par la richesse de ses sujets, à la recherche des signes. Tel un magicien, il associe les couleurs et les formes, les dessins décoratifs de fleurs et les styles fauvistes. S'inspirant d'autres cultures, ce sont des motifs inhabituels empreints de tension et parfaitement réalisés qui se rencontrent dans ses travaux.

Black Paradise/120 x 84 cm/Ltd Edition 150/No. OHA27

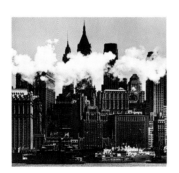

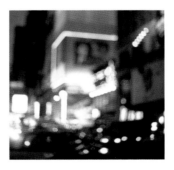

ANDREAS FEININGER

¬ 1906 in Paris geboren, zog der älteste Sohn des Malers Lionel Feininger 1939 nach New York und blieb dort für immer. Die Bildsprache der Fotografie bezeichnete er als die einzige Sprache, die überall in der Welt verstanden wird. Seine formvollendeten Abzüge, seine fototechnischen Erfindungen, seine lehrreichen Bücher und Reflexionen über Fotografie weisen ihn als modernes Genie aus.

¬ Born 1906 in Paris, the eldest son of the painter Lionel Feininger moved to New York in 1939, never to return. He considered the language of photography to be the only language understood around the world. His perfectly shaped prints, his photographically technical innovations, his instructive books, and his reflections on photography reveal his modern genius.

¬ Né à Paris en 1906, l'aîné des fils du peintre Lionel Feininger, Andreas Feininger, déménaga en 1939 à New York, ville qu'il ne quittera plus. Il considérait le langage de la photographie comme le seul langage à pouvoir être compris aux quatre coins du monde. Ses épreuves photographiques aux formes parfaites, ses inventions phototechniques et ses livres et réflexions particulièrement instructifs sur la photographie en font un véritable génie moderne.

Hudson River waterfront, New York/60 x 52 cm
Ltd Edition 100/No. AFI07

DAVID ARMSTRONG

¬ Die Bilder des Fotografen DAVID ARMSTRONG konzentrieren sich auf die scheinbaren Nebenschauplätze des Großstadtlebens: eine rote Ampel oder eine nächtlich illuminierte Straßenschlucht. Nach dem Besuch der School of The Museum of Fine Arts in Boston gründete er zusammen mit Nan Goldin und anderen die „Boston School", die seit Beginn der 1990er Jahre in der zeitgenössischen Fotografie für eine subjektive Bildsprache steht.

¬ In his images, photographer DAVID ARMSTRONG focuses on the seemingly negligible of modern life in the city: a red street light, an illuminated nighttime street. After attending the School of Museum of Fine Arts in Boston, he, Nan Goldin, and others together founded the so-called "Boston School", which has since the 1990s come to represent a subjective visual language in contemporary photography circles.

¬ Les images du photographe DAVID ARMSTRONG se concentrent sur des éléments de second plan de la vie urbaine: un feu de signalisation, une rue éclairée de nuit. Après avoir étudié à l'École des Beaux-Arts de Boston, il créé avec Nan Goldin et d'autres "l'École de Boston" qui traite, depuis le début des années 1990, le thème de la subjectivité en tant que langage visuel.

Untitled/120 x 80 cm/Ltd Edition 100/No. DAR07

© 2013 teNeues Verlag GmbH & Co. KG, Kempen
© 2013 by the artists and the authors. All rights reserved.

EDITED Heike Dander, Stefanie Harig, Marc A. Ullrich, Gunnar Wagner
TEXTS Erich Lessing, Claudius Seidl, Jock Sturges / Tim Morehead, Isabella Knoesel
TRANSLATIONS Spiralcat Translations (French), Pete Rees (English), Oriane Durand (French)
COPY EDITING Isabella Knoesel
PHOTOGRAPHS the participating artists
COVER Werner Pawlok

EDITORIAL DESIGN Antonia Offizier Pereira
FONTS Sabon, Sabon Bold, Sabon Italic, Sabon Bold Italic, Berthold Akzidenz Grotesk Condensed
COLOR SEPARATION Josephine Wolf
EDITORIAL COORDINATION LUMAS by Isabel Wagner | teNeues by Inga Wortmann
PRODUCTION teNeues by Nele Jansen

PUBLISHED teNeues Publishing Group

teNeues Verlag GmbH + Co. KG
Am Selder 37, 47906 Kempen, Germany
T +49 2152916 0 **F** +49 2152916 111
M books@teneues.de

Press department: Andrea Rehn
T +49 2152916 202
M arehn@teneues.de

teNeues Digital Media GmbH
Kohlfurter Straße 41–43, 10999 Berlin, Germany
T +49 30 70077650

teNeues Publishing Company
7 West 18th Street, New York, NY 10011, USA
T +1 212 6279090 **F** +1 212 627 9511

teNeues Publishing UK Ltd.
12 Ferndene Road, London, SE24 0AQ, UK
T +44 20 35428997

teNeues France S.A.R.L.
39, Rue des Billets, 18250 Henrichemont, France
T +33 248269348 **F** +33 170723482

www.teneues.com
www.LUMAS.info

ISBN 978-3-8327-9734-8
Library of Congress Control Number 2013940502

Printed in Italy

Bibliographic information published by the Deutsche Nationalbibliothek.
The Deutsche Nationalbibliothek lists this publication in the Deutsche Nationalbibliografie; detailed bibliographic data are available in the Internet at http://dnb.d-nb.de.

FSC
www.fsc.org
MIX
Papier aus verantwortungsvollen Quellen
FSC® C023419

teNeues Publishing Group
Kempen
Berlin
Cologne
Düsseldorf
Hamburg
London
Munich
New York
Paris

teNeues

LUMAS

All editions shown in this book are published by LUMAS and may be purchased at www.LUMAS.info or at the following galleries (subject to availability):

AACHEN
Buchkremerstr. 1–7
Mayersche Buchhandlung

BIELEFELD
Obernstr. 23

BREMEN
Sögestr. 37–39
Katharinenpassage

COLOGNE
Mittelstr. 15

DORTMUND
Rosemeyerstr. 14
Im INHOUSE

DUSSELDORF
Grünstr. 8

FRANKFURT
Kaiserstr. 13

BERLIN
Rosenthaler Str. 40–41
Hackesche Höfe – Mitte

Friedrichstr. 71
Quartier 206, UG

Fasanenstr. 73
Nähe Ku'damm

HAMBURG
ABC-Str. 51

HANNOVER
Luisenstr. 10–11
In der Kröpcke-Passage

HEIDELBERG
Hauptstr. 160

NEW YORK
1100 Madison Avenue
Upper East Side

362 West Broadway
SoHo

MUNICH
Brienner Str. 3

MÜNSTER
Roggenmarkt 13

STUTTGART
Lange Str. 3

LONDON
102 Westbourne Grove
Notting Hill

57 South Molton Street
Mayfair

PARIS
40, rue de Seine, 6e
Saint-Germain

24, rue Saint Martin, 4e
Marais

SALZBURG
Judengasse 9

VIENNA
Wollzeile 1–3

ZURICH
Marktgasse 9
Niederdorf